FOREVER TWILIGHT

IN

NEW YORK

WE WON'T FORGET

To all of those who have suffered the loss of a loved one and to the souls of those who live in infinity

THANK YOU, FOREVER.

David L. SUAREZ

OMNIA ET SINGULA FIERI PEDE ET RURSUS, UT MORI NON OMNIS PULVIS?

Does everything pass and is totally forgotten? Does everything die and turn to dust?

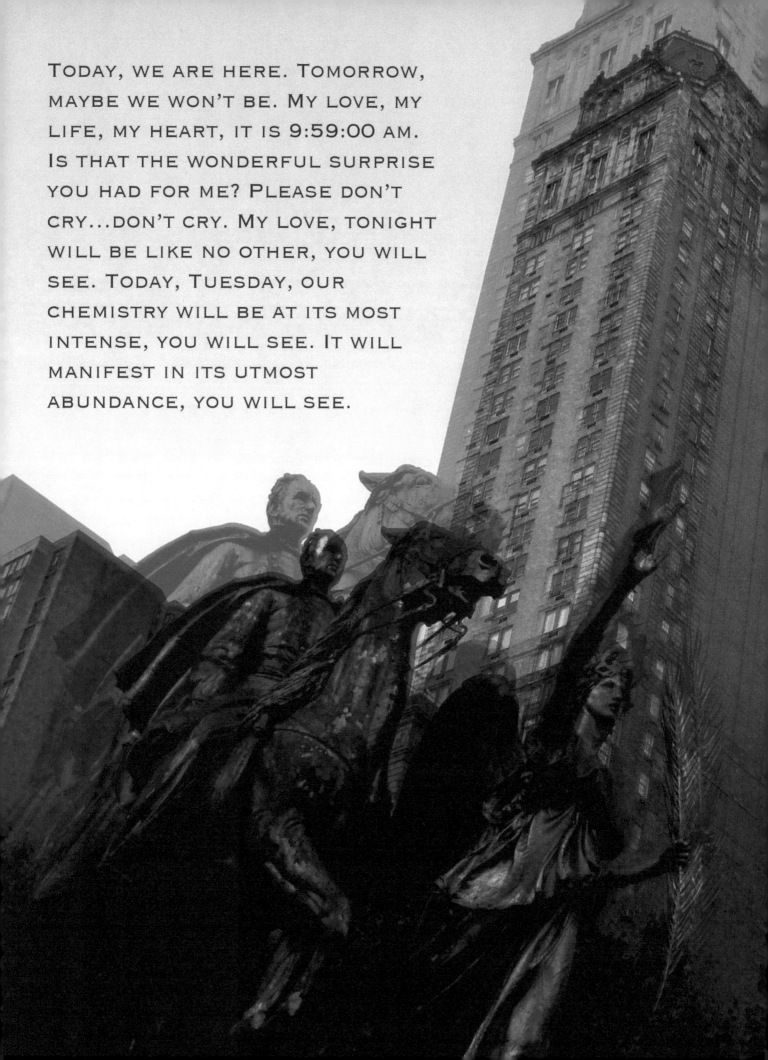

TODAY, WE ARE HERE. TOMORROW, MAYBE WE WON'T BE. MY LOVE, MY LIFE, MY HEART, IT IS 9:59:00 AM. IS THAT THE WONDERFUL SURPRISE YOU HAD FOR ME? PLEASE DON'T CRY...DON'T CRY. MY LOVE, TONIGHT WILL BE LIKE NO OTHER, YOU WILL SEE. TODAY, TUESDAY, OUR CHEMISTRY WILL BE AT ITS MOST INTENSE, YOU WILL SEE. IT WILL MANIFEST IN ITS UTMOST ABUNDANCE, YOU WILL SEE.

למה, ניו יורק

מי, ניו יורק

מתי, ניו יורק

איפה היא, ניו יורק

האם זה אתה, ניו יורק

Why, New York? Who, New York? When, New York? Where is she, New York? Was it you, New York?

← EXIT ◆ 47TH ST. & MADISON AVE. ◆ 48TH ST. & PARK AVE

One runs in New York, one runs. Run, don't stop. Run! In New York, everyone is exposed to everything so that anyone can think about anything. Destruction, death, and resurrection all appear in a minute, then kiss and disappear.

STANCO?

No! Never tired. Run, don't stop. Run! In New York, one cries, one yells, one laughs, one speaks, one becomes quite... and one runs, yes, one runs.

Exhausted?

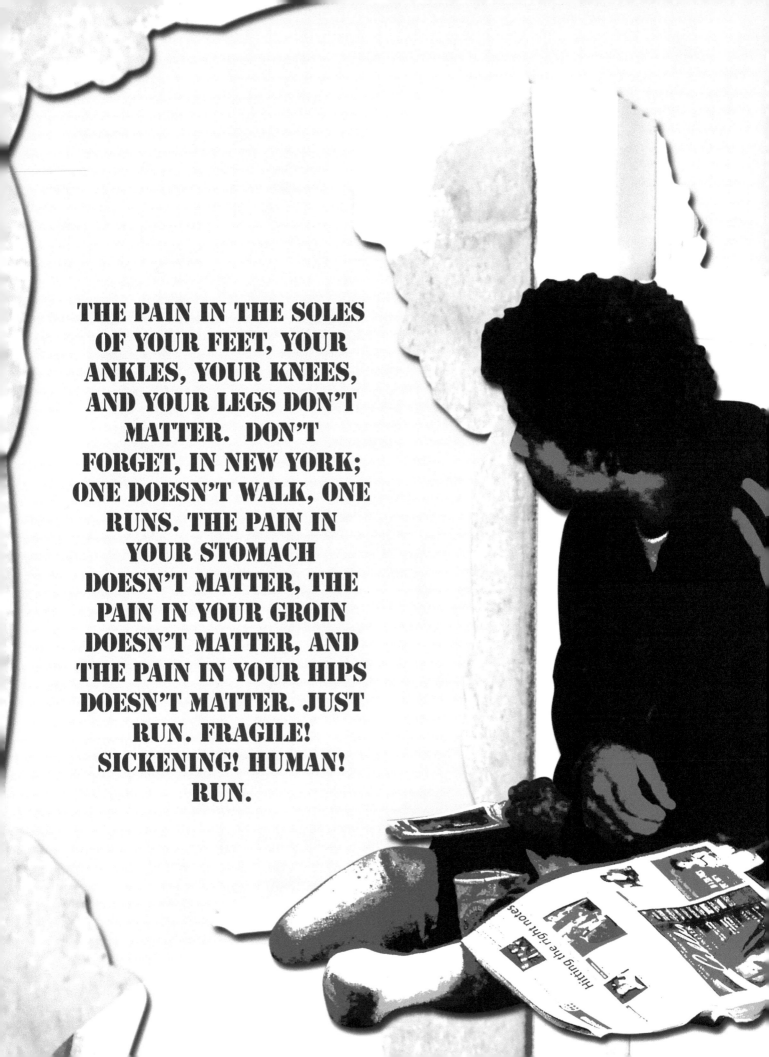

THE PAIN IN THE SOLES OF YOUR FEET, YOUR ANKLES, YOUR KNEES, AND YOUR LEGS DON'T MATTER. DON'T FORGET, IN NEW YORK; ONE DOESN'T WALK, ONE RUNS. THE PAIN IN YOUR STOMACH DOESN'T MATTER, THE PAIN IN YOUR GROIN DOESN'T MATTER, AND THE PAIN IN YOUR HIPS DOESN'T MATTER. JUST RUN. FRAGILE! SICKENING! HUMAN! RUN.

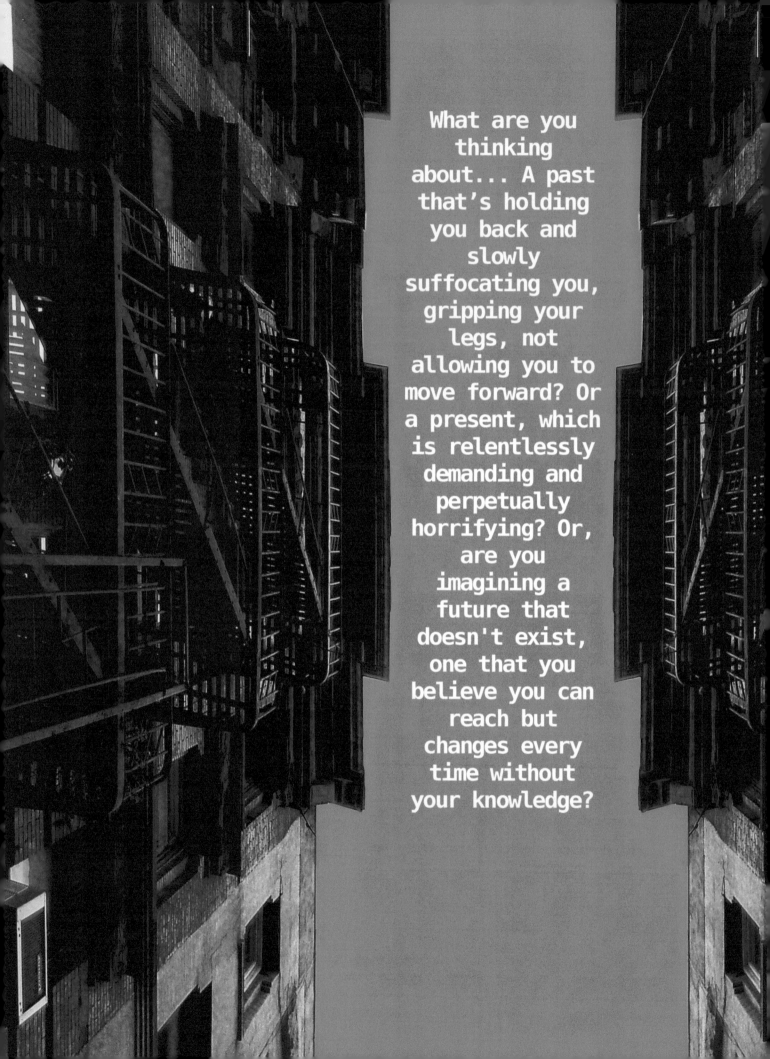

What are you thinking about... A past that's holding you back and slowly suffocating you, gripping your legs, not allowing you to move forward? Or a present, which is relentlessly demanding and perpetually horrifying? Or, are you imagining a future that doesn't exist, one that you believe you can reach but changes every time without your knowledge?

CORRE, NO PARES!

Run, don't stop!

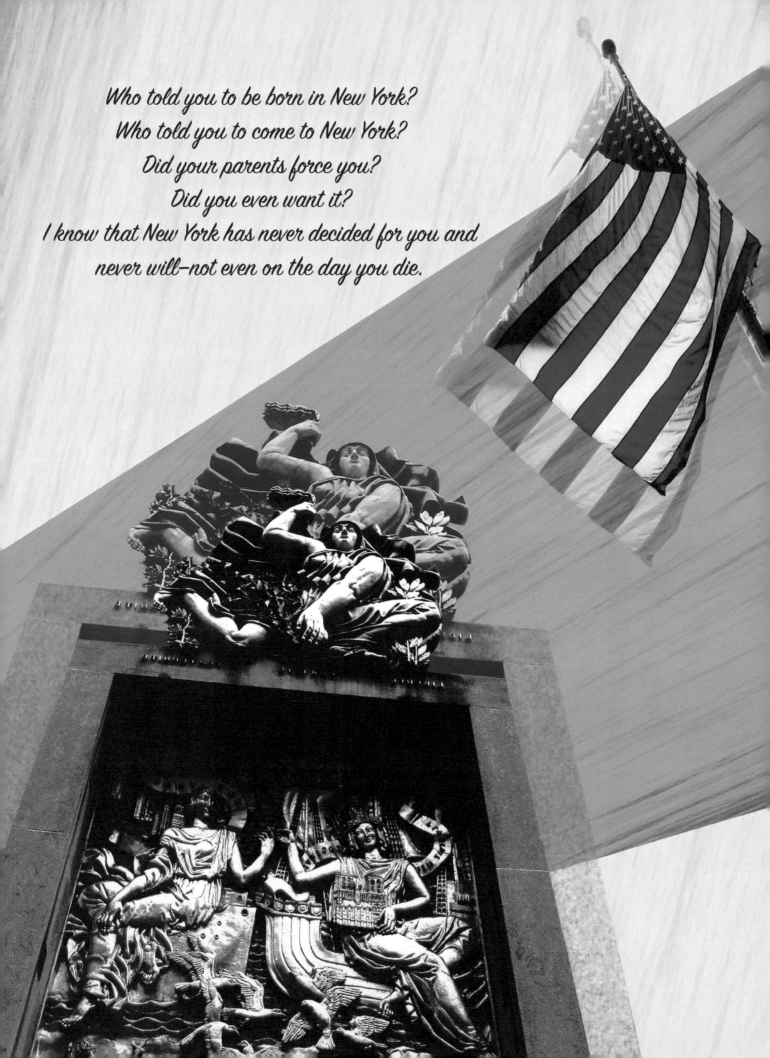

Who told you to be born in New York?
Who told you to come to New York?
Did your parents force you?
Did you even want it?
I know that New York has never decided for you and
never will—not even on the day you die.

Du ser efter det;
du finder det.
Løb!

You look for it; you find it. Run!

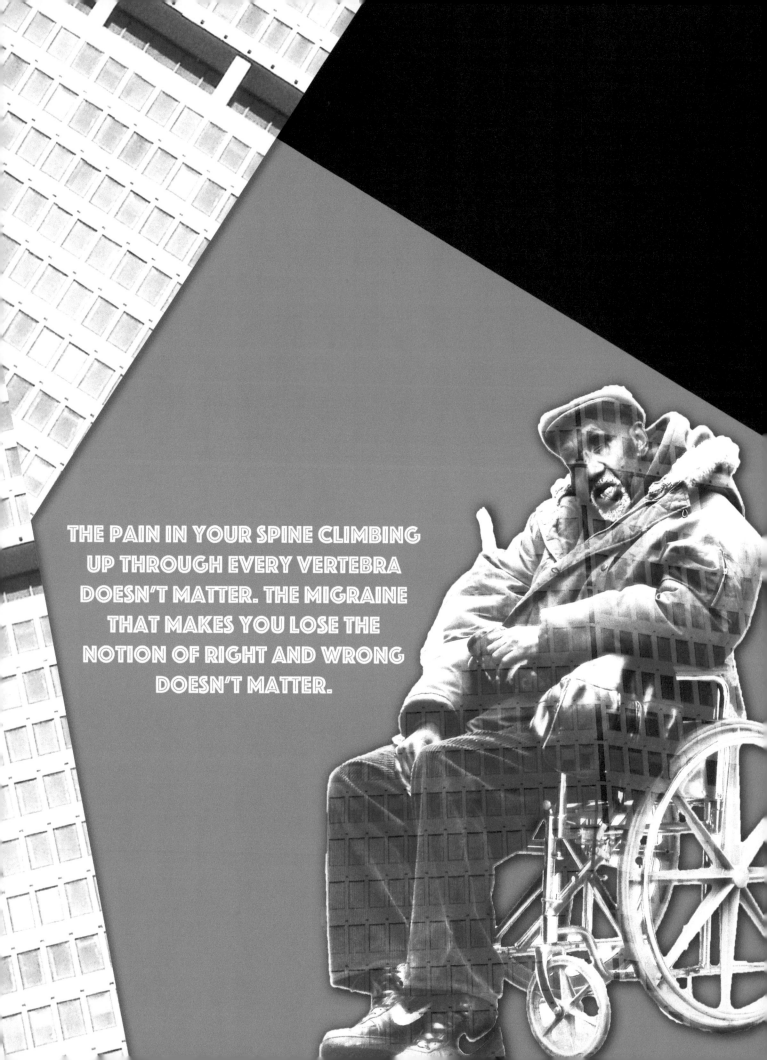

THE PAIN IN YOUR SPINE CLIMBING UP THROUGH EVERY VERTEBRA DOESN"T MATTER. THE MIGRAINE THAT MAKES YOU LOSE THE NOTION OF RIGHT AND WRONG DOESN"T MATTER.

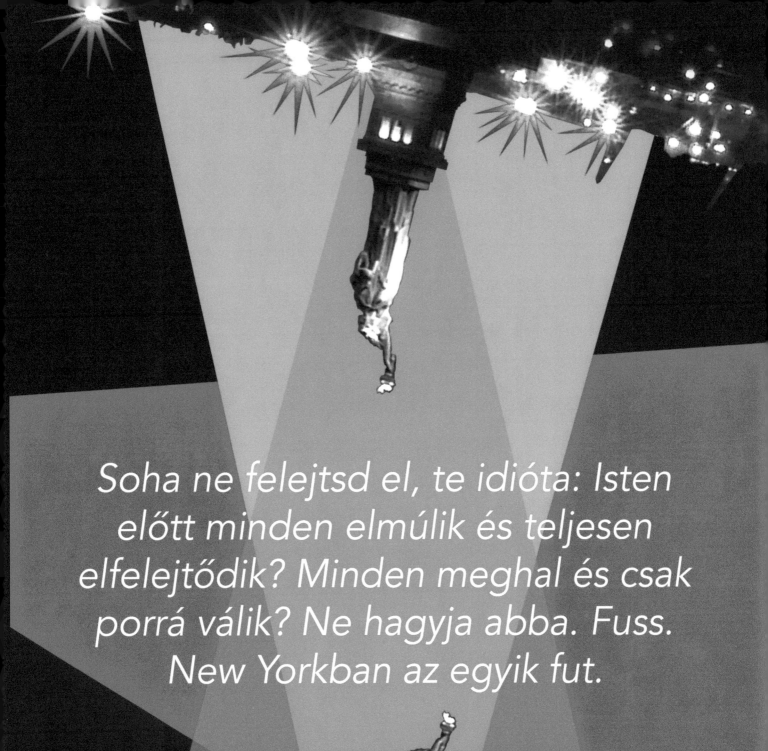

Soha ne felejtsd el, te idióta: Isten előtt minden elmúlik és teljesen elfelejtődik? Minden meghal és csak porrá válik? Ne hagyja abba. Fuss. New Yorkban az egyik fut.

Never forget it, you idiot: before God, does everything pass and is totally forgotten? Does everything die and turn to dust? Don't stop. Run. In New York, one runs.

The pain in your arms and your fingers doesn't matter. Come on, don't cry. The pain in your chest, the toothache—they don't matter. The constant pain in your ears doesn't matter, idiot! Don't lose your balance; just run!

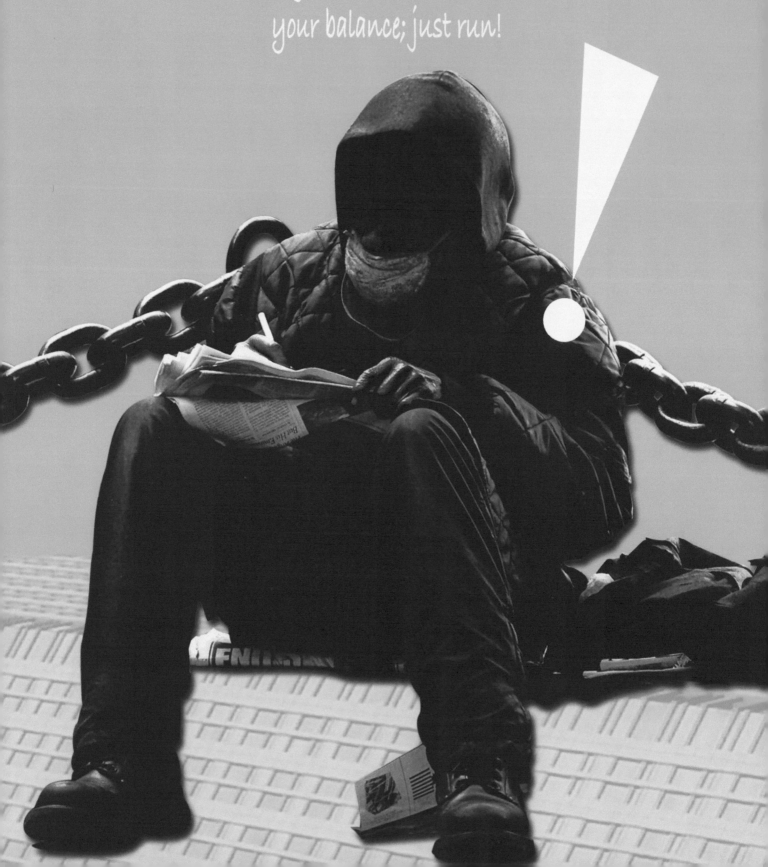

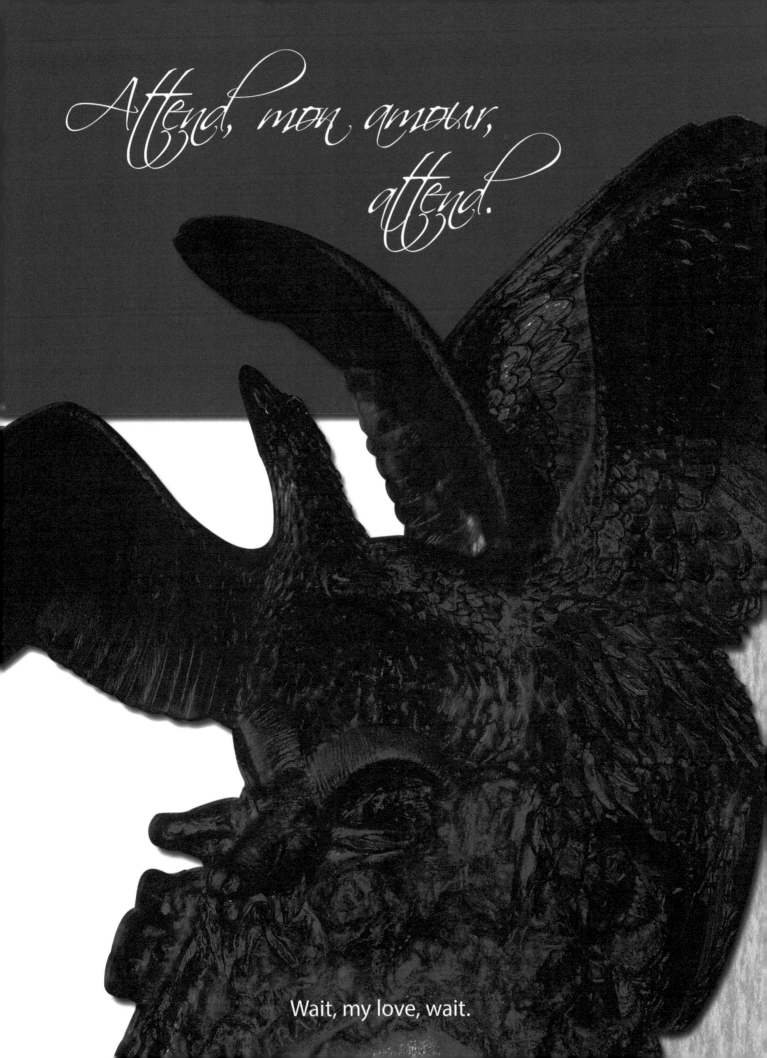

Attend, mon amour, attend.

Wait, my love, wait.

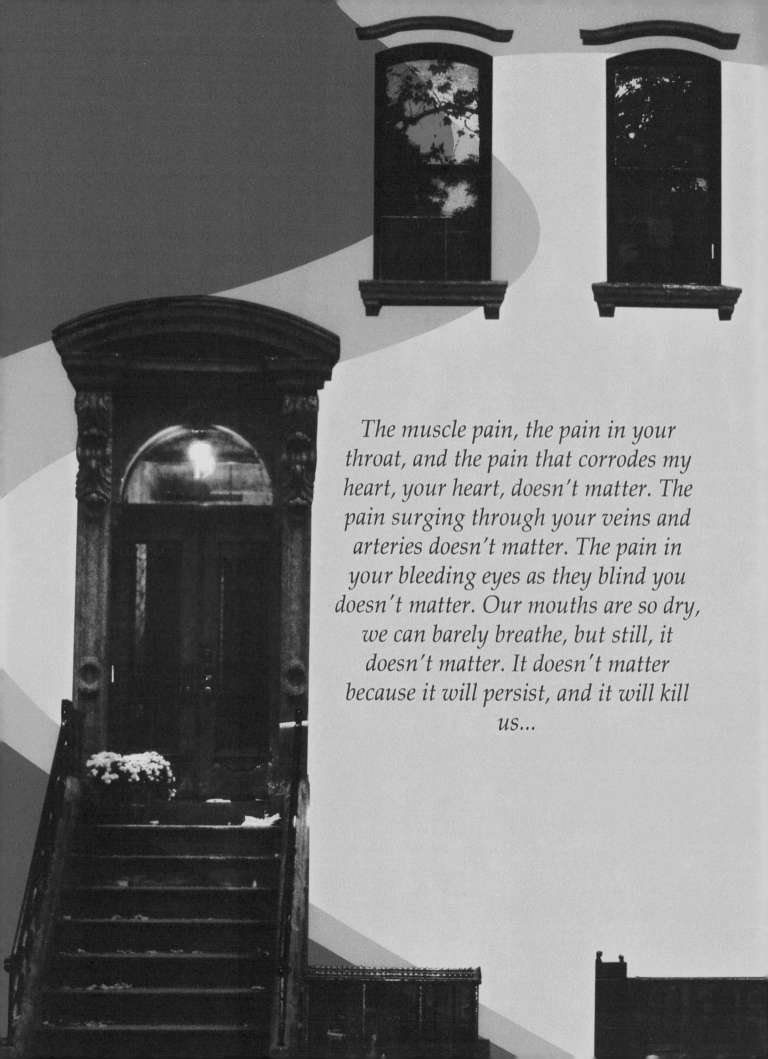

The muscle pain, the pain in your throat, and the pain that corrodes my heart, your heart, doesn't matter. The pain surging through your veins and arteries doesn't matter. The pain in your bleeding eyes as they blind you doesn't matter. Our mouths are so dry, we can barely breathe, but still, it doesn't matter. It doesn't matter because it will persist, and it will kill us...

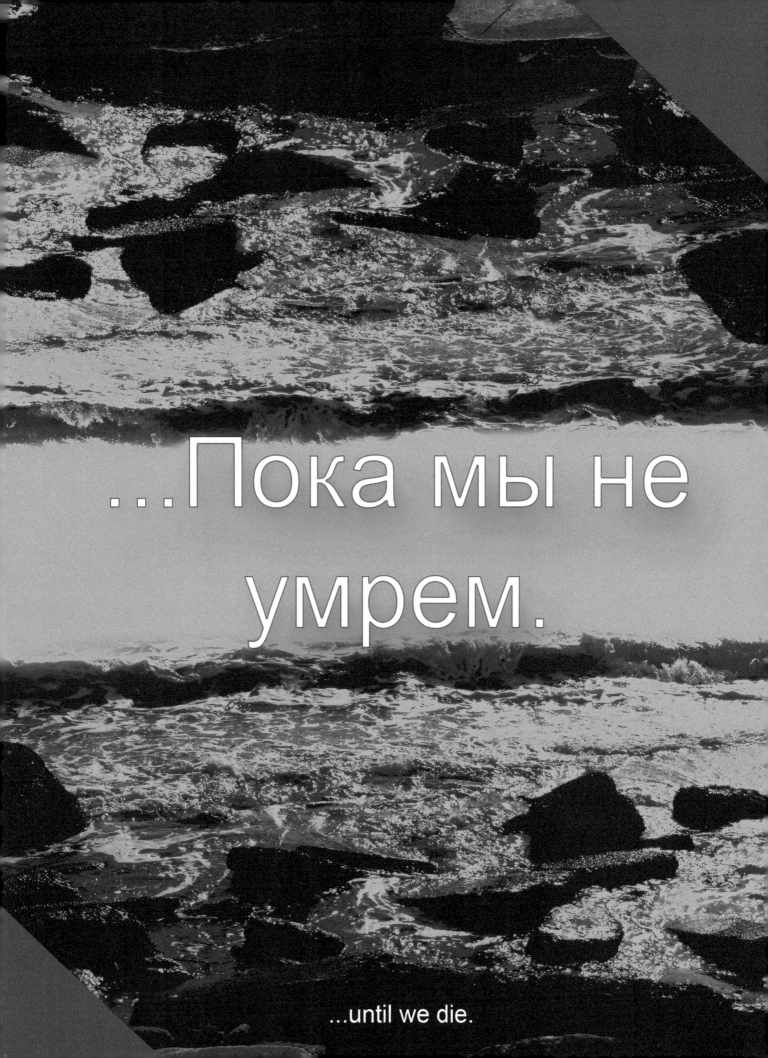

...Пока мы не

умрем.

...until we die.

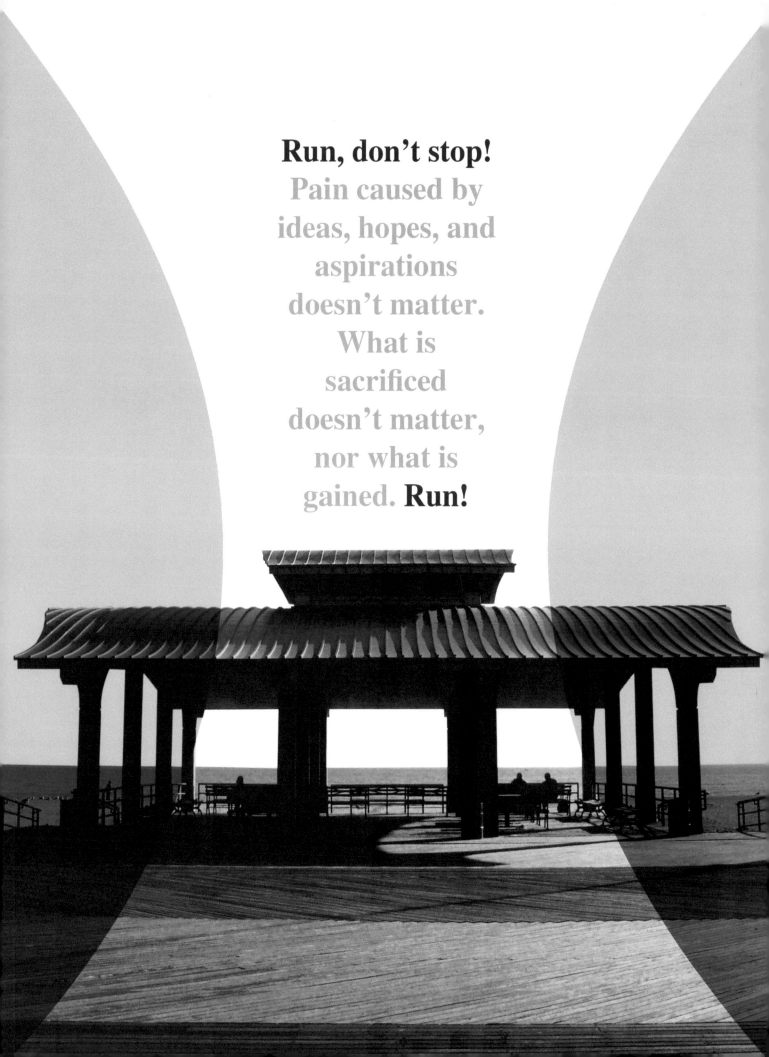

Run, don't stop!
Pain caused by
ideas, hopes, and
aspirations
doesn't matter.
What is
sacrificed
doesn't matter,
nor what is
gained. **Run!**

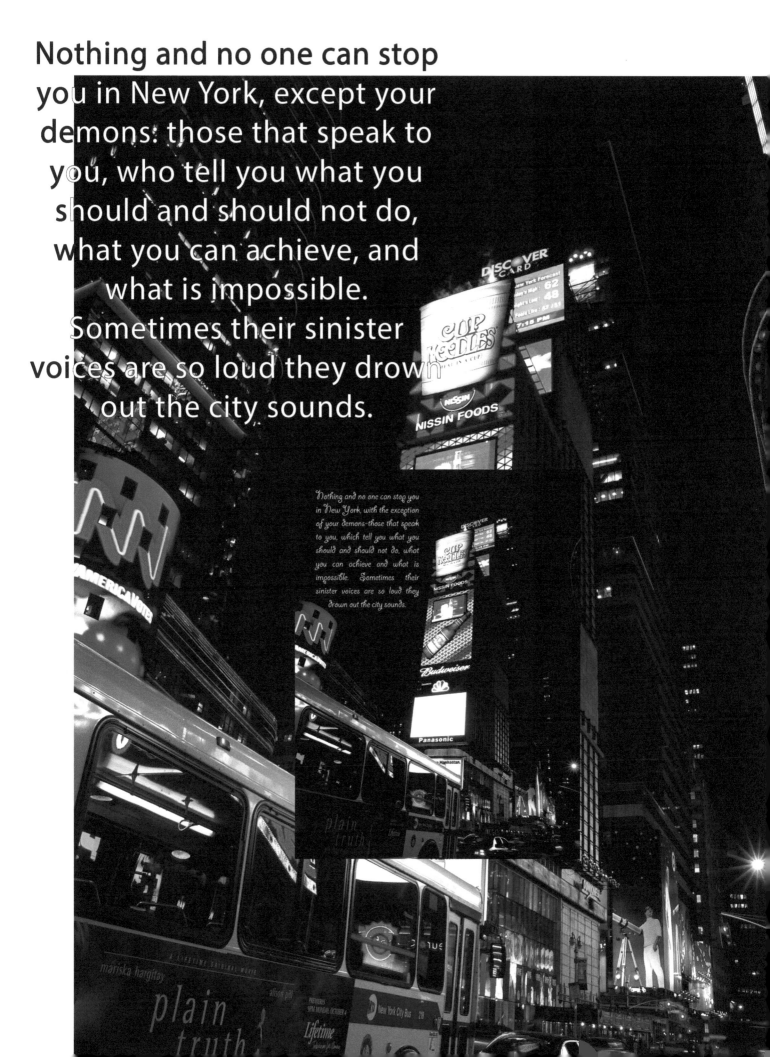

Nothing and no one can stop you in New York, except your demons: those that speak to you, who tell you what you should and should not do, what you can achieve, and what is impossible. Sometimes their sinister voices are so loud they drown out the city sounds.

Nothing and no one can stop you in New York, with the exception of your demons—those that speak to you, which tell you what you should and should not do, what you can achieve and what is impossible. Sometimes their sinister voices are so loud they drown out the city sounds.

VOCÊ AINDA NÃO ESTÁ ILUMI-NADO, SEU CHAMADO POLI-GLOTA.

You are not enlightened yet, you so-called polyglot.

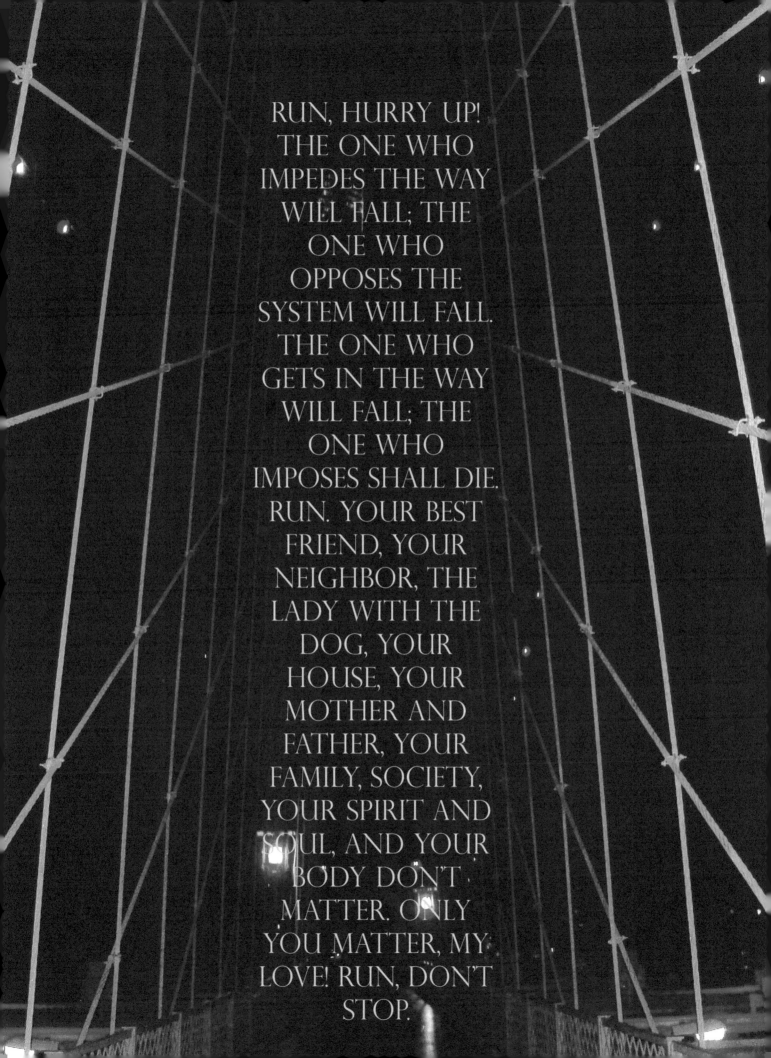

RUN, HURRY UP!
THE ONE WHO
IMPEDES THE WAY
WILL FALL; THE
ONE WHO
OPPOSES THE
SYSTEM WILL FALL.
THE ONE WHO
GETS IN THE WAY
WILL FALL; THE
ONE WHO
IMPOSES SHALL DIE.
RUN. YOUR BEST
FRIEND, YOUR
NEIGHBOR, THE
LADY WITH THE
DOG, YOUR
HOUSE, YOUR
MOTHER AND
FATHER, YOUR
FAMILY, SOCIETY,
YOUR SPIRIT AND
SOUL, AND YOUR
BODY DON'T
MATTER. ONLY
YOU MATTER, MY
LOVE! RUN, DON'T
STOP.

Day and night, the sun and moon don't matter. Space and time, the universe; what's unknown and limitless doesn't matter. The astronomical force of Mother Nature doesn't matter. May God swallow it, spit it out, and stomp on it until it turns to dust. Yes, into dust that God will snort and use as inspiration for his new creation. A creation with fewer errors. A creation without men.

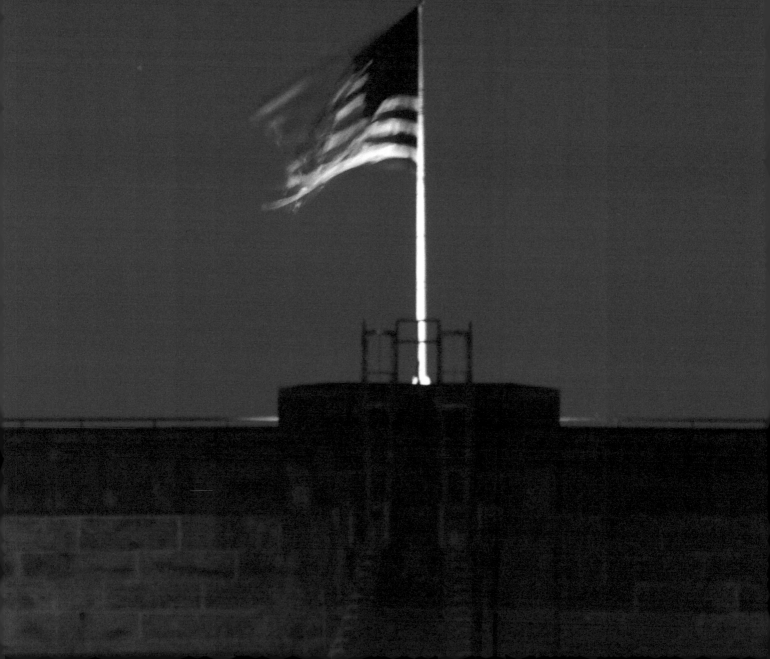

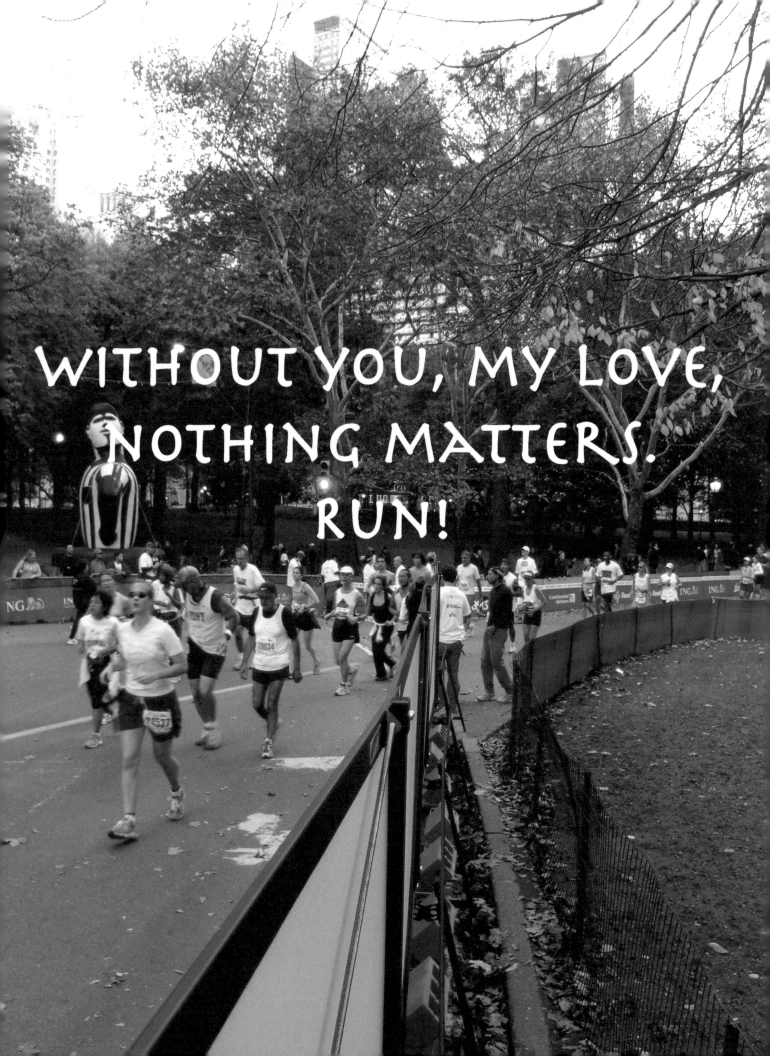

Don't cry or complain, or sit down and rest, or think about resting, just run. Don't laugh, don't speak a word, don't sing, don't blink or breathe. Just run! You will be grateful for it. You will achieve what you have always dreamed of. Yes, you will achieve it. Run, hurry up. Don't love, want, or think. Don't waste your time with reflections and ideas that, in the end, will only produce the same result.

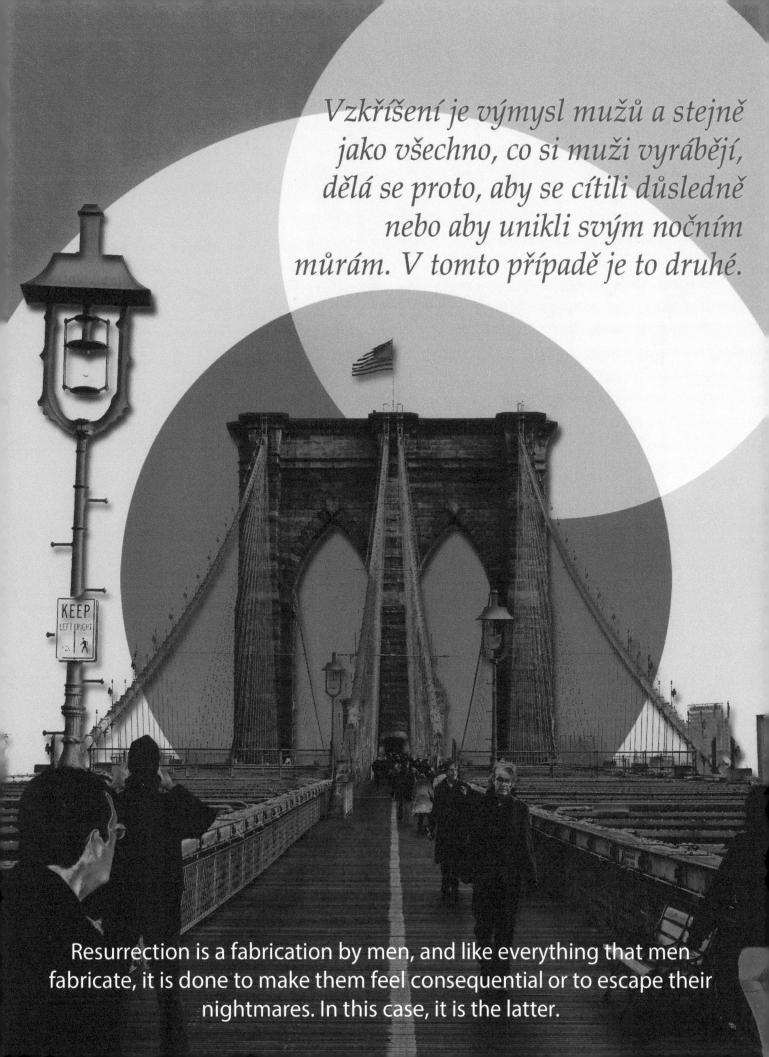

Vzkříšení je výmysl mužů a stejně jako všechno, co si muži vyrábějí, dělá se proto, aby se cítili důsledně nebo aby unikli svým nočním můrám. V tomto případě je to druhé.

Resurrection is a fabrication by men, and like everything that men fabricate, it is done to make them feel consequential or to escape their nightmares. In this case, it is the latter.

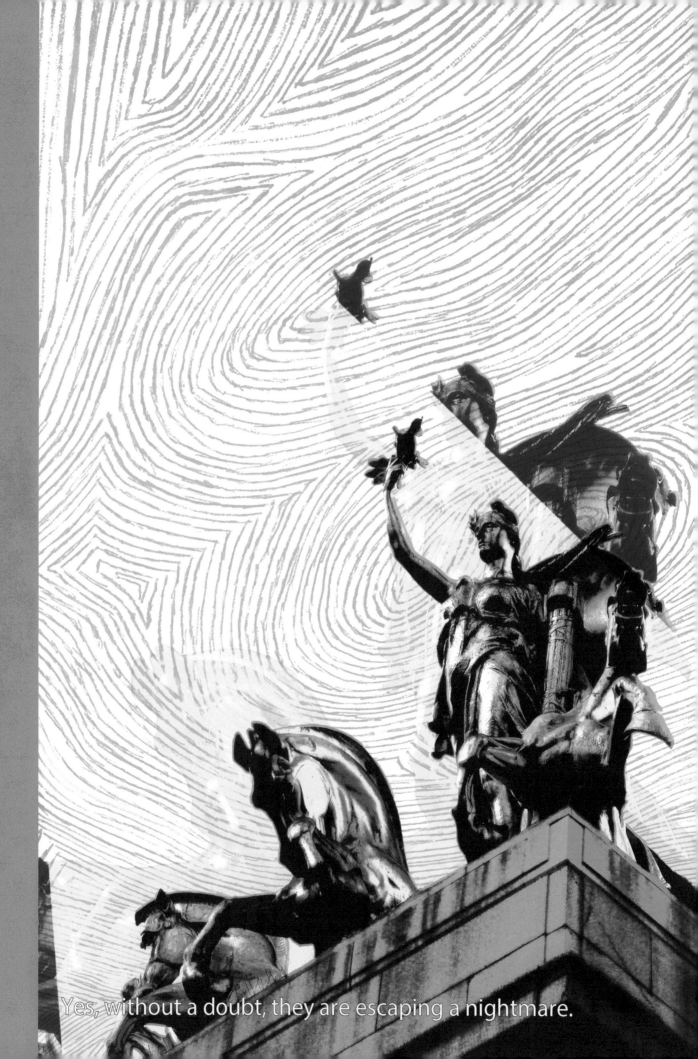

Ja, zonder twijfel ontsnappen ze aan een nachtmerrie.

Yes, without a doubt, they are escaping a nightmare.

RUN!

IN NEW YORK, DAY AND NIGHT, MEET EACH OTHER AND FUSE TOGETHER. LOVE AND HATE MEET EACH OTHER AND STARE FIRMLY. THE IMMORAL AND THE NOBLE MEET EACH OTHER AND PAY WITH THE SAME MONEY. THE MISERABLE AND THE PRIVILEGED MEET EACH OTHER, AND THEY BOTH GO BY THE NAME JEFF. THE MANIAC AND HYPOCHONDRIAC MEET EACH OTHER AND MARCH INTO EMPTINESS. THE PERSON WITH SCHIZOPHRENIA FINDS HIMSELF AND TAUNTS HIMSELF. THE INTELLECTUAL AND THE DIM-WITTED MEET EACH OTHER AND SHED TEARS. MUHAMMAD ALI AND ABRAHAM COHEN MEET EACH OTHER AND SHAKE HANDS. WHITE AND BLACK MEET EACH OTHER, AND AN AMERICAN IS BORN. NORTH AND SOUTH MEET EACH OTHER, AND SOUTH MOUNTS ON NORTH'S SHOULDERS. EAST AND WEST MEET EACH OTHER, AND WAR IS TRIGGERED. DAVID MIYAMOTO SUAREZ AND NANCY TAO SUAREZ MEET EACH OTHER AND LAUGH AT HOW MINUSCULE THE WORLD IS. THE POOR AND THE RICH MEET EACH OTHER AND ARE BURIED IN THE SAME GRAVE. CATHOLICS AND PROTESTANTS MEET EACH OTHER AND BELIEVE IN THE SAME GOD. DEATH AND LIFE MEET EACH OTHER AND SPAWN A NEW BEING. THE WORLD AND NEW YORK MEET EACH OTHER, AND THE PRESSURE BECOMES MORE INTENSE, MORE UNBEARABLE--SO, RUN, DON'T STOP. YES, RUN, DON'T STOP. YES, RUN!

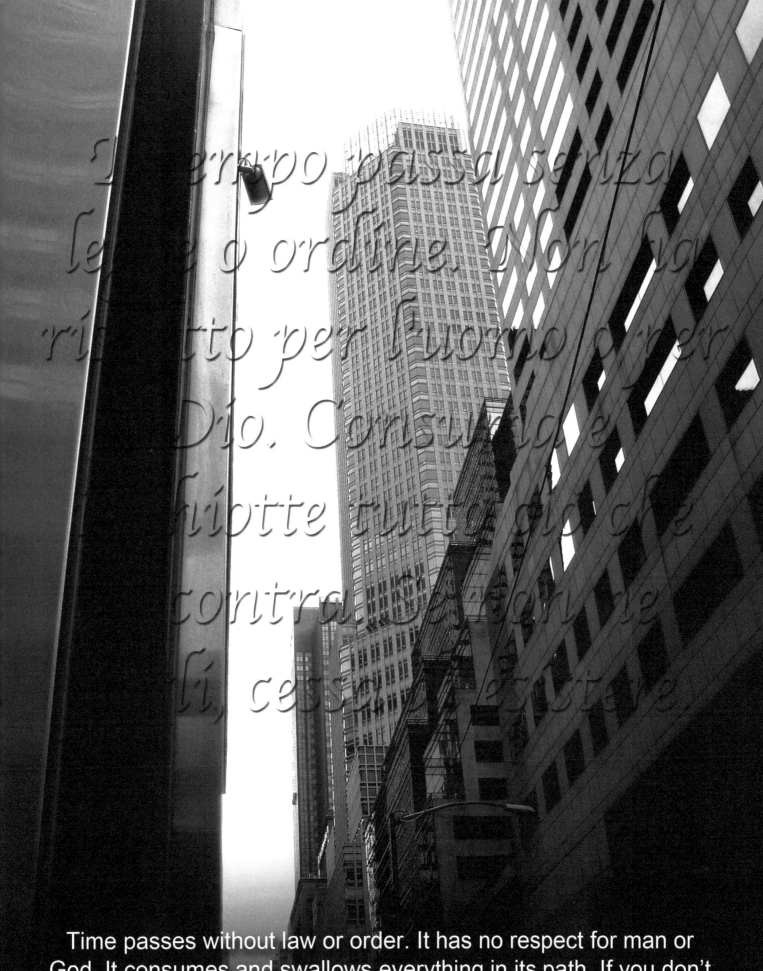

Time passes without law or order. It has no respect for man or God. It consumes and swallows everything in its path. If you don't talk about it, it ceases to exist.

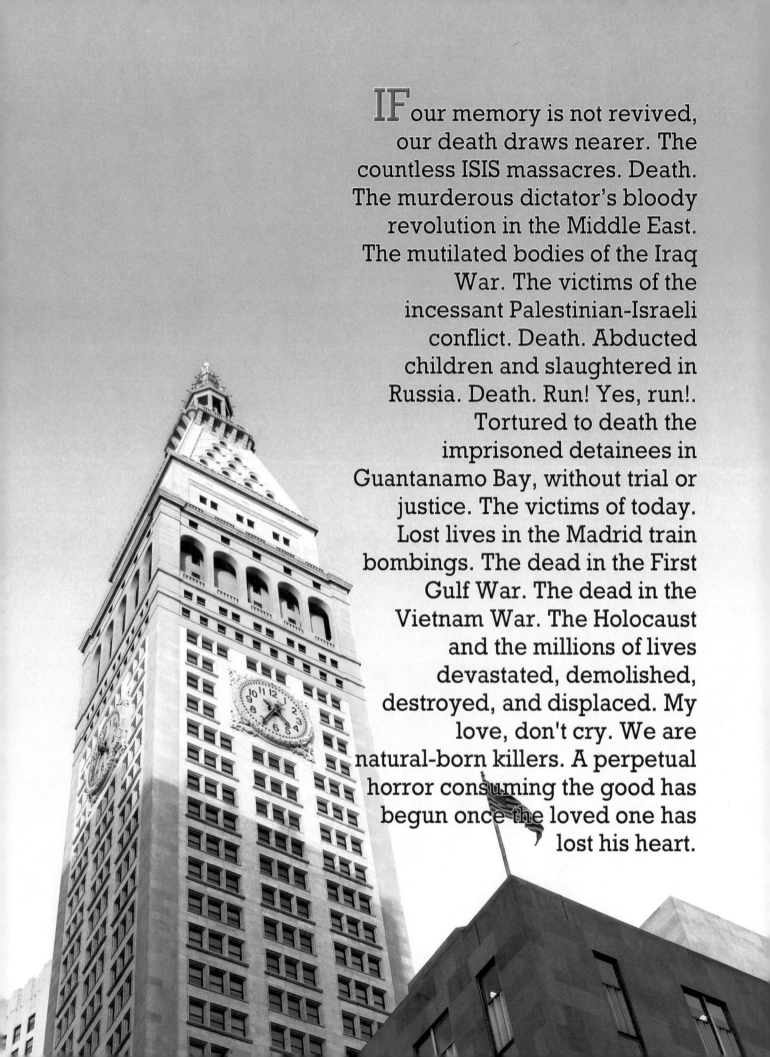

IF our memory is not revived, our death draws nearer. The countless ISIS massacres. Death. The murderous dictator's bloody revolution in the Middle East. The mutilated bodies of the Iraq War. The victims of the incessant Palestinian-Israeli conflict. Death. Abducted children and slaughtered in Russia. Death. Run! Yes, run!. Tortured to death the imprisoned detainees in Guantanamo Bay, without trial or justice. The victims of today. Lost lives in the Madrid train bombings. The dead in the First Gulf War. The dead in the Vietnam War. The Holocaust and the millions of lives devastated, demolished, destroyed, and displaced. My love, don't cry. We are natural-born killers. A perpetual horror consuming the good has begun once the loved one has lost his heart.

走れ！急いで、やめないで！私の愛、心配しないでください。まもなく到着します。私はあなたと一緒にいます、そして私はあなたの中にいます。

Run! Hurry up, don't stop! My love, don't worry. Soon, I will arrive. I'll be with you, and I will be within you.

My love, I know that **I would give up my life for you.**
My love, I know that **it is my destiny to be with you.**
My love, I know that **my nights are nothing without you**
by my side.
My love, I know that **I lose all reason when I am with**
you.

By your side, time turns to magic.
By your side, the three dimensions don't justify our
love.
By your side, the impossible only exists among
individuals and mortals.

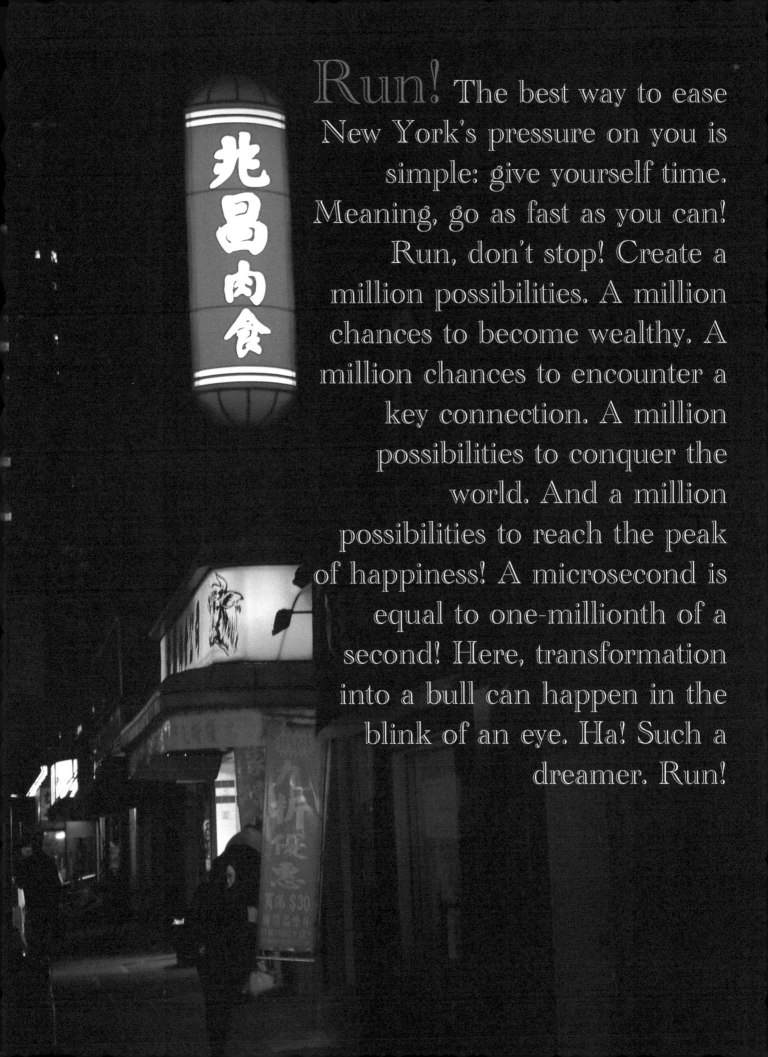

Run! The best way to ease New York's pressure on you is simple: give yourself time. Meaning, go as fast as you can! Run, don't stop! Create a million possibilities. A million chances to become wealthy. A million chances to encounter a key connection. A million possibilities to conquer the world. And a million possibilities to reach the peak of happiness! A microsecond is equal to one-millionth of a second! Here, transformation into a bull can happen in the blink of an eye. Ha! Such a dreamer. Run!

In New York, one minute and 30 seconds are required to eat a hamburger, leaving behind the fries. Run! Around four to six seconds are needed to cross from one street to another; it is better if the street is not too wide, especially if there is an important appointment with the next financial victim: a wealthy and extravagant client. Run! Over 3'916,700 cups of coffee are sold each day. Run! In this immense city, a dollar bill exchanges hands more than 101 times in 24 hours. Don't stop; keep on moving! In New York, more than 400 million phone calls are made every single day. Tired? Never tired! In this city, more than nine million individuals worldwide are in touch with Wall Street, one way or another. Run! It will continue tomorrow, and the next day, until the inception of World War III. Heil, mein Führer DJT 47th! Run!

Беги, не останавливайся. Бежать!

Madison Ave

East 2?TH St

ONE WAY

Run, don't stop. Run!

New York, tell me why you never sleep?
Tell me why you never sleep, New York.

Are you looking for something? Has your weariness been stolen?
Look at your eyes; they're as red as fire.
The shadow of the past, has it inhibited you?
Scream your pain. It's worthy of being heard.

New York, tell me why you never sleep?
Tell me why you never sleep, New York.

You, who have lived through it all, why have you left her?
Whisper in a low voice. I am by your side.
Leave me. Am I committing suicide?
The apple you gave me is poisoning me.

New York, tell me why you never sleep?
Tell me why you never sleep, New York.

Here in New York, some are seeking life while others seek death; some seek light while others seek darkness; some seek war while others seek peace; some seek God while others seek Satan; some seek companionship while others seek solitude, and some seek blood while others seek water.

Στη Νέα Υόρκη, οι άνθρωποι βρίσκουν αυτό που αναζητούν.

I ❤ EARTH

In New York, people find what they seek.

भागो, जल्दी करो, और भागो! शापित की भीड़ नींद को कुचल देगी।

Run, hurry up, and run! The crowds of the damned will crush the sleepy one.

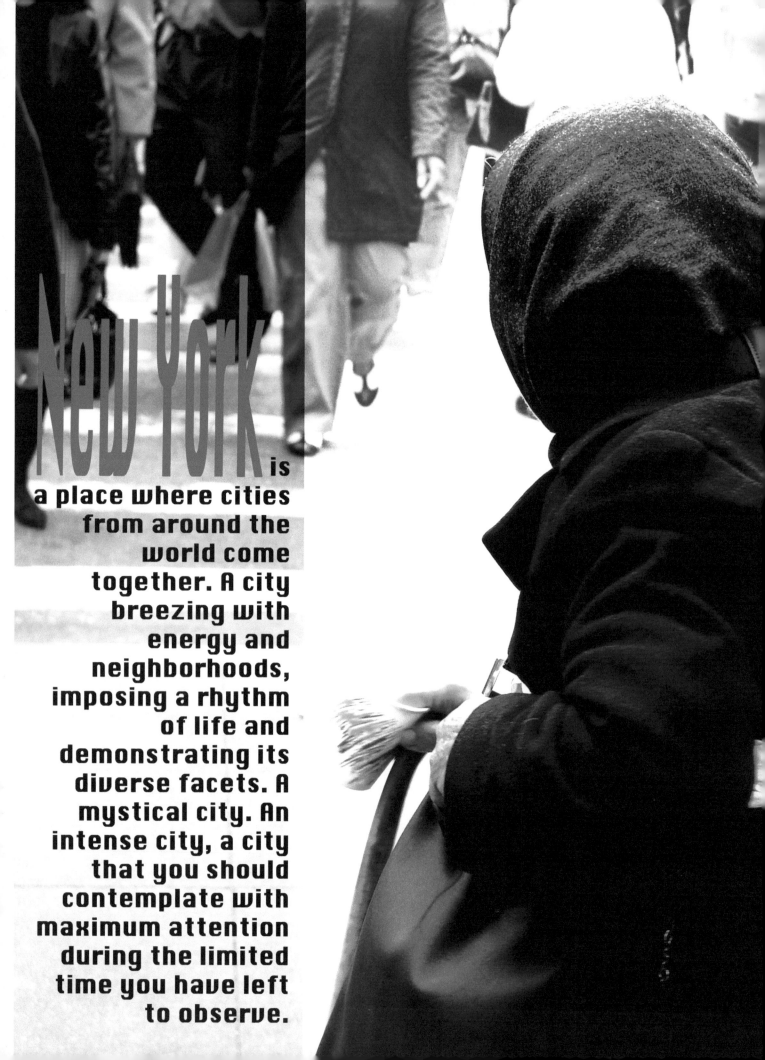

New York is a place where cities from around the world come together. A city breezing with energy and neighborhoods, imposing a rhythm of life and demonstrating its diverse facets. A mystical city. An intense city, a city that you should contemplate with maximum attention during the limited time you have left to observe.

Běh!

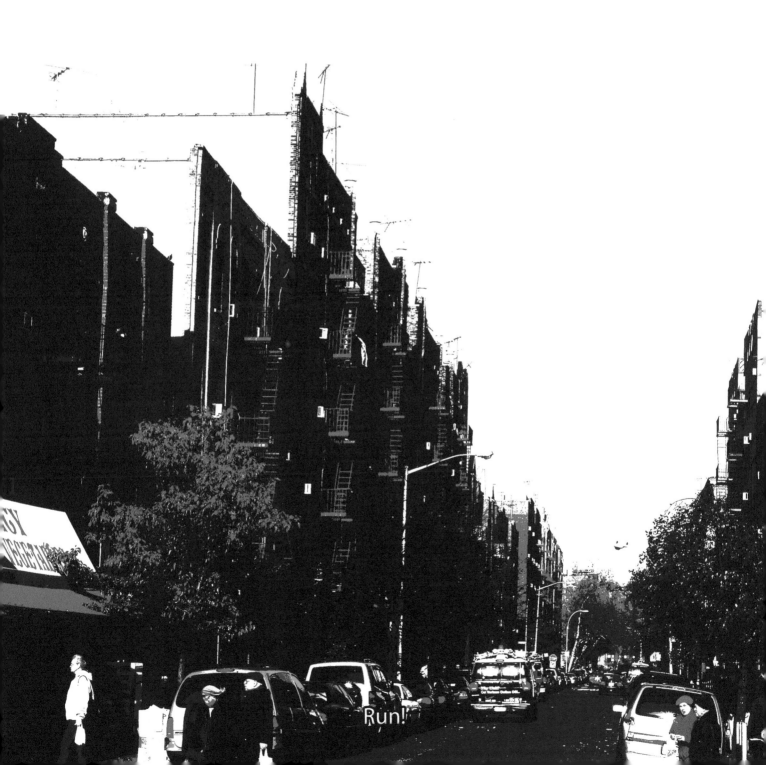

Run!

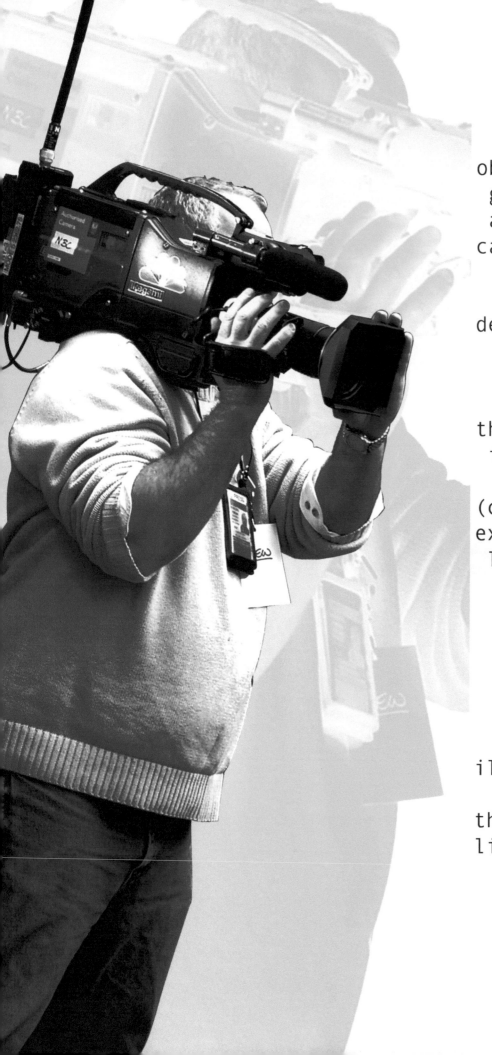

The Big Apple deserves to be observed through a good camera lens, a 5D Mark III, to capture its beauty further. Every inch of its body deserves attention from the camera, for hiding in every crevice of this colossal city is the life of an individual: (click) persona is exposed; (flash) a life of interest, differences, originality, and tension. Each click of the camera captures the reason for life to exist, illuminates a life that defends theory, embraces a life that deserves eternity.

EACH LIFE IS COMPOSED DOWN AS IF A SCRIPTWRITER DEVELOPED IT FROM A SCENE IN A MOVIE. THE STORY: ACTION-REACTION, CAUSE-EFFECT, WITH ITS OBSTACLES AS THE PLOT UNFOLDS WITH TOTAL ORIGINALITY. PERSONA: PEOPLE WITH DIFFERENT PERSONALITIES. LOVING, PATIENT, AND CALM. BUY YOUR TICKET. GRAB A SEAT AND LOOK AT ALL THESE CRAZY, SAD, BRAVE, AND SCARRED SOULS.

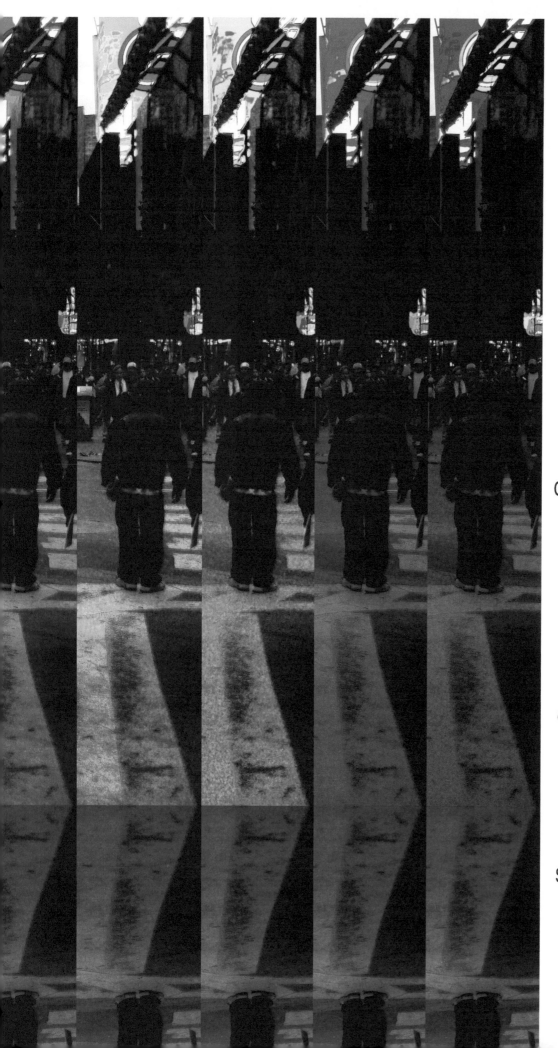

In New York, a city of a million skies, we find all types of individuals, simple or complex, that exist on the Earth's surface. Each corner of New York represents something of this world. Each corner has seen the world almost grow towards the end, reaching stars. The corners of New York, thanks to their differences, show us the past, the present, and the future of a complex world.

For a long time, I dreamed about her.
For a long time, I lived with her.
For a long time, I prayed for her.
For a long time, I loved her.

Just looking into her eyes was enough to love her.
Just looking at her lips was enough to love her.
Just looking at her breasts was enough to love her.
Just looking at her perfect curves was enough to never forget her.

She lives as though she is immortal.
She lives like the distant horizon on the sea.
She lives like the energy that only transforms.
She lives like the love that once united us eternally.

Mr. Minoru Yamasaki? Why are you here?

アーメン.

Amen.

RUN! YOU ARE NOT FAR, MY FRIEND. SOON YOU WILL FIND YOURSELF IN THE WORLD OF THOSE WHO NEVER SLEEP.

NEW YORK

跑！不要停下来！

T&LC
Manhattan Limousine

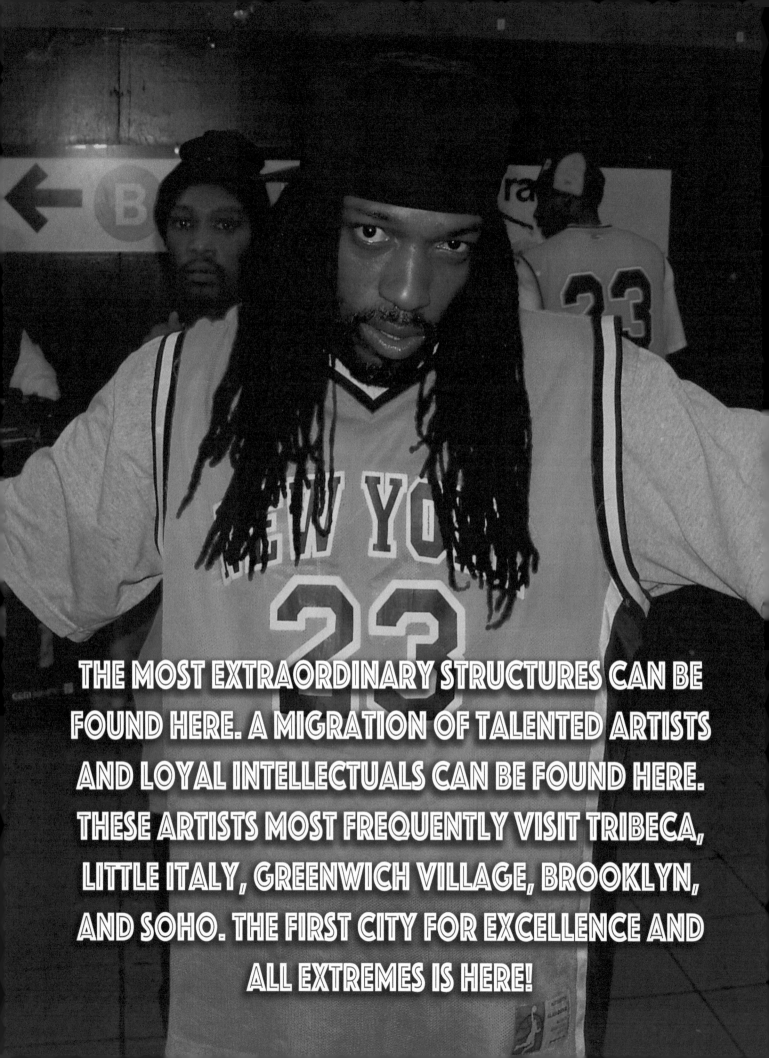

THE MOST EXTRAORDINARY STRUCTURES CAN BE FOUND HERE. A MIGRATION OF TALENTED ARTISTS AND LOYAL INTELLECTUALS CAN BE FOUND HERE. THESE ARTISTS MOST FREQUENTLY VISIT TRIBECA, LITTLE ITALY, GREENWICH VILLAGE, BROOKLYN, AND SOHO. THE FIRST CITY FOR EXCELLENCE AND ALL EXTREMES IS HERE!

운영! 네,
달려요.

Run! Yes, run.

This city has an energy that would drive anyone to madness. It's a city that will always make you feel like a little boy left speechless. It's a city where innocent foreigners feel like kids again, humbled and obedient at what they are viewing. It's a city in which, one second to the next, fantasy clashes with reality. Walking through Times Square is like traveling 150 years beyond the third world war. The future is in our hands. Hold onto it tightly as you run. Come on, run!

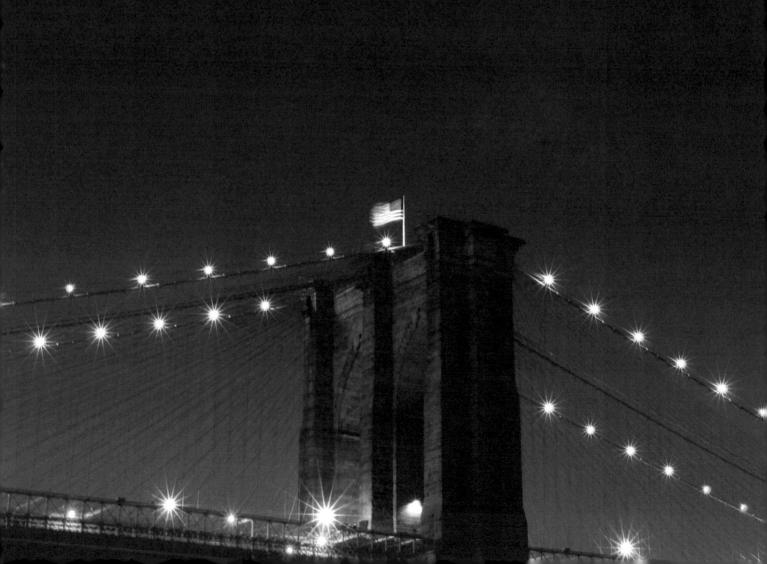

À New York on y trouve tout ce que l'on veut

New York has it all.

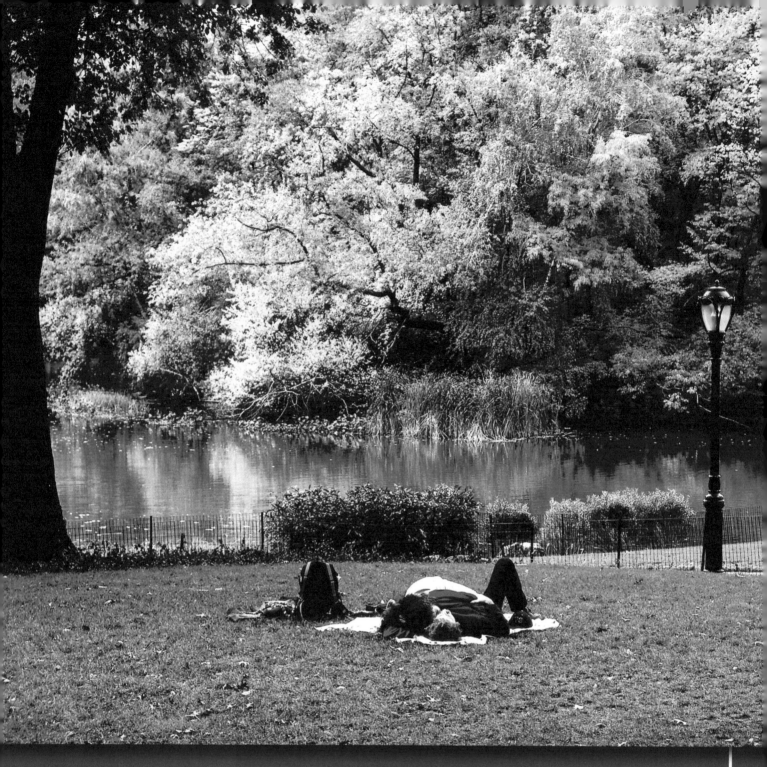

It's a city where living and non-living things meet, part, and re-encounter. New York is a city where every person has the freedom to do as they wish, like making love in Central Park or hiding underneath a red blanket at two in the afternoon—which, incidentally, is considered as everyday and normal as ordering a hot dog without mustard, please! It's a city where all ethnicities express themselves in any way they want.

Wir befinden uns in einem himmlischen Dschungel, in dem sich alles befindet was wir wahrnehmen nicht natürlich und ist nicht menschlich.

We are in a celestial jungle in which everything we perceive is not natural and is not human.

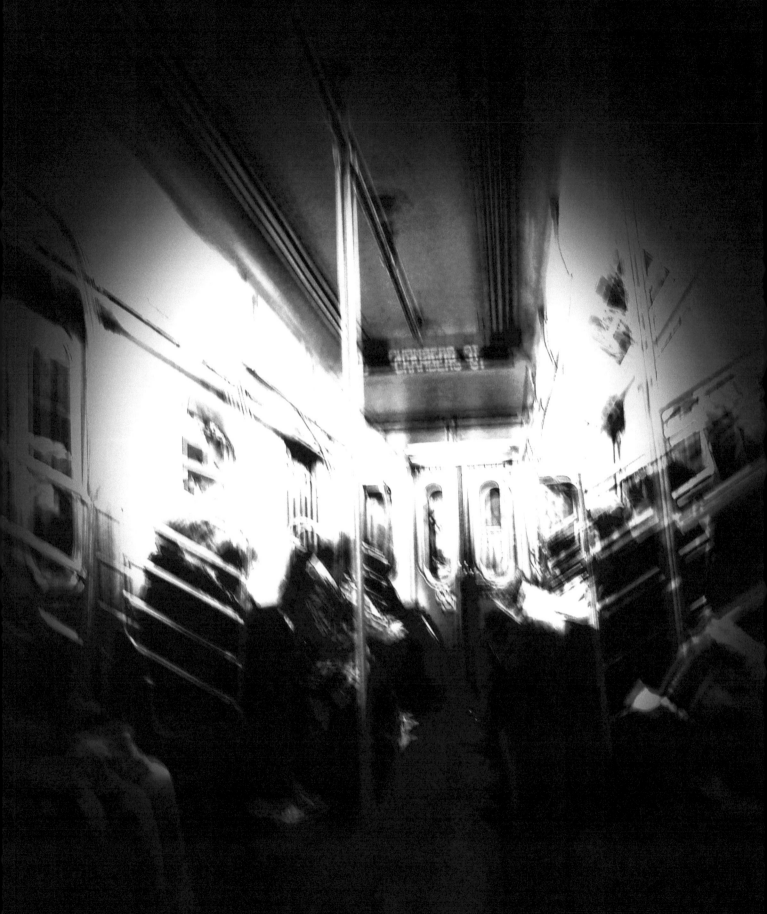

A million faces cannot cast doubt on the
intensity of vibrations this place produces.

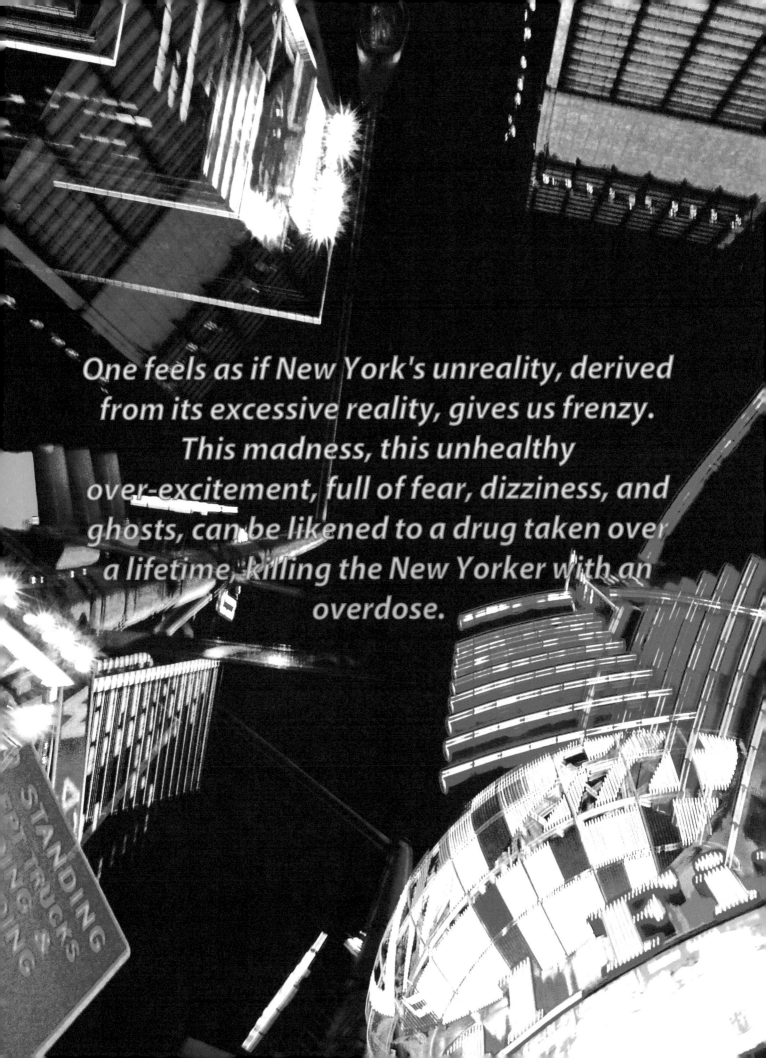

One feels as if New York's unreality, derived from its excessive reality, gives us frenzy. This madness, this unhealthy over-excitement, full of fear, dizziness, and ghosts, can be likened to a drug taken over a lifetime, killing the New Yorker with an overdose.

The pain in your feet doesn't matter. The pain in your knees doesn't matter. Your whole body aches, but it doesn't matter…

Alerga! Nu te opri, fugi!

Run! Don't stop, run!

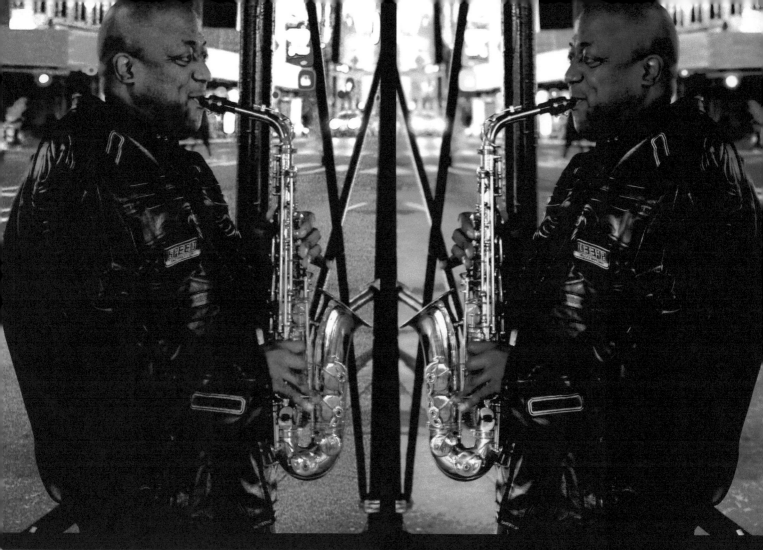

Those who live in New York should know just what a complex metropolis it is. The city is not easy to read, accept, or control. It's certainly not stupid. The only idiot here is you. It is a city that doesn't respect anyone; it is easy to demonstrate this vague theory by the saying "a man is the wolf-man of man."

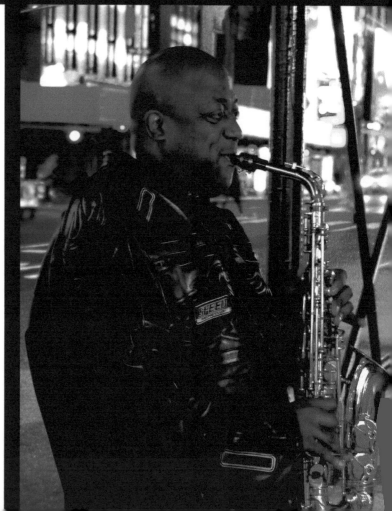

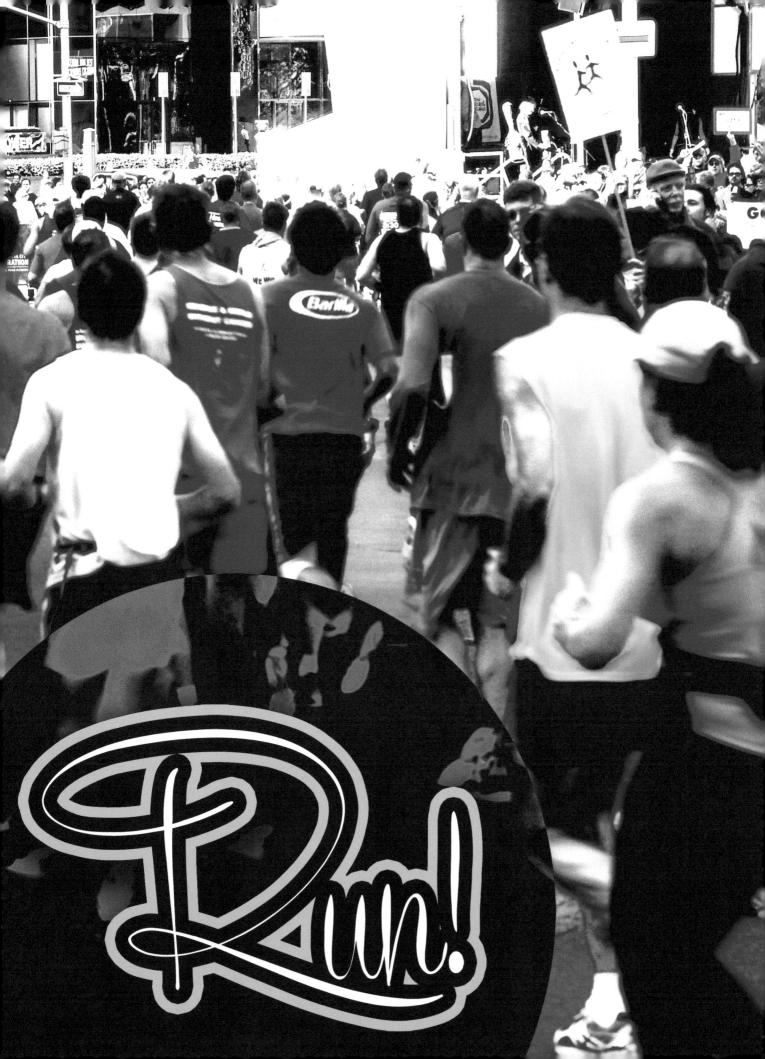

The hours' pass.
Will you sing?

Life passes.
Will you live?

Help me, mother.
Shut up!

Help me, father.
Leave me alone!
I want to laugh--
sew your mouth!

I want to die.
Die now.

The hours' pass.
Will you sing?

Life passes.
Will you live?

Help me, mother.
Shut up!

Help me, father.
Leave me alone!
I want to laugh--
sew your mouth!

I want to die.
Die now.

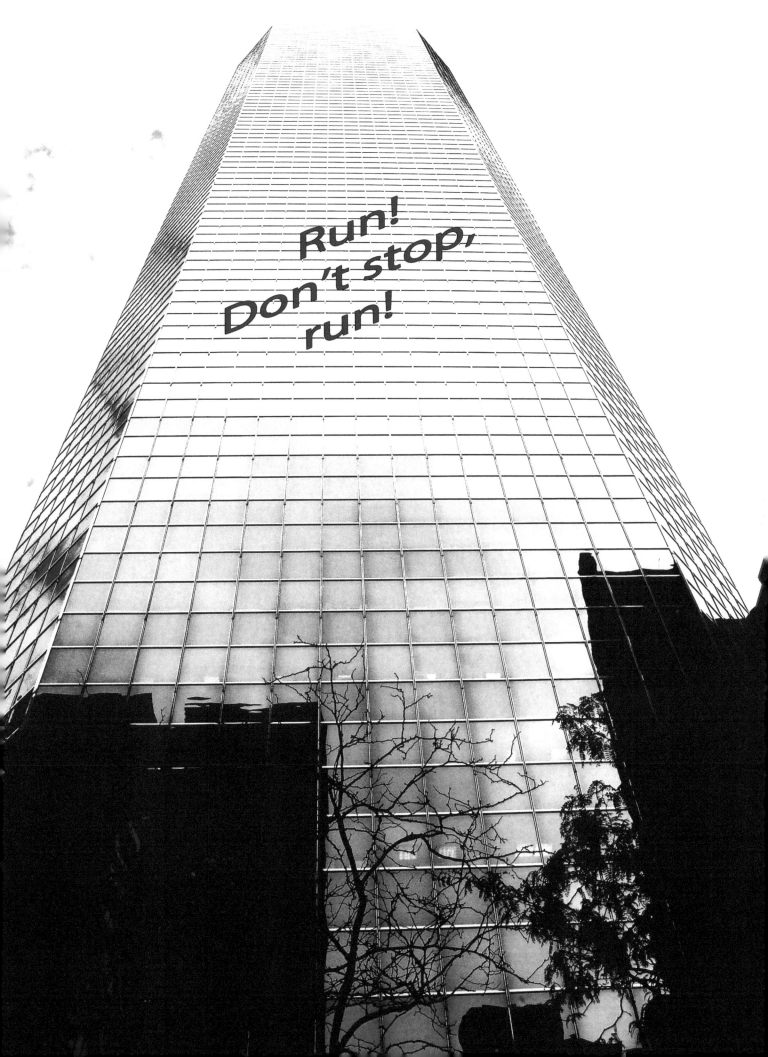

Every day the tribal
islands--the Bronx,
Manhattan, Brooklyn,
Queens, Staten
Island--find
themselves populated
with birds and
airplanes. Run!

ਦੁਬਾਰਾ, ਤੁਸੀਂ ਉਸ ਕਾਲੇ ਆਦਮੀ ਨੂੰ ਠੋਕਰ ਦਿੱਤੀ ਹੈ ਜੋ ਉਸ ਦੇ ਮਨਮੋਹਕ ਸੈਕਸੋਫੋਨ 'ਤੇ ਉਹੀ ਗਾਣਾ ਵਜਾਉਂਦਾ ਹੈ. ਹਾਂ, ਦੌੜੋ.

Again, you have stumbled upon the black man who plays the same song on his charming saxophone.

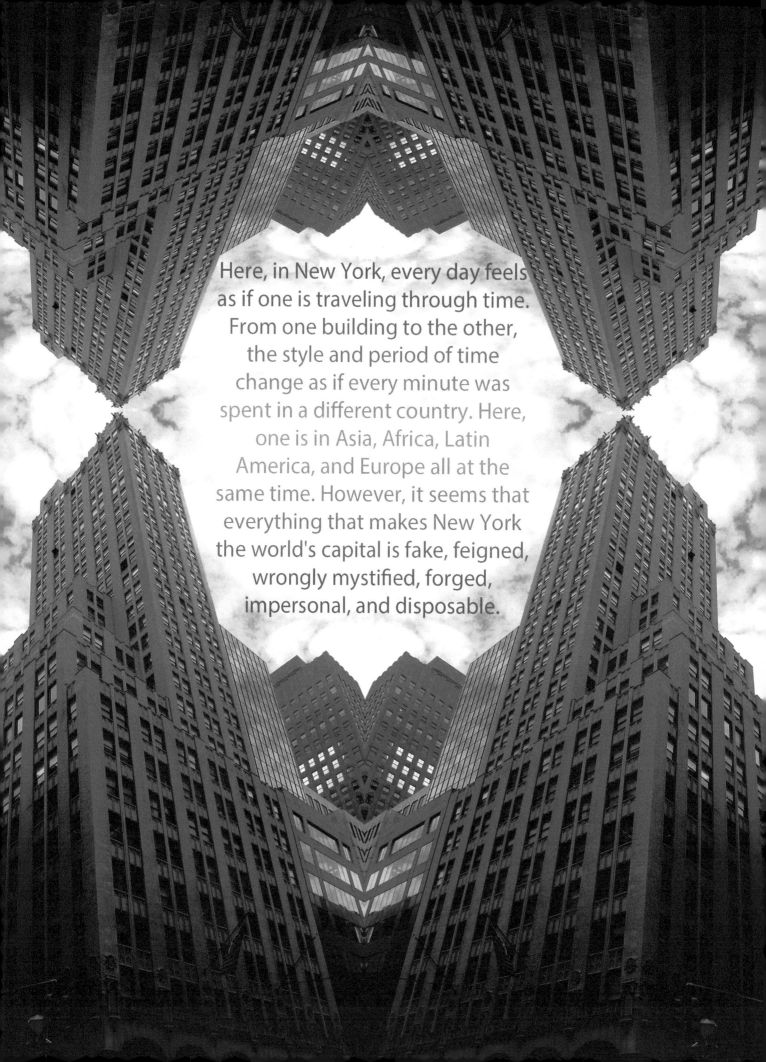

Here, in New York, every day feels as if one is traveling through time. From one building to the other, the style and period of time change as if every minute was spent in a different country. Here, one is in Asia, Africa, Latin America, and Europe all at the same time. However, it seems that everything that makes New York the world's capital is fake, feigned, wrongly mystified, forged, impersonal, and disposable.

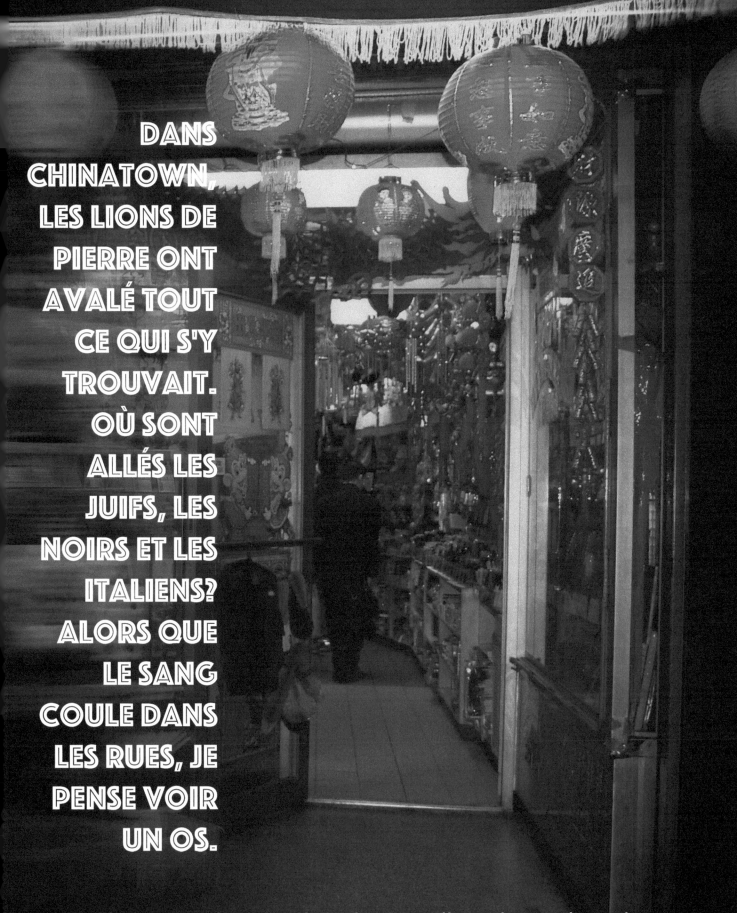

DANS CHINATOWN, LES LIONS DE PIERRE ONT AVALÉ TOUT CE QUI S'Y TROUVAIT. OÙ SONT ALLÉS LES JUIFS, LES NOIRS ET LES ITALIENS? ALORS QUE LE SANG COULE DANS LES RUES, JE PENSE VOIR UN OS.

In Chinatown, the stone lions have swallowed everything that was around. Where have the Jews, Blacks, and Italians gone? As the blood flows through the streets, I think I see a bone.

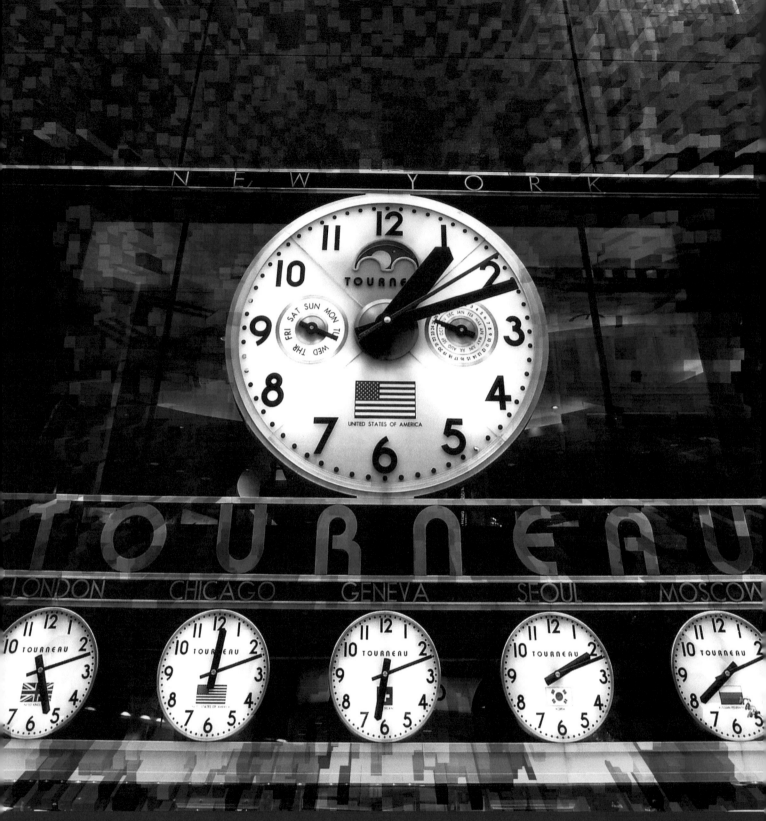

Only five-hours difference with London? Only six-hours difference with Ville-Lumière? Tell me the truth, Mr. Watch. Or has the insomniac show made you tired and crazy too?

Run, don't stop, run!

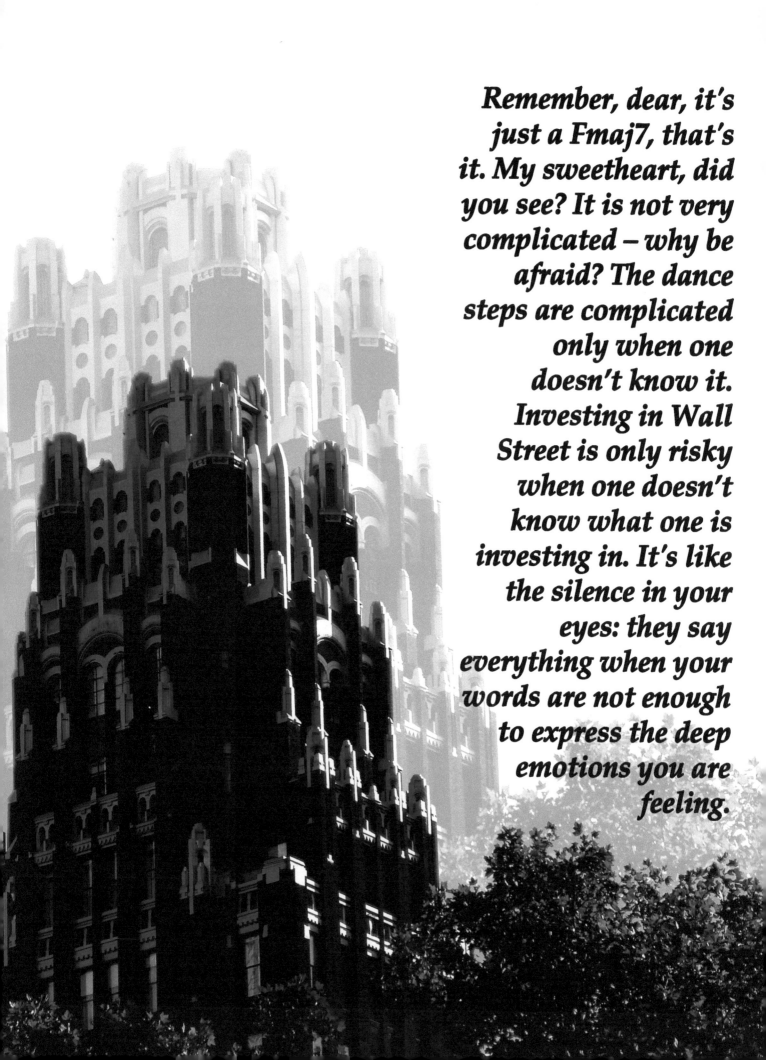

Remember, dear, it's just a Fmaj7, that's it. My sweetheart, did you see? It is not very complicated – why be afraid? The dance steps are complicated only when one doesn't know it. Investing in Wall Street is only risky when one doesn't know what one is investing in. It's like the silence in your eyes: they say everything when your words are not enough to express the deep emotions you are feeling.

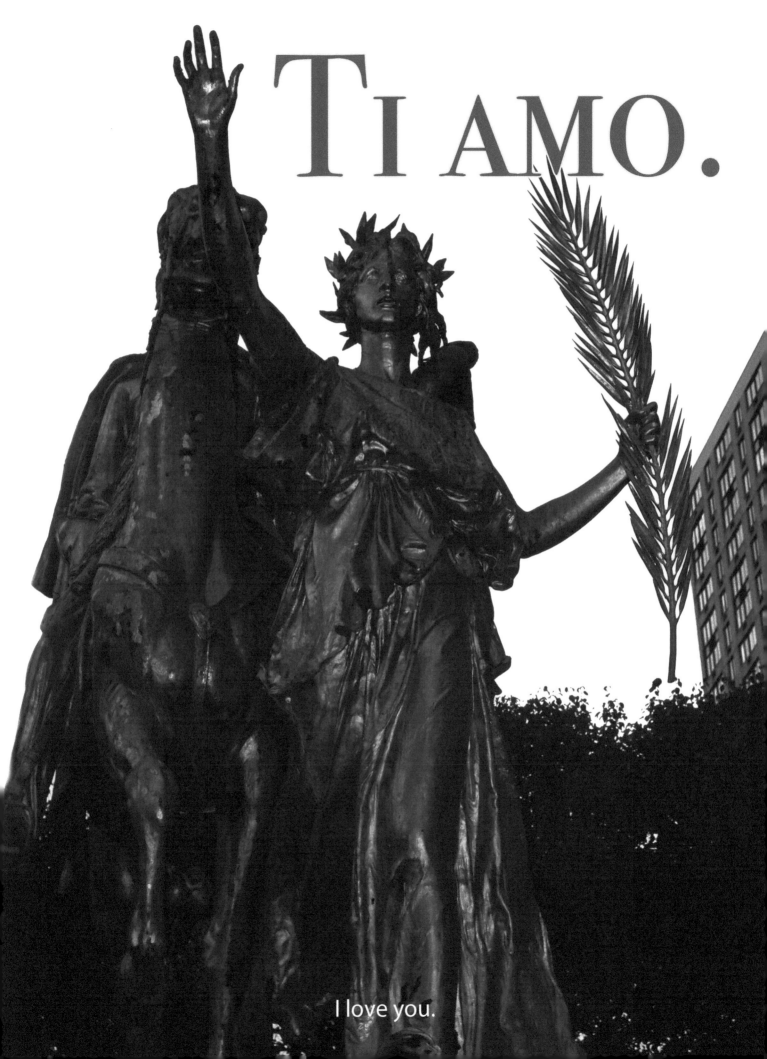

TI AMO.

I love you.

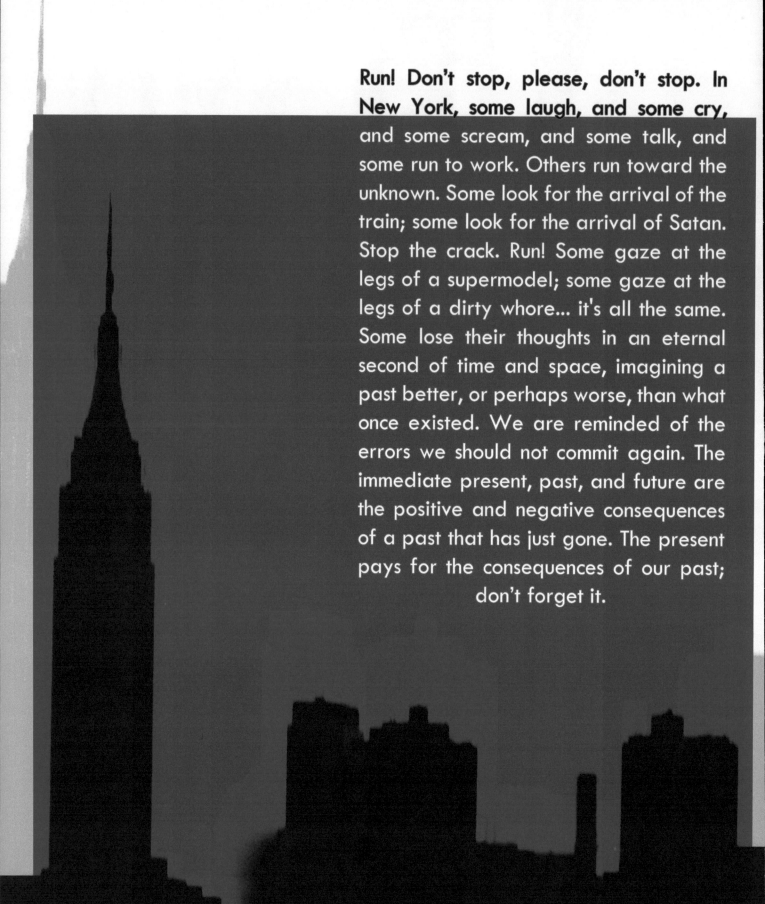

Run! Don't stop, please, don't stop. In New York, some laugh, and some cry, and some scream, and some talk, and some run to work. Others run toward the unknown. Some look for the arrival of the train; some look for the arrival of Satan. Stop the crack. Run! Some gaze at the legs of a supermodel; some gaze at the legs of a dirty whore... it's all the same. Some lose their thoughts in an eternal second of time and space, imagining a past better, or perhaps worse, than what once existed. We are reminded of the errors we should not commit again. The immediate present, past, and future are the positive and negative consequences of a past that has just gone. The present pays for the consequences of our past; don't forget it.

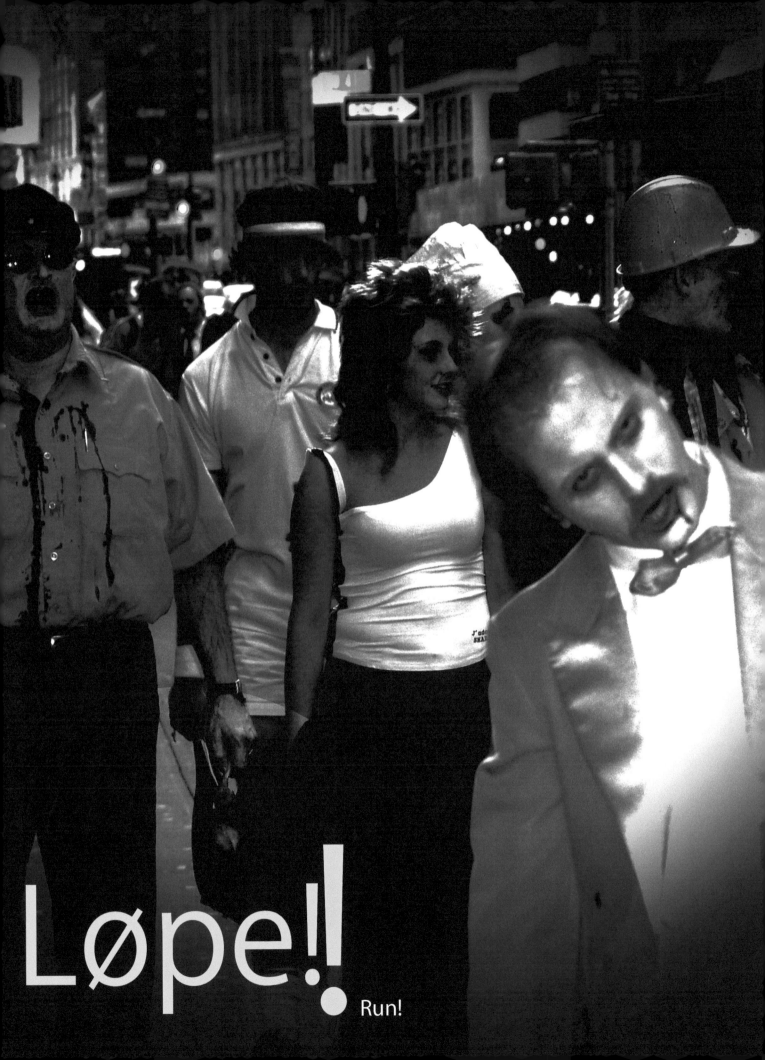

Løpe!!

Run!

Nevertheless, New York is an exception because it keeps the past alive.

ES UNA CIUDAD QUE CAMBIA MÁS RÁPIDO QUE EL CORAZÓN DE CUALQUIER MORTAL.

It's a city that changes faster than any mortal heart.

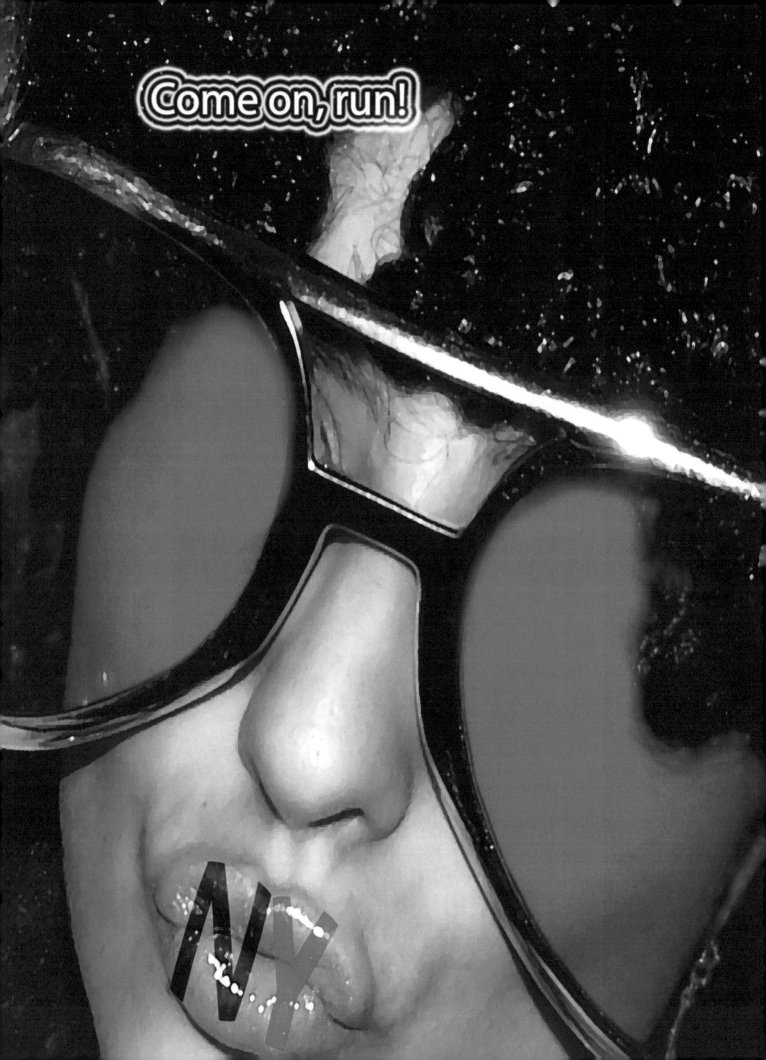

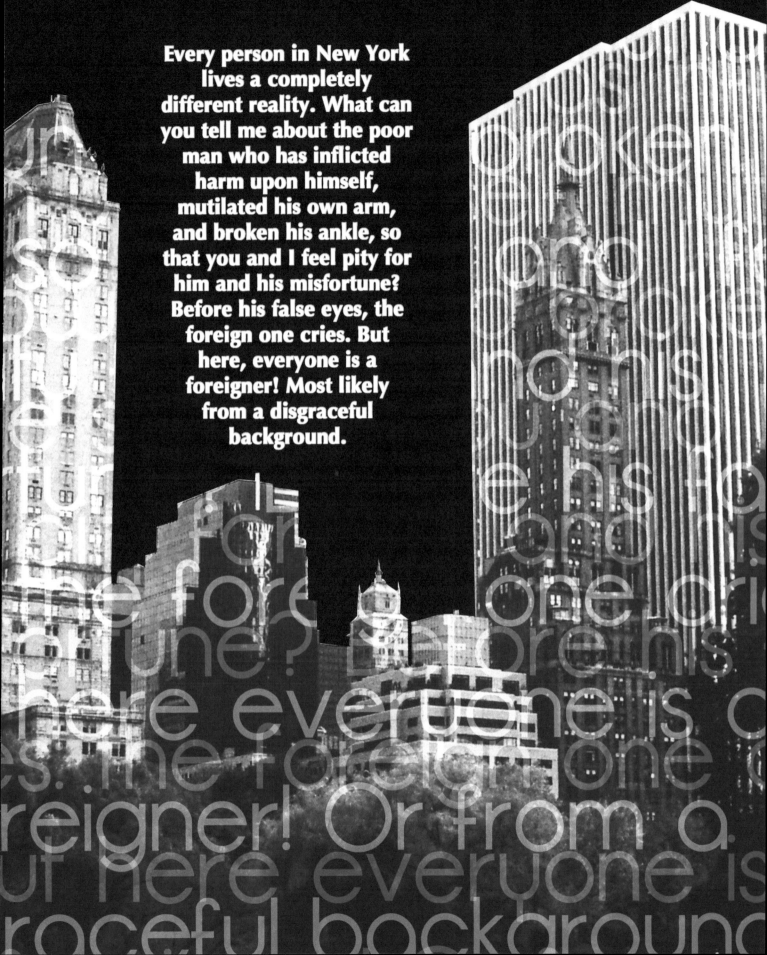

Every person in New York lives a completely different reality. What can you tell me about the poor man who has inflicted harm upon himself, mutilated his own arm, and broken his ankle, so that you and I feel pity for him and his misfortune? Before his false eyes, the foreign one cries. But here, everyone is a foreigner! Most likely from a disgraceful background.

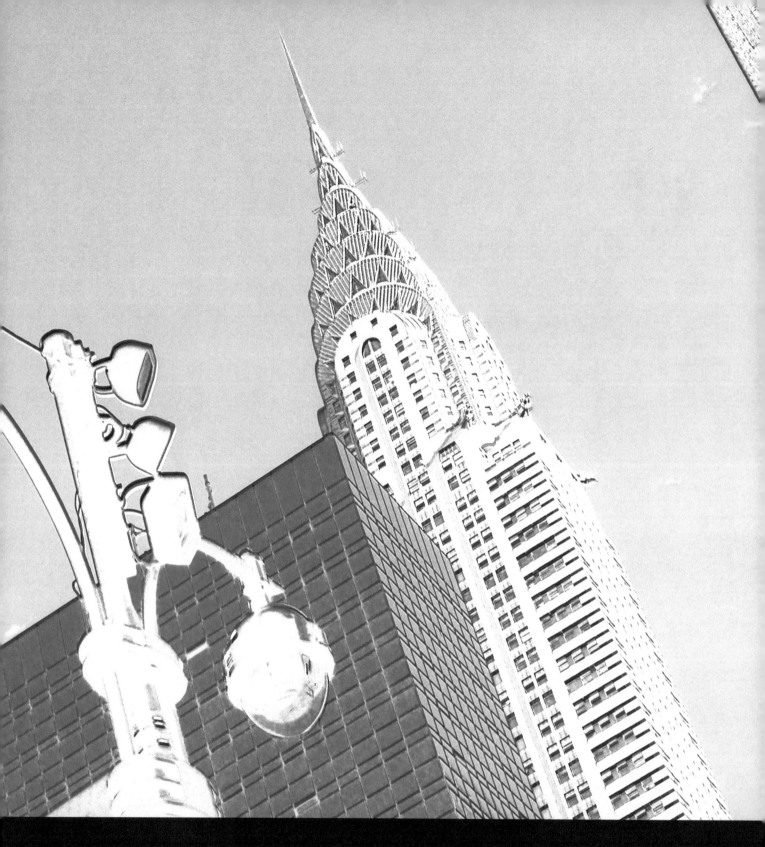

It is true: the wealthy, like the impoverished, also take out their claws. Sometimes the luxurious find themselves dangerously close to dirt, abandonment, and necessity. But this doesn't mean those who lead decadent lifestyles don't have the opportunity to be good. They have simply chosen the wrong path, the one they liked because it was easy, crazy, and different. Unconsciousness is outrageousness that leads to failure and unquestionably to a quick death.

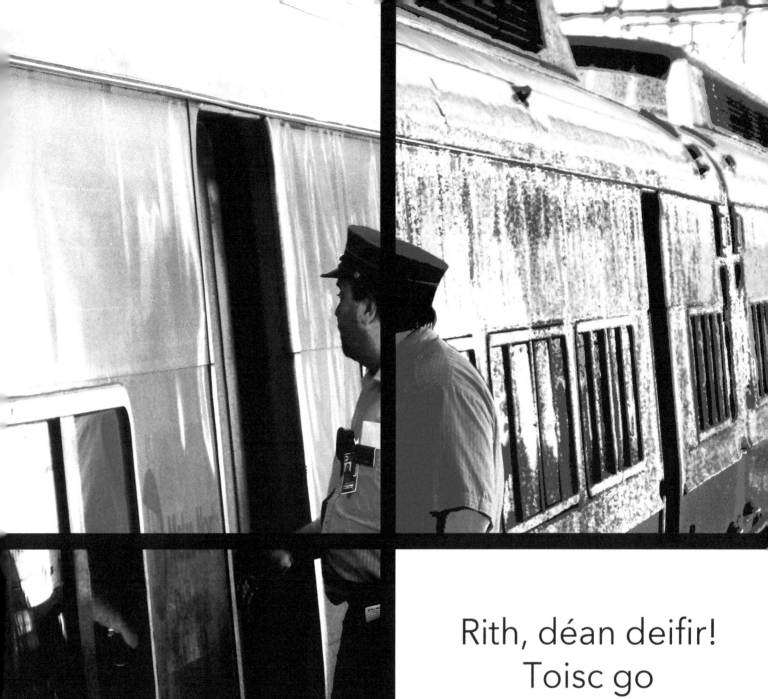

Rith, déan deifir! Toisc go dtarlaíonn milliún rud difriúil i Nua Eabhrac i gceann soicind.

Run, hurry up! Because a million different things happen in New in one second.

Here, monotony doesn't exist, not for someone who paints every hour of every day at the south exit of Central Park. He is sure that his brushes, upon a white canvas, will dance a Japanese dance, or maybe Arabic, French, or perhaps a Colombian dance in a couple of hours. Run!

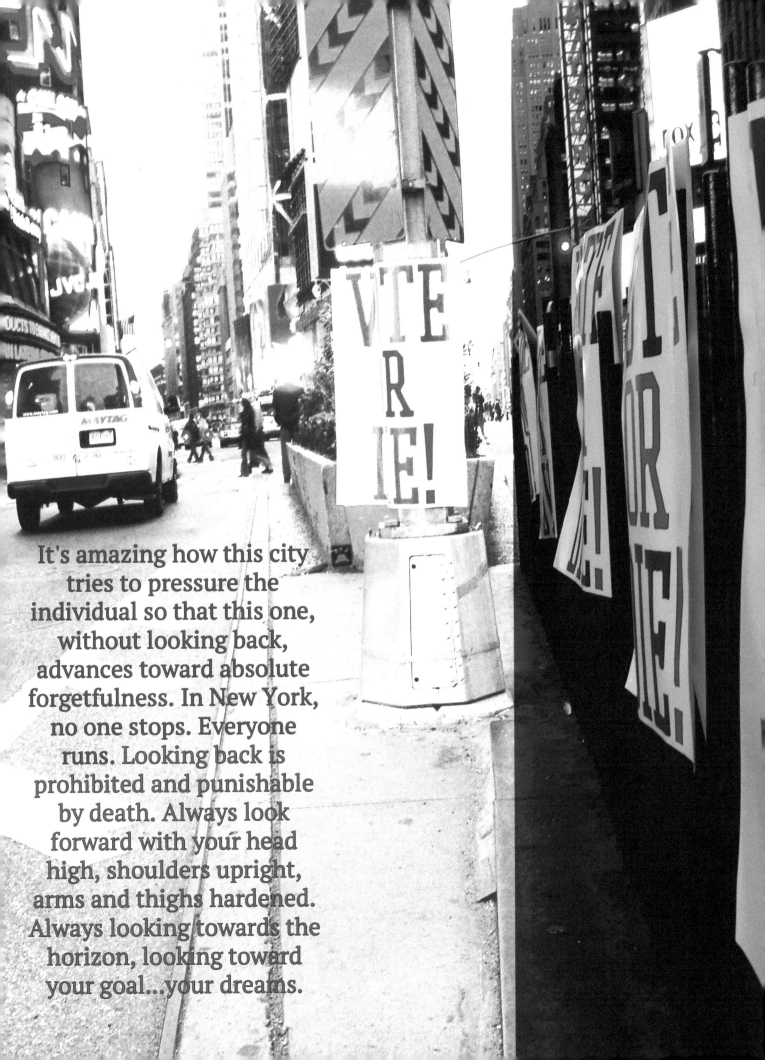

It's amazing how this city tries to pressure the individual so that this one, without looking back, advances toward absolute forgetfulness. In New York, no one stops. Everyone runs. Looking back is prohibited and punishable by death. Always look forward with your head high, shoulders upright, arms and thighs hardened. Always looking towards the horizon, looking toward your goal...your dreams.

It is better to die imposing yourself upon life than to be manipulated by it. It is better to die looking for eternity than to be defeated by the present. It is better to die by our own ideals and goals than by the visions of someone else who takes advantage of our weaknesses and abilities. It is better to die fighting a bloody battle against death than to allow it to take you by the hand gently. It is better to conquer the world than to let the world conquer us. It is better to run and escape poverty than walk through what is rotten or walk through what will soon invade your body, your being...

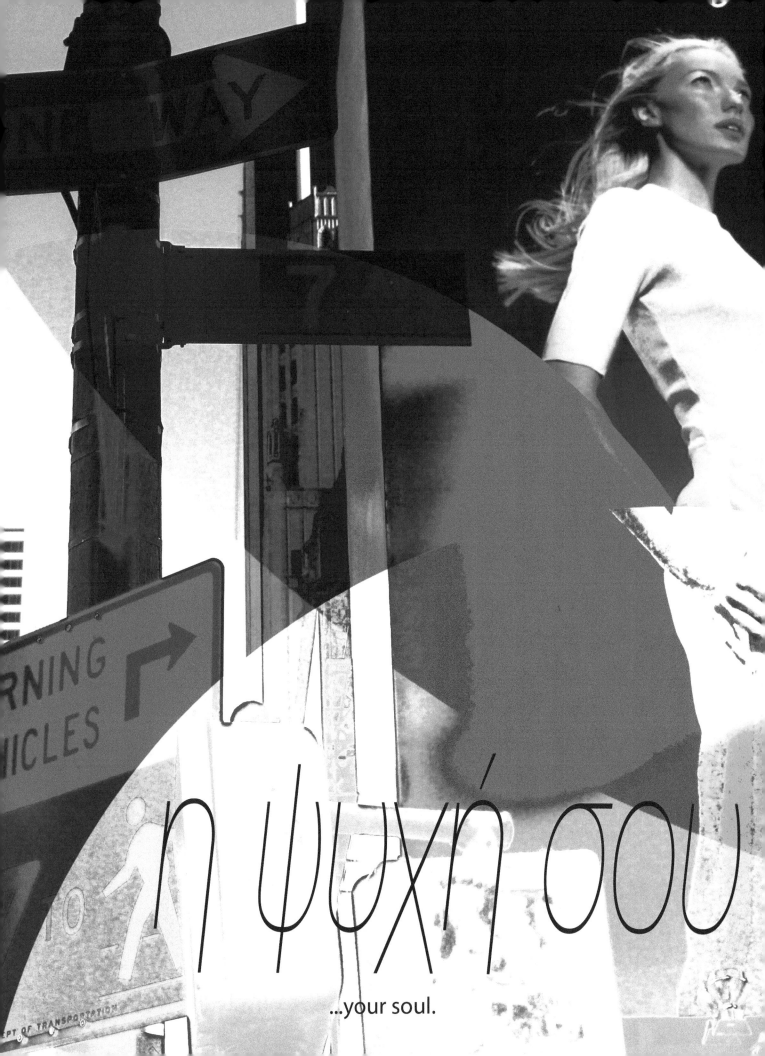

η ψυχή σου

...your soul.

IT IS BETTER TO MASTER INTELLIGENCE THAN TO BE SLAVES OF THE INTELLIGENT; IT IS BETTER TO STUDY FOR A BETTER FUTURE THAN TO BE SURPRISED AT FINDING YOURSELF ON THE STREET, ASKING FOR A PIECE OF BREAD, CRYING, COMPLAINING, AND LAMENTING ABOUT WHAT YOU DID NOT DO. WHAT A DISGRACE TO REMOVE ONE'S OWN EAR OR EYE FOR A LITTLE PAY! IT IS BETTER TO LIVE 24 HOURS OF EVERY DAY WITH INTENSITY THAN TO STOP TIME, SLEEP, AND ALLOW THE WORLD TO ADVANCE WITHOUT YOU. MY FRIEND, IT IS BETTER TO HAVE THE WORLD IN YOUR HANDS THAN TO LET THE WORLD HAVE YOU IN ITS HANDS.

Zayıf insan, koaş!
Baş ağrısının önemi
yok, gözlerinizdeki
ağrı önemli değil,
midenizdeki ağrı
önemli değil ...
ağlama, çığlık atma,
hiçbir şey söyleme.

Weak human, run! The headache doesn't matter, the pain in your eyes
doesn't matter, the pain in your stomach doesn't matter...don't cry,
don't scream, don't say anything. Run!

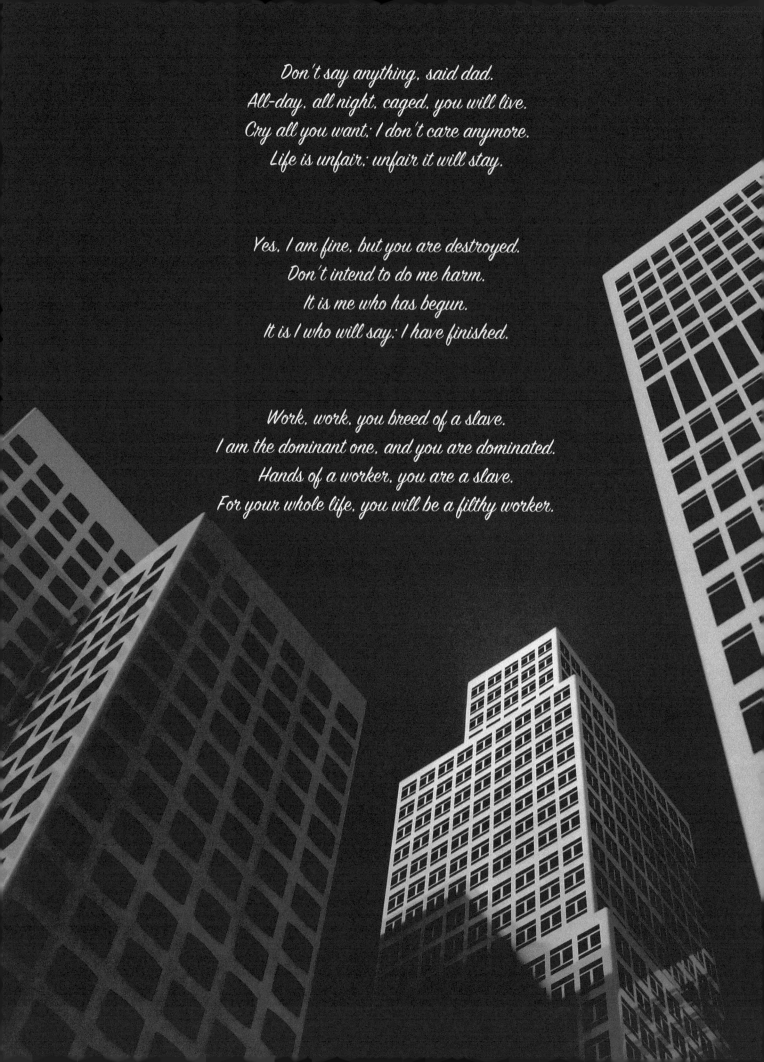

Don't say anything, said dad.
All-day, all night, caged, you will live.
Cry all you want; I don't care anymore.
Life is unfair; unfair it will stay.

Yes, I am fine, but you are destroyed.
Don't intend to do me harm.
It is me who has begun.
It is I who will say: I have finished.

Work, work, you breed of a slave.
I am the dominant one, and you are dominated.
Hands of a worker, you are a slave.
For your whole life, you will be a filthy worker.

10:28:22 OM MORGENEN, SKAT. INTET ER TILBAGE.

10:28:22 in the morning, baby. Nothing is left.

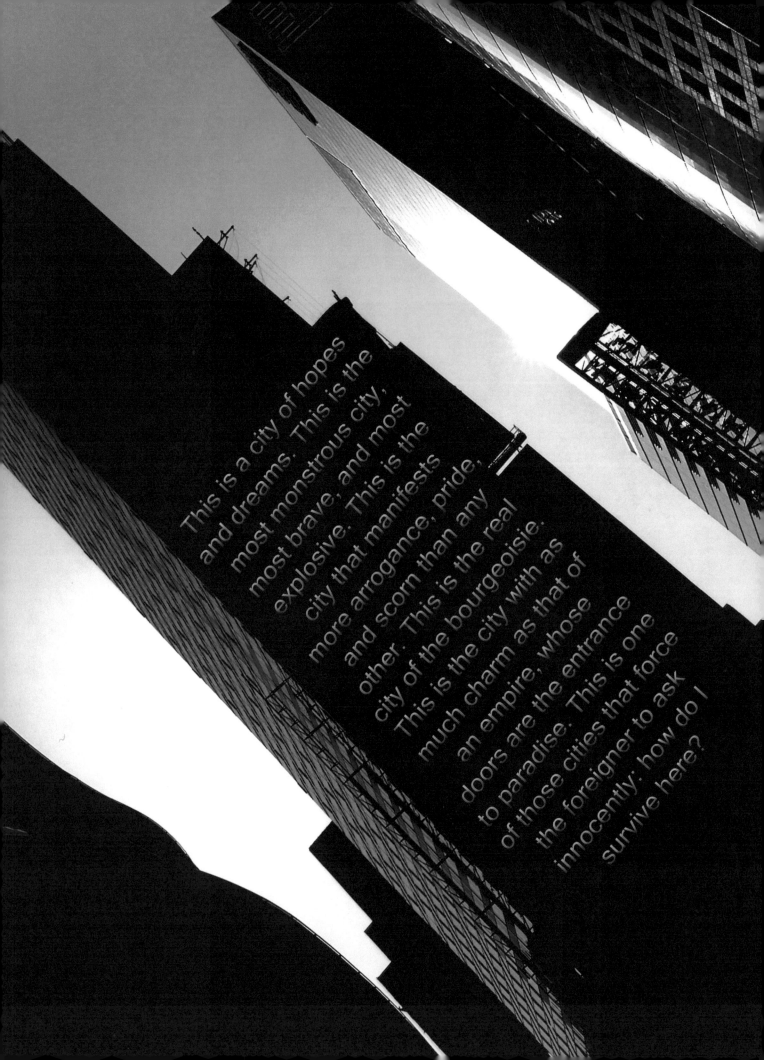

This is a city of hopes and dreams. This is the most monstrous city, most brave, and most explosive. This is the city that manifests more arrogance, pride, and scorn than any other. This is the real city of the bourgeoisie. This is the city with as much charm as that of an empire, whose doors are the entrance to paradise. This is one of those cities that force the foreigner to ask innocently: how do I survive here?

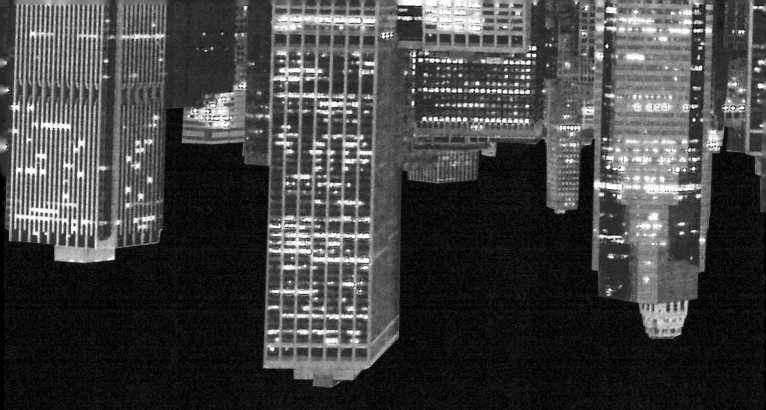

Nostalgia doesn't exist here. The past doesn't exist: gone without a trace, without any memory. Where are you, King Kong? New York advances without stopping, even if she loses her vision. She is transformed into a unicorn. This is the city where the horizon bites the sky. This is the city that most resembles hell.

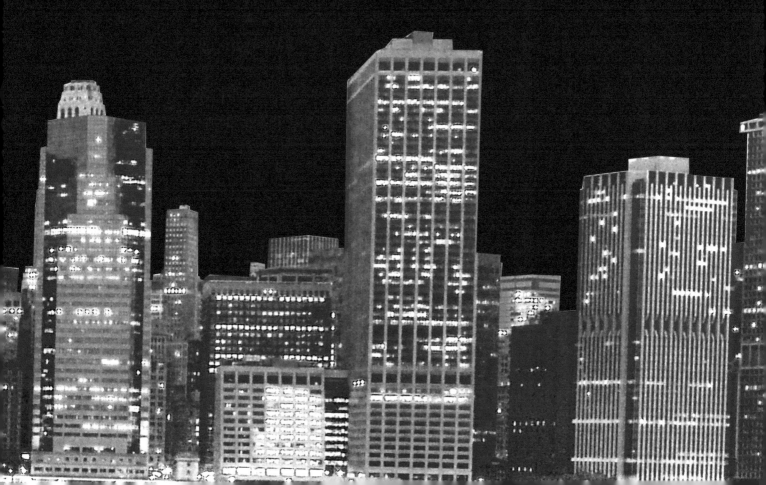

HIERDIE STAD
IS NIE NUUT
OF OUD NIE,
NIE U EN
MYNE NIE.
HIERDIE STAD
BEHOORT
AAN
NIEMAND NIE.

This city is not new nor old, not yours nor mine. This city doesn't
belong to anyone.

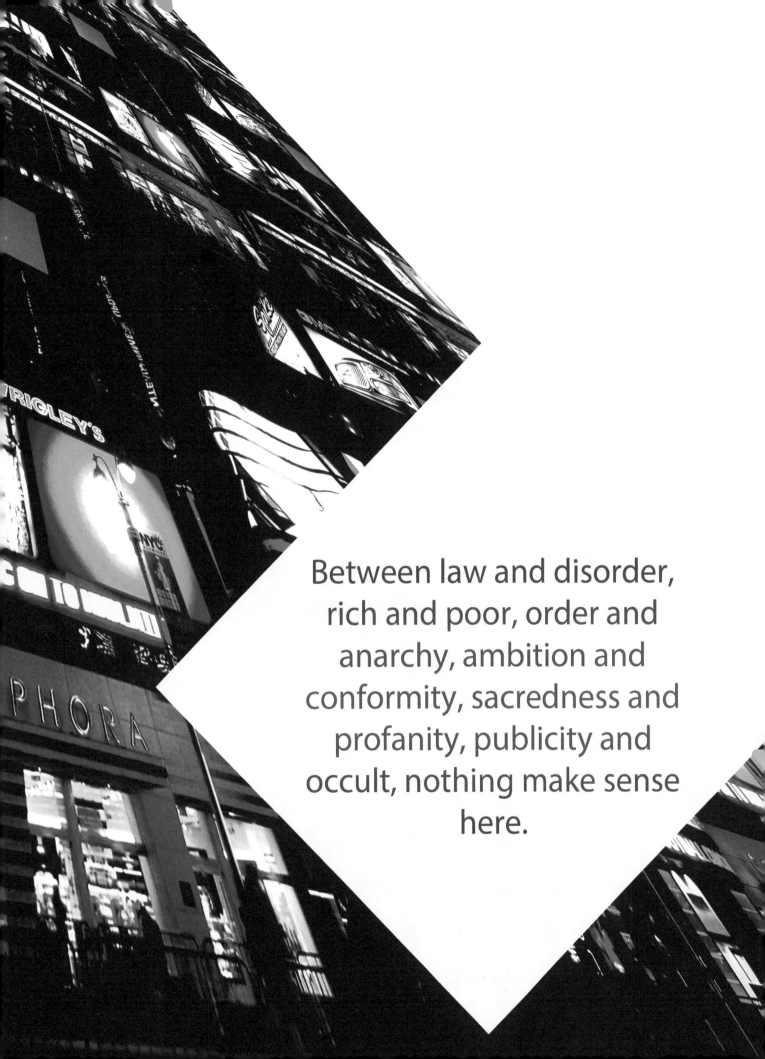

Between law and disorder, rich and poor, order and anarchy, ambition and conformity, sacredness and profanity, publicity and occult, nothing make sense here.

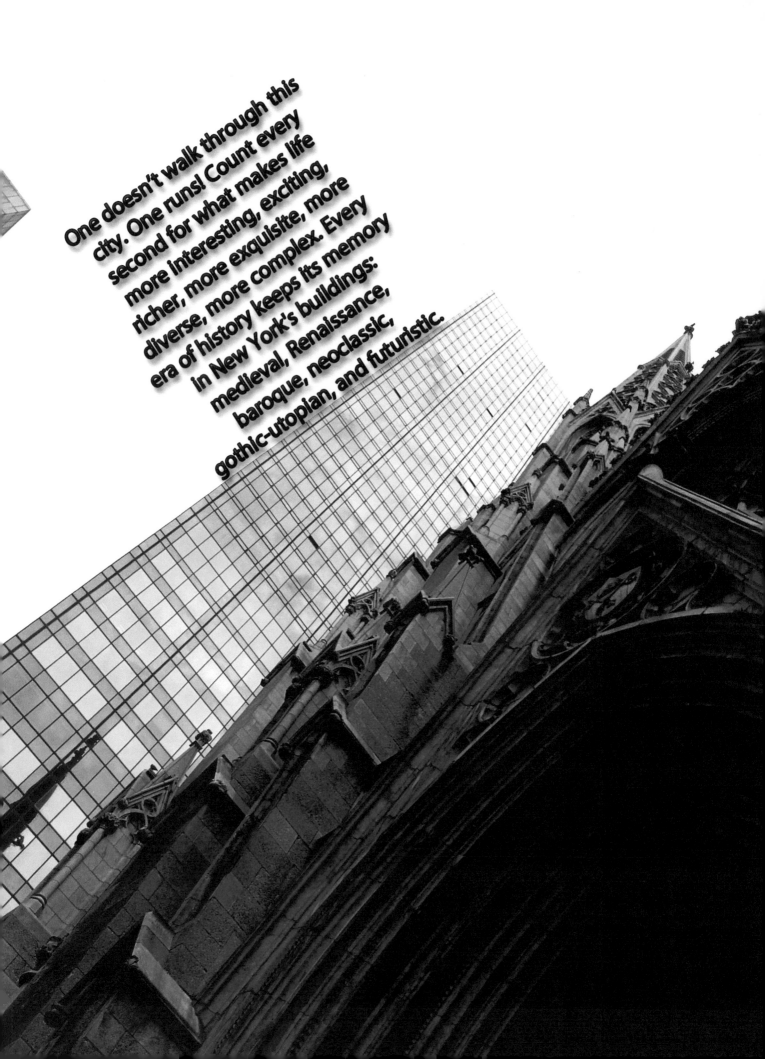

One doesn't walk through this city. One runs! Count every second for what makes life more interesting, exciting, richer, more exquisite, more diverse, more complex. Every era of history keeps its memory in New York's buildings: medieval, Renaissance, baroque, neoclassic, gothic-utopian, and futuristic.

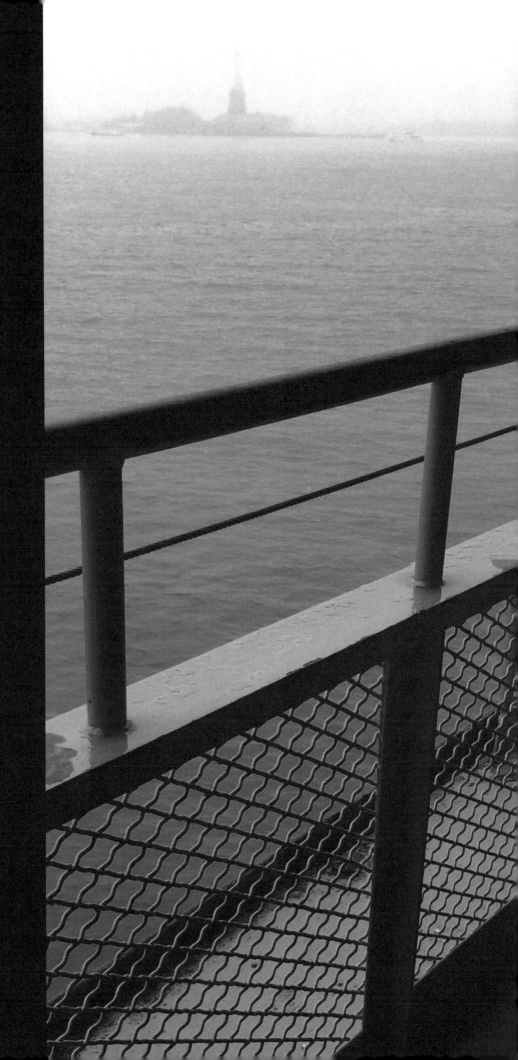

You can smell, see, feel, hear, and taste triumphant capitalism in this city. The sky touches the tips of skyscrapers but doesn't protect them. In this city, neck pain is not produced from sleeping incorrectly but from constantly looking up to observe the wonderful. Run! No one is afraid of anything; if one is afraid, he has to leave this jungle, or he will quickly cease to exist—don't cry, please, don't cry.

Նրանք, ովքեր վախենում
են, քամին է տարվում.
Նրանց, ովքեր վախենում
են, վերցված է Աստծո
կողմից, եթե բախտ
ունենան: Նյու Յորքը
սպանում է նրանցից,
ովքեր վախենում են
դրանից; նրանք, ովքեր
չեն դիմանում այն ճնշող
ճնշմանը, որը նա
գործադրում է:

Those who fear are taken by the wind; those who fear are taken by
God, if they're lucky. New York kills those who fear it; those who can't
stand the back-breaking pressure it exerts.

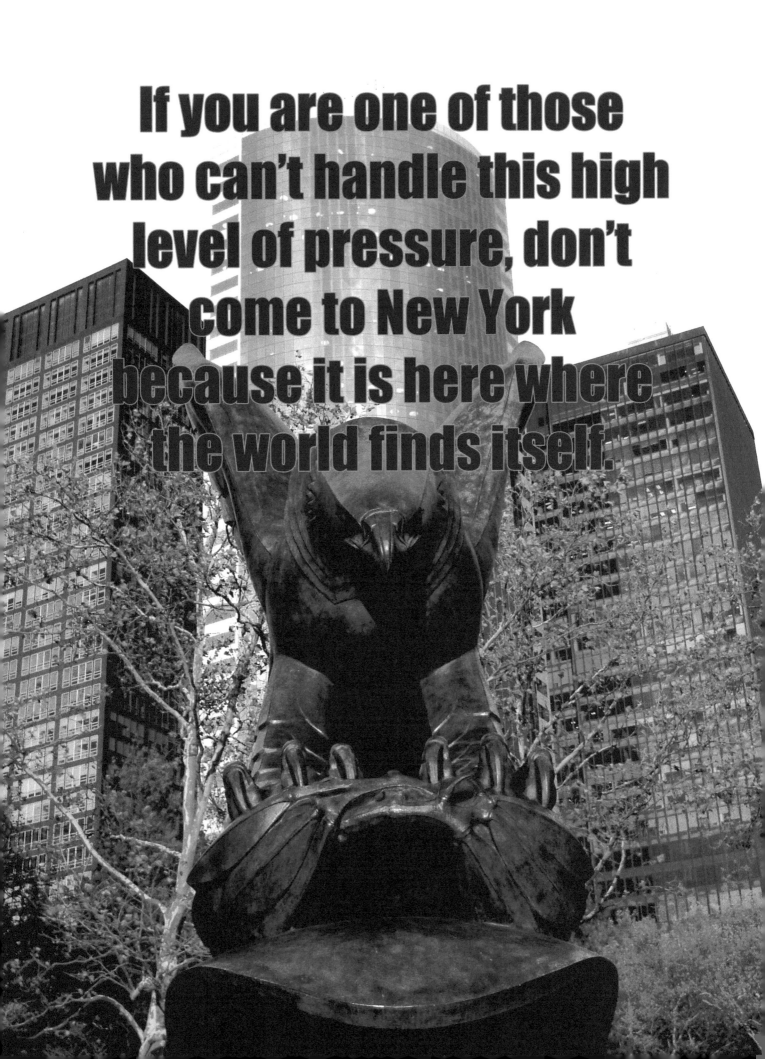

If you are one of those who can't handle this high level of pressure, don't come to New York because it is here where the world finds itself.

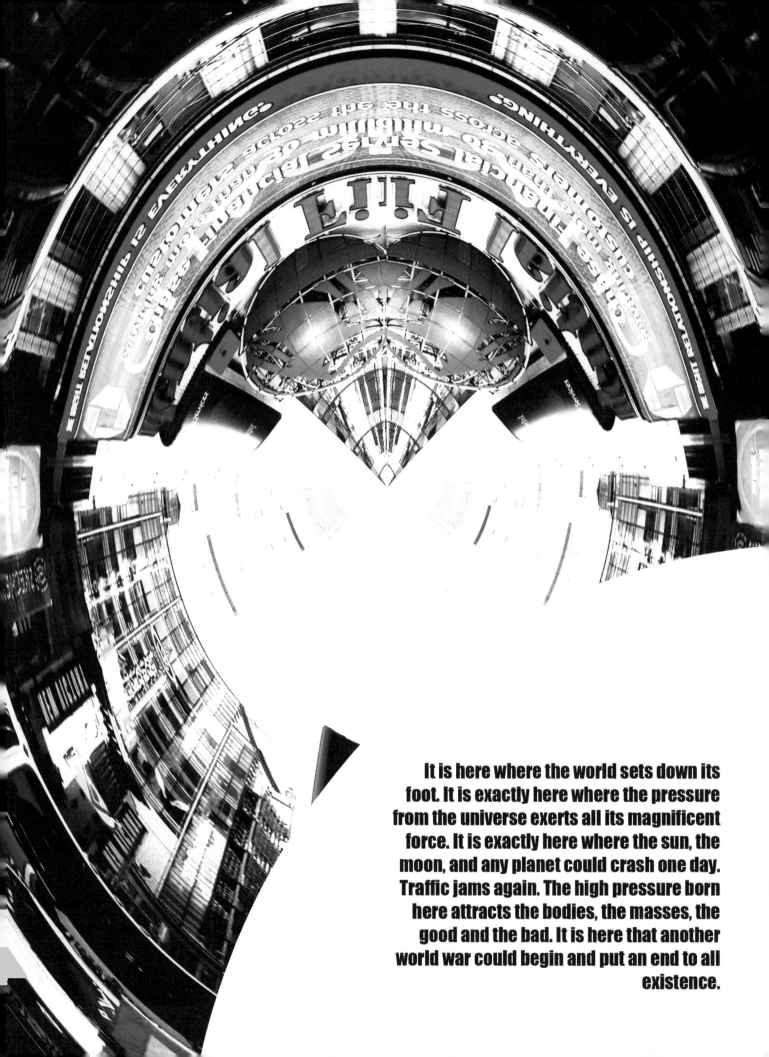

It is here where the world sets down its foot. It is exactly here where the pressure from the universe exerts all its magnificent force. It is exactly here where the sun, the moon, and any planet could crash one day. Traffic jams again. The high pressure born here attracts the bodies, the masses, the good and the bad. It is here that another world war could begin and put an end to all existence.

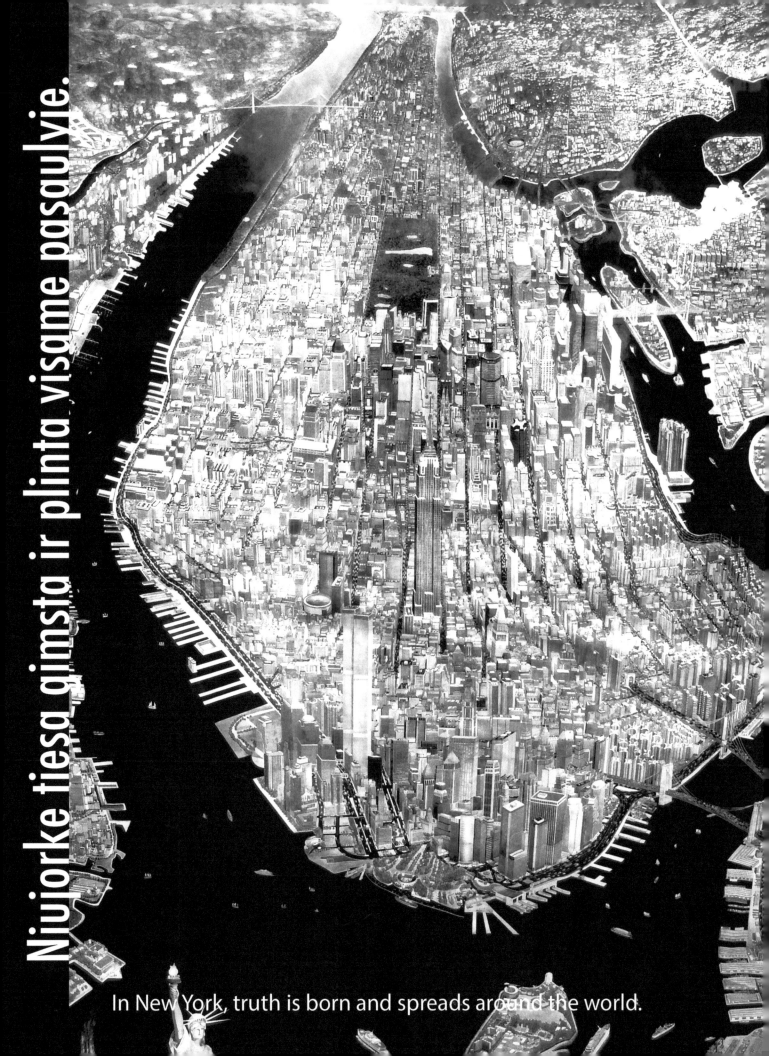

Niujorke tiesa gimsta ir plinta visame pasaulyje.

In New York, truth is born and spreads around the world.

IT
IS
HERE
WHERE
THE
PUREST
BEAUTY
APPEARS.

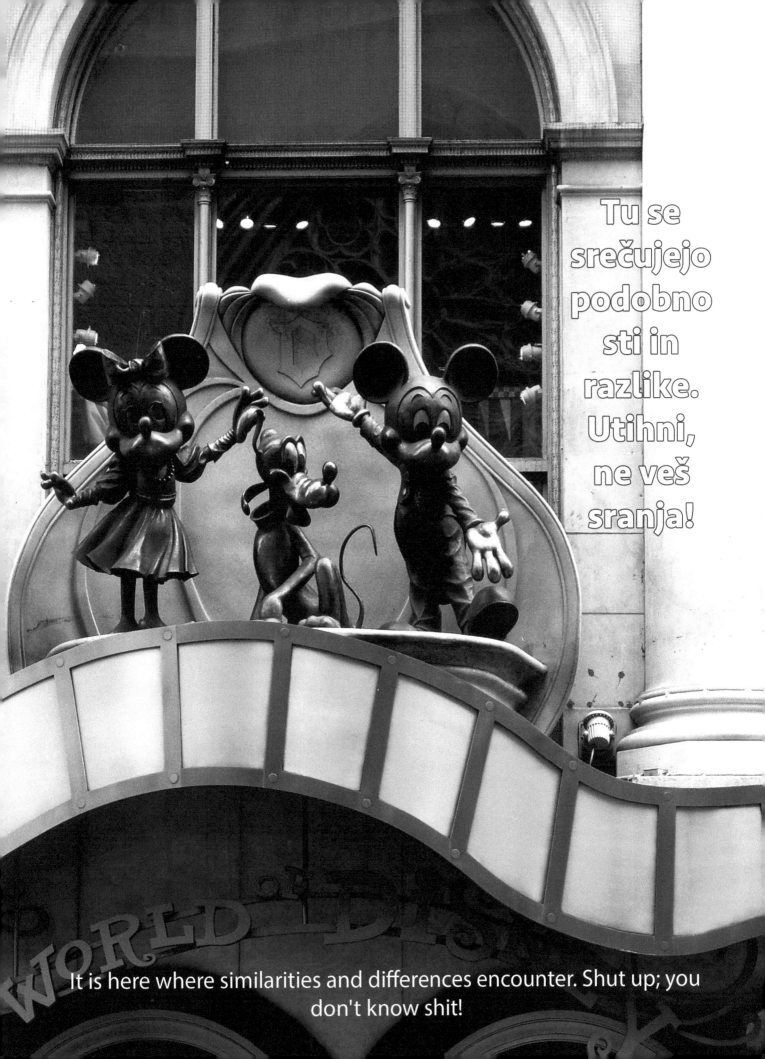

Tu se srečujejo podobnosti in razlike. Utihni, ne veš sranja!

It is here where similarities and differences encounter. Shut up; you don't know shit!

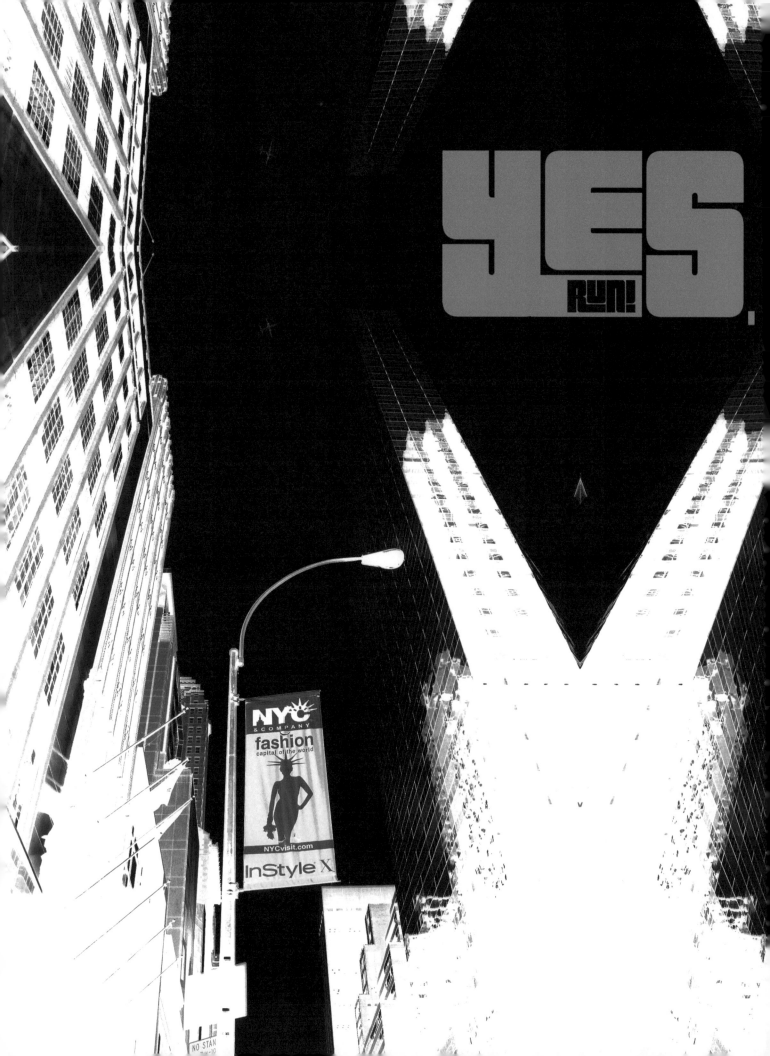

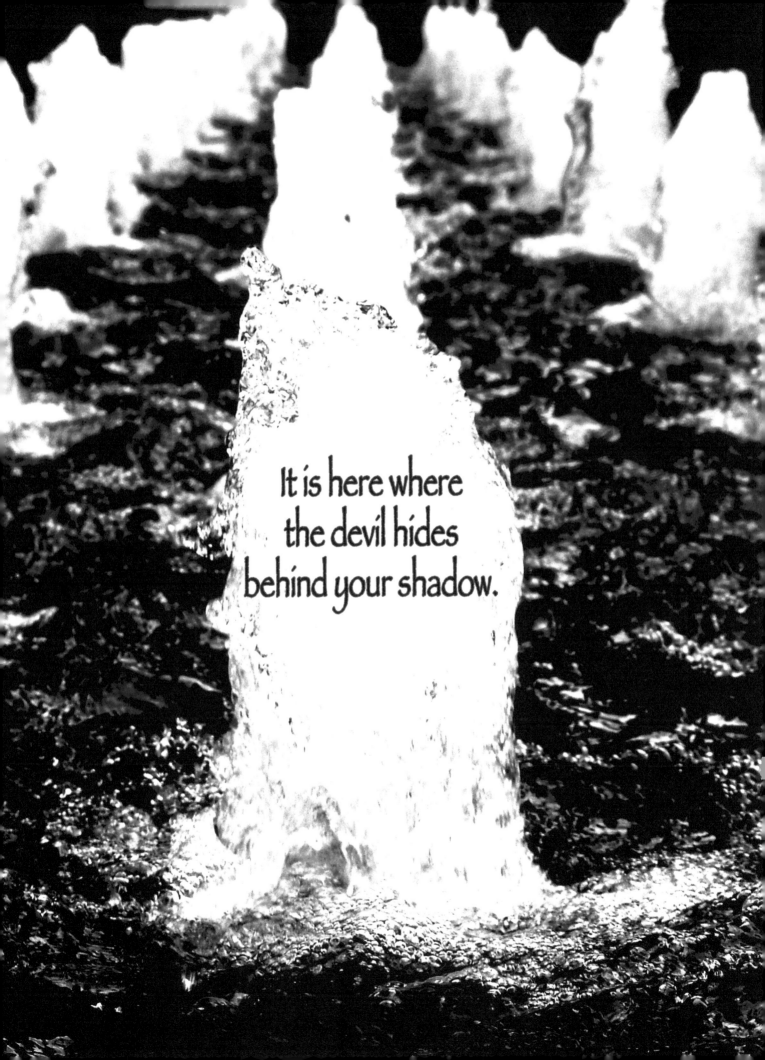

It is here where
the devil hides
behind your shadow.

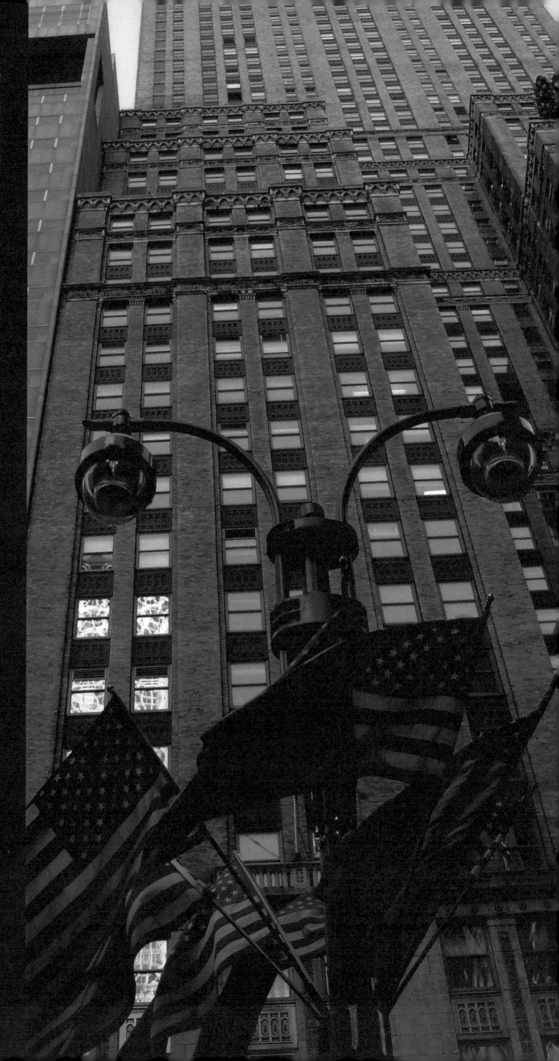

It is here where God has his biggest, most complex, and most complete army.

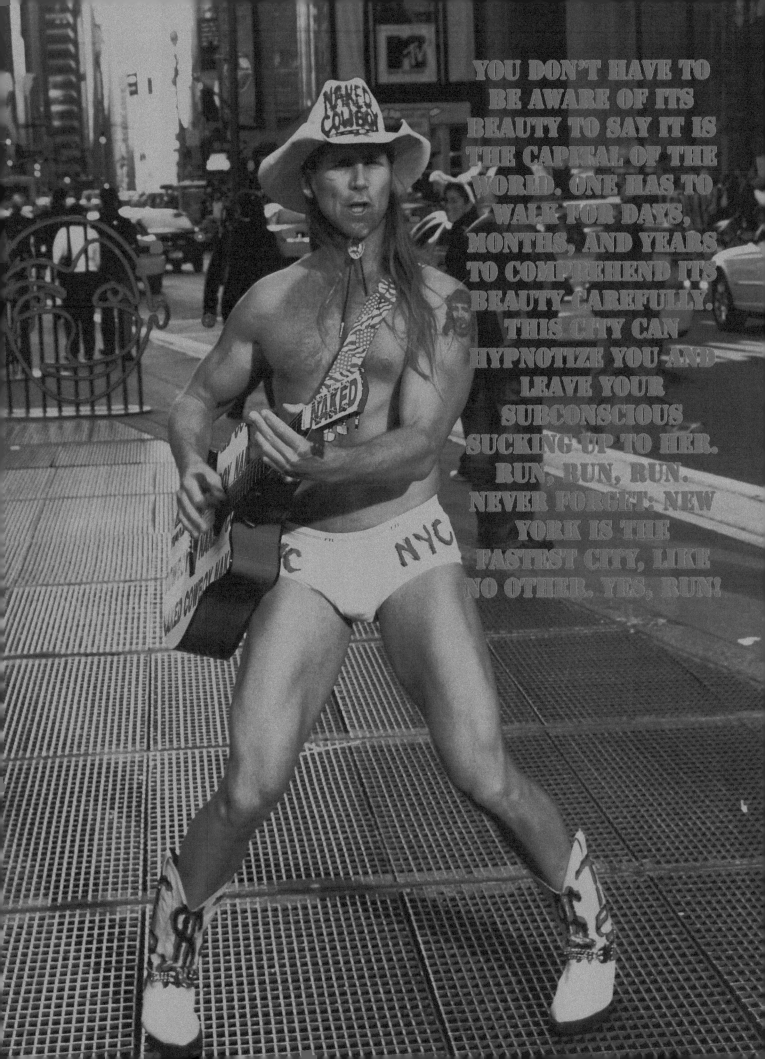

YOU DON'T HAVE TO BE AWARE OF ITS BEAUTY TO SAY IT IS THE CAPITAL OF THE WORLD. ONE HAS TO WALK FOR DAYS, MONTHS, AND YEARS TO COMPREHEND ITS BEAUTY CAREFULLY. THIS CITY CAN HYPNOTIZE YOU AND LEAVE YOUR SUBCONSCIOUS SUCKING UP TO HER. RUN, RUN, RUN. NEVER FORGET: NEW YORK IS THE FASTEST CITY, LIKE NO OTHER. YES, RUN!

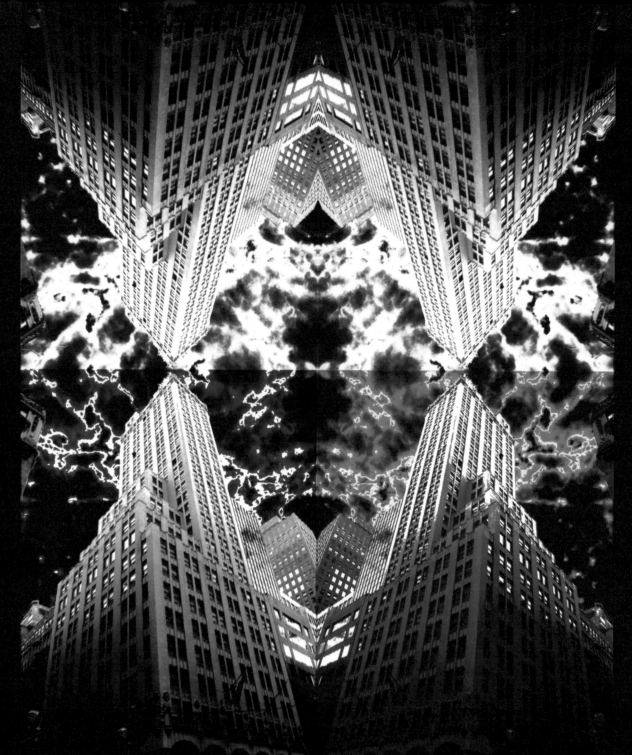

White horse, innocent dove,
Shower of stars, a heart that bursts with love.

Give me your hand; give me your other hand, crazy beauty,
I want us to make love.

Throughout eternity,
Until we reach the sky and hell too.

With the fullness of our love, the world will vanish.
Only you and I will live forever in just one body and totally free.

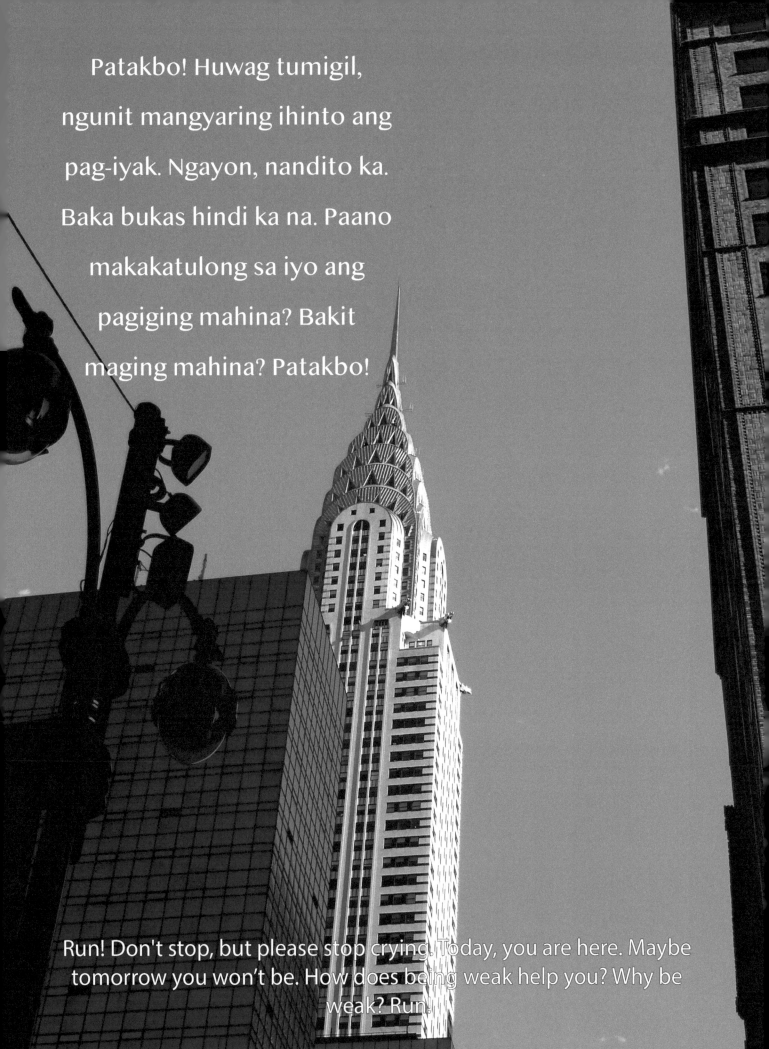

Patakbo! Huwag tumigil, ngunit mangyaring ihinto ang pag-iyak. Ngayon, nandito ka. Baka bukas hindi ka na. Paano makakatulong sa iyo ang pagiging mahina? Bakit maging mahina? Patakbo!

Run! Don't stop, but please stop crying. Today, you are here. Maybe tomorrow you won't be. How does being weak help you? Why be weak? Run!

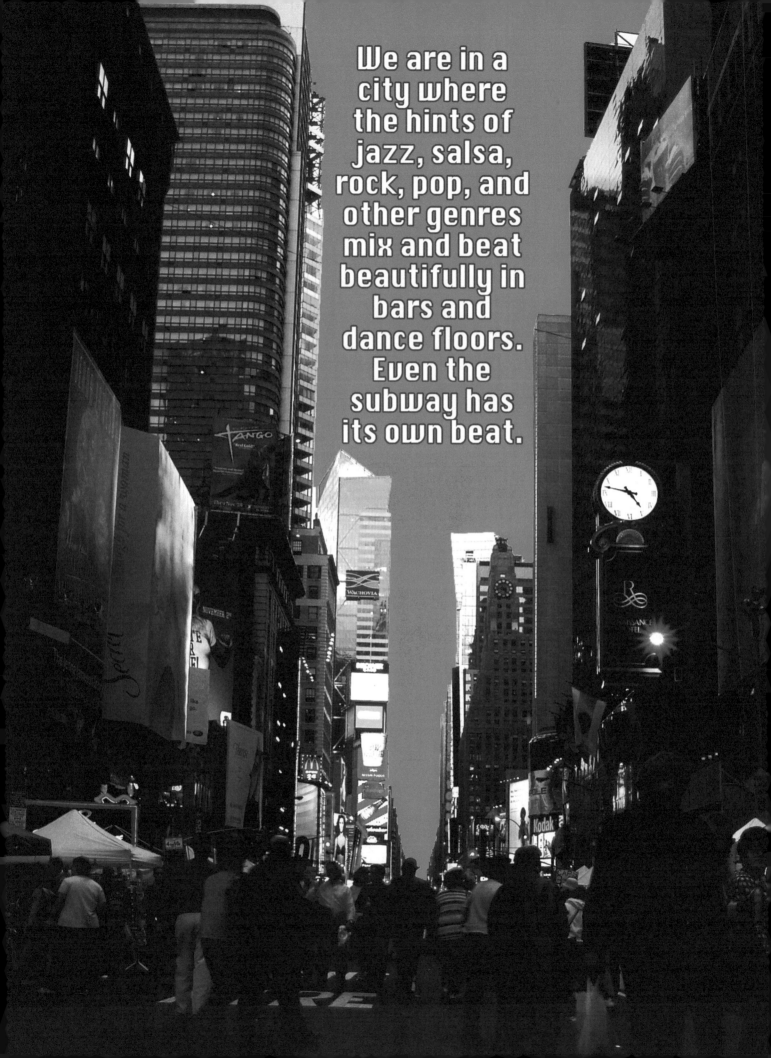

We are in a city where the hints of jazz, salsa, rock, pop, and other genres mix and beat beautifully in bars and dance floors. Even the subway has its own beat.

Vier Meter näher an der Hölle.
COVID-19

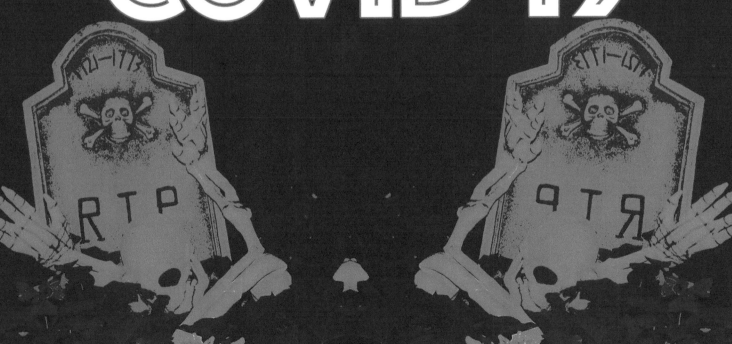

Four meters closer to hell. COVID-19

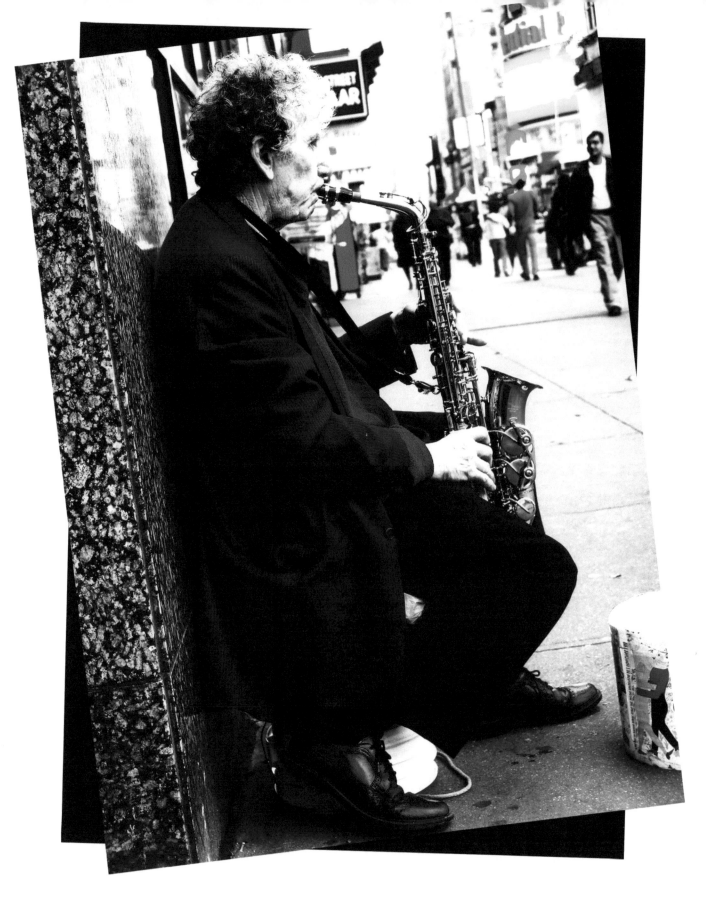

We are in a city where we all have the right to sing songs that reveal the unforgettable moments and unique times stored in our bank of memories. We are in a city where each person has a right to live as organized or disorganized as they wish. There's no doubt that New York's heterogeneity makes her the queen of the world.

Run, don't stop.

The world's capital is a city of all extremes, where the big and small live together and where the pretty and ugly are not easily distinguished. Everything is beautiful. Here, one is born every day; it is here where 50 years of life will only permit us to witness 20% of its magnitude. It is here where one is like a child in a complex maze, confused and tormented. It is here where one admires those who arrive safe and sound and advance toward success and happiness.

QUIKSILVER
BOARDRIDERS CLUB

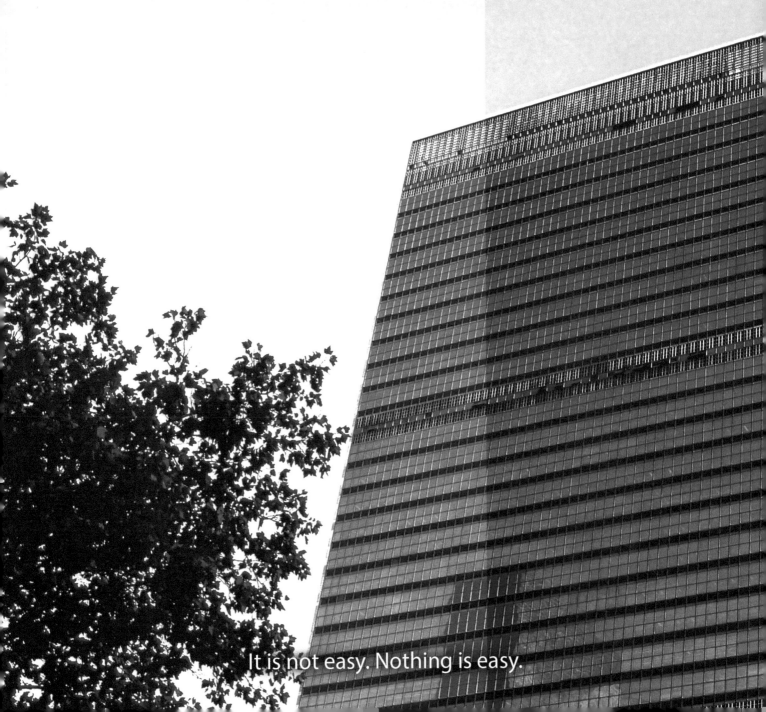

Ce n'est pas facile. Rien n'est facile.

It is not easy. Nothing is easy.

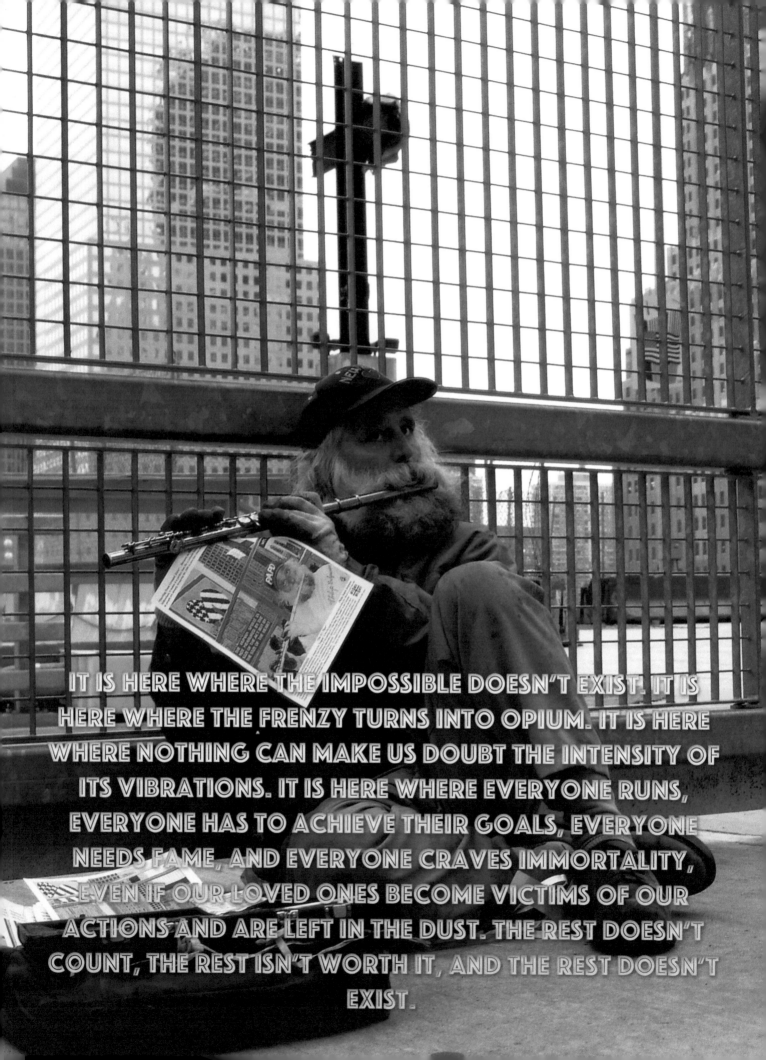

IT IS HERE WHERE THE IMPOSSIBLE DOESN'T EXIST. IT IS HERE WHERE THE FRENZY TURNS INTO OPIUM. IT IS HERE WHERE NOTHING CAN MAKE US DOUBT THE INTENSITY OF ITS VIBRATIONS. IT IS HERE WHERE EVERYONE RUNS, EVERYONE HAS TO ACHIEVE THEIR GOALS, EVERYONE NEEDS FAME, AND EVERYONE CRAVES IMMORTALITY, EVEN IF OUR LOVED ONES BECOME VICTIMS OF OUR ACTIONS AND ARE LEFT IN THE DUST. THE REST DOESN'T COUNT, THE REST ISN'T WORTH IT, AND THE REST DOESN'T EXIST.

In this world, the end justifies the means.

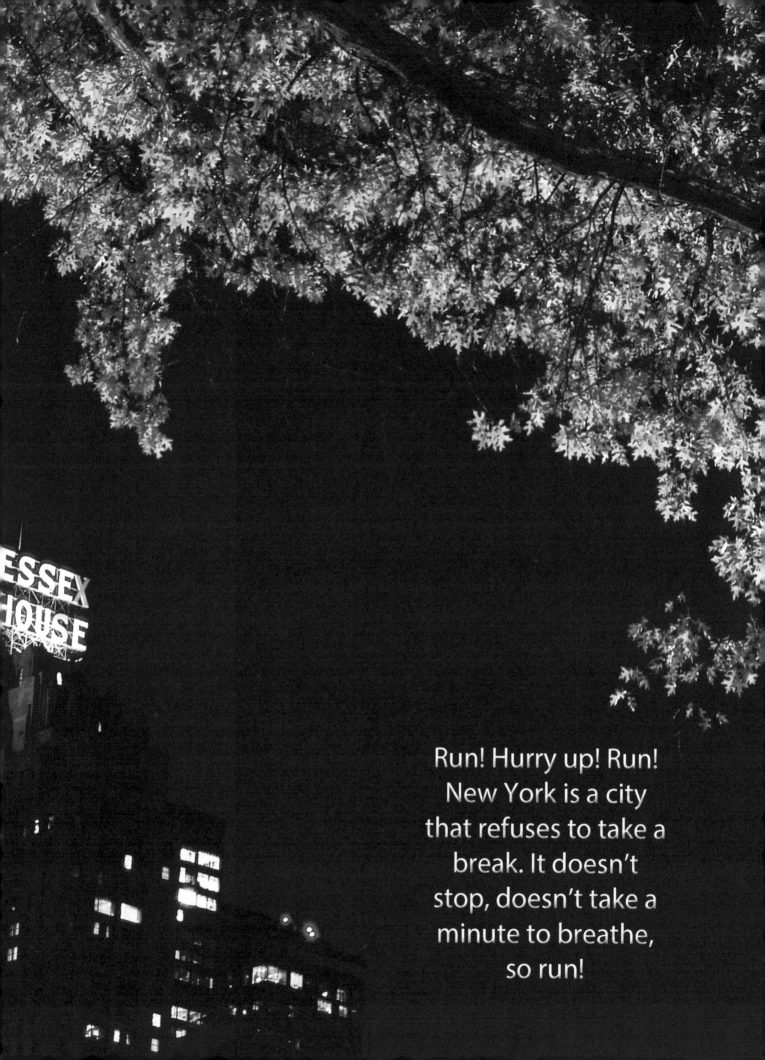

Run! Hurry up! Run!
New York is a city
that refuses to take a
break. It doesn't
stop, doesn't take a
minute to breathe,
so run!

Remember that time in New York city
is vertical, my love.
Remember, I'm here and there.
Always with you.
Remember that my body and soul are
only for you.
Remember, I am all yours since 1966,
the year I was born, my love.

Don't forget that everything I own is
for you.
I love you; don't forget that, my love.
Today I'm here and tomorrow too.
Always and forever, I will be with you.

Manhattan could be described as a kind of labyrinth, very complex. It is organized chaos, rationally composed. This piece of the city represents the beauty in the past, present, and future. Time is not justified or defined here. There is no "one" time on any given street. To walk through 43rd Street and Madison Avenue is to walk through many years of evolution. Is that King Kong crossing 44th street? Where is he going this time? 1976? It's all unreal. New York City. Run!

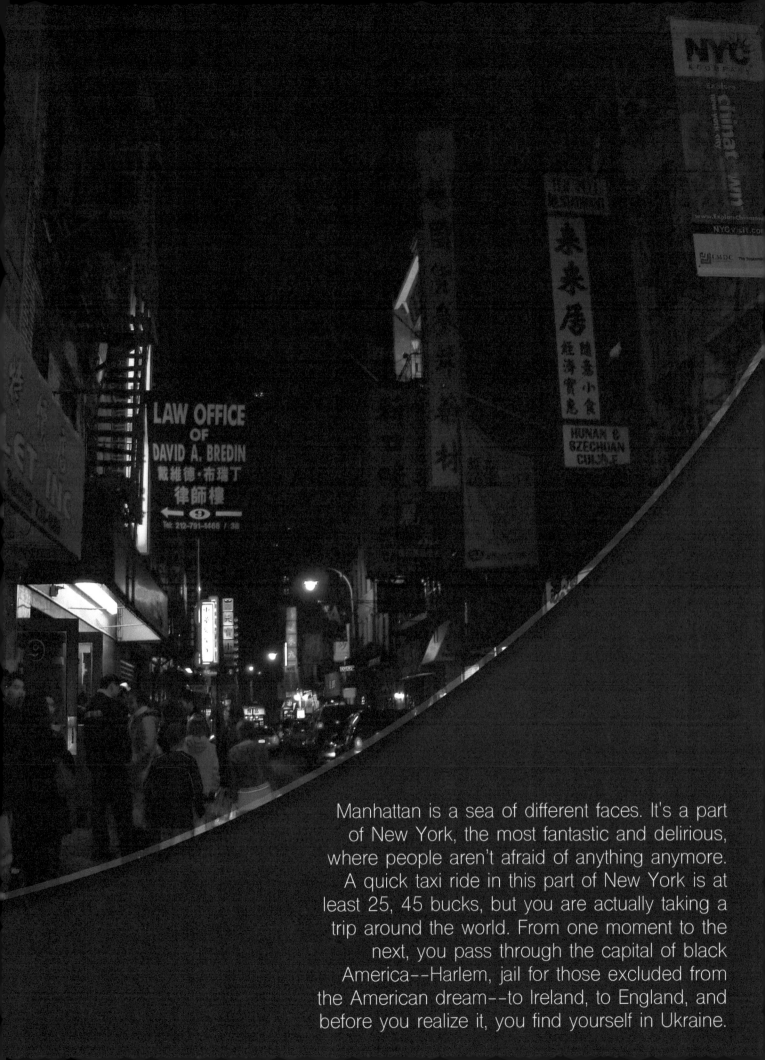

Manhattan is a sea of different faces. It's a part of New York, the most fantastic and delirious, where people aren't afraid of anything anymore. A quick taxi ride in this part of New York is at least 25, 45 bucks, but you are actually taking a trip around the world. From one moment to the next, you pass through the capital of black America--Harlem, jail for those excluded from the American dream--to Ireland, to England, and before you realize it, you find yourself in Ukraine.

You will find yourself in another part of New York, which is 80% Hispanic, otherwise known as Latinos: Salvadorians, Cubans, Hondurans, Puerto Ricans, Colombians, Argentinians, Mexicans, Chileans, Ecuadorians, and others. No other city in the world offers so much cultural diversity. Nevertheless, after making their money, their green dollars, they leave the "land of dreams" and go back to their countries of origin; to be close to their loved ones once again and enjoy the fruits of their labor like human beings, "in peace."
#ontheothersideofthatbeautifulWALL

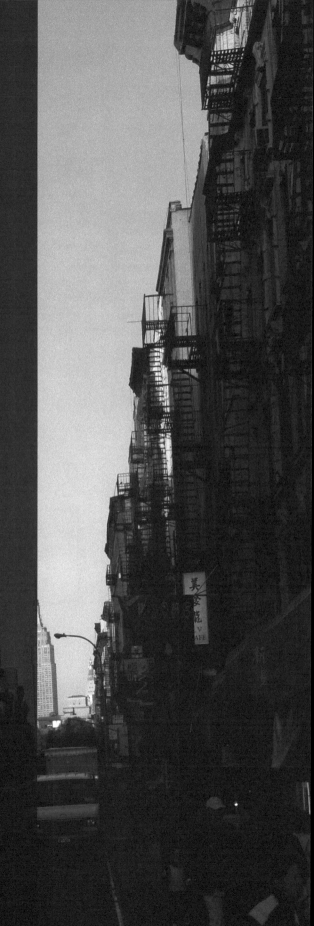

Run! In Manhattan, mortal and immortal creatures collide. Manhattan is a place where fear has lost its value and is no longer present…it doesn't exist. Here people are in tune with the city's violence. In this place, people are like machines, aware of everything at all times, all five senses connected and alert, 100% of the time, 24 hours a day, 365 days a year. In Manhattan, those who get tired fall and die: don't worry about going slow, worry about stopping. Let the president help you. He will grab you by the pu… the city is a stampede! Don't get crushed. Run!

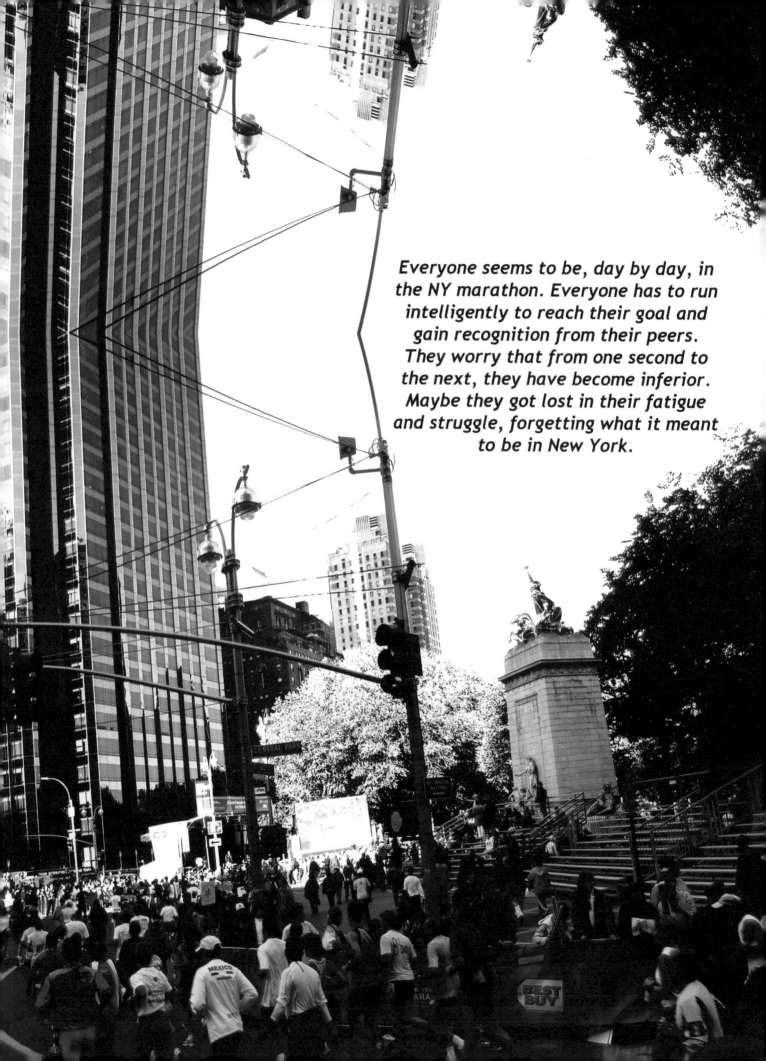

Everyone seems to be, day by day, in the NY marathon. Everyone has to run intelligently to reach their goal and gain recognition from their peers. They worry that from one second to the next, they have become inferior. Maybe they got lost in their fatigue and struggle, forgetting what it meant to be in New York.

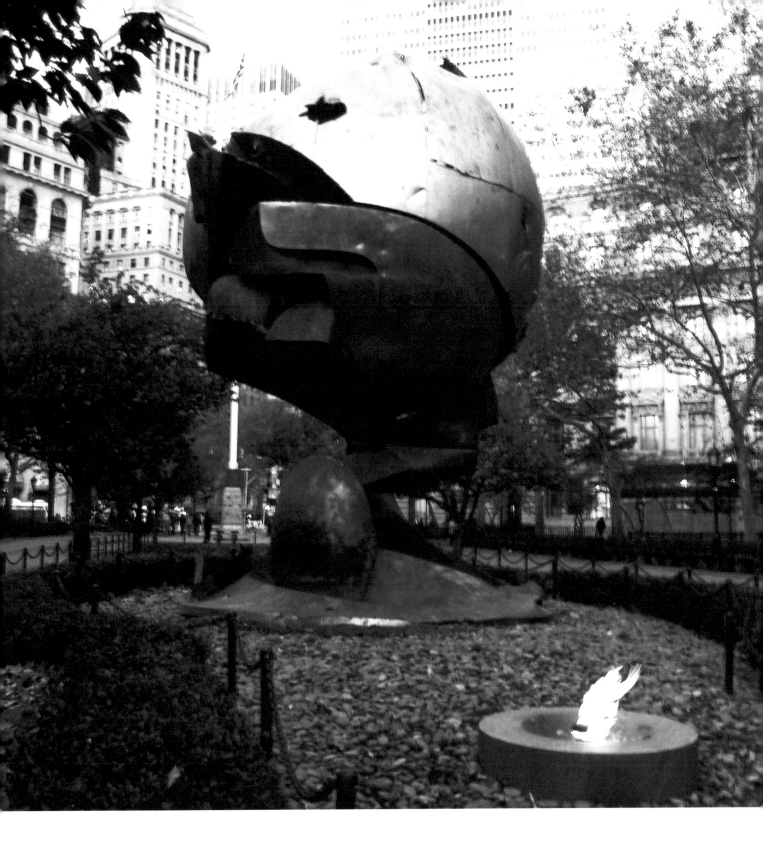

IN MANHATTAN AND THIS WHOLE JUNGLE, TIME IS MONEY. THIS IS THE REALITY. HERE, MONEY IS OF EXTREME IMPORTANCE; IT IS THE PRINCIPAL OBJECTIVE OF THOSE WHO LIVE HERE. THOSE WHO DO NOT HAVE MONEY ARE NOT WORTH ANYTHING, AND THOSE WHO HAVE IT TAKE CONTROL AND DOMINATE. WEALTH COMMANDS RESPECT AND ADMIRATION: THE WEALTHIER, THE MORE SEDUCTIVE. WEALTH IS THE ENGINE THAT DRIVES THE RAT RACE, AND THE RATS CAN'T HELP BUT BE SLAVES TO THE SYSTEM. WAKE UP! NOT EVEN A SECOND SHOULD BE WASTED. RUN!

न्यूयॉर्क में, हर कोई एक ही उद्देश्य का पीछा करता दिखाई देता है। यही कारण है कि यह अनुमान लगाना आसान है कि यह दुनिया की राजधानी है।

In New York, everyone appears to be in pursuit of the same aim. This is why it is easy to guess that this is the capital of the world.

The pain felt in the eyes,
in the temples, and the
tooth doesn't matter. My
love, nothing matters,
except you; the world is
not worth anything.
走れ！

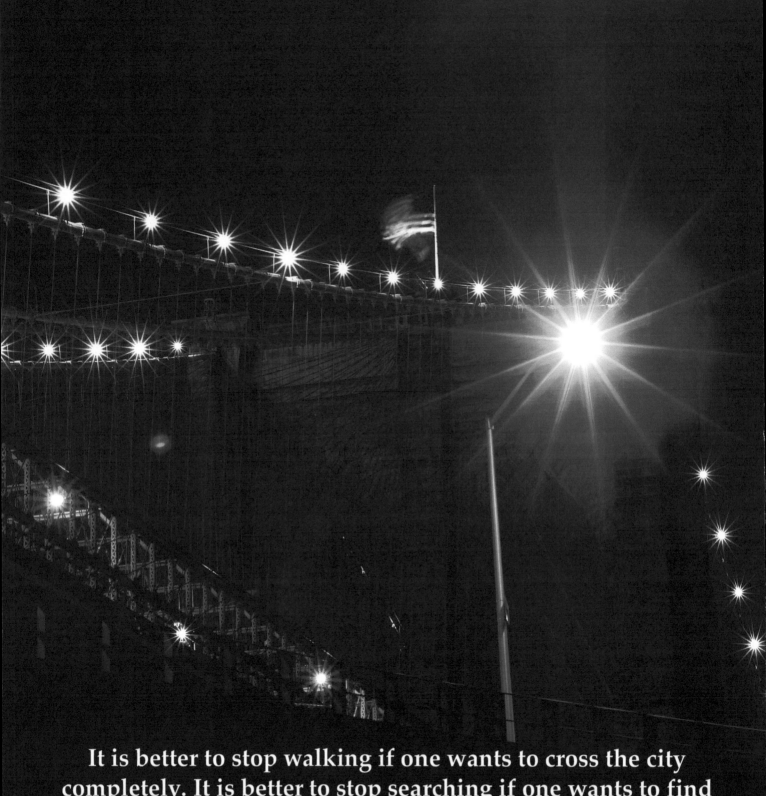

It is better to stop walking if one wants to cross the city completely. It is better to stop searching if one wants to find all the answers. It is better to stop talking if one wants to hear the city speak. It is better to lose your sense of touch if one wants to feel all the things that comprise the city. It is better to stop breathing if one wants to smell the air made up of an infinite number of smells and odors that deluge this city. It is better to die if one wants to be part of New York, honestly. Run!

Her şey burada doğar, her şey burada gelişir ve her şey burada ölür.

Everything is born here, everything develops here, and everything dies here.

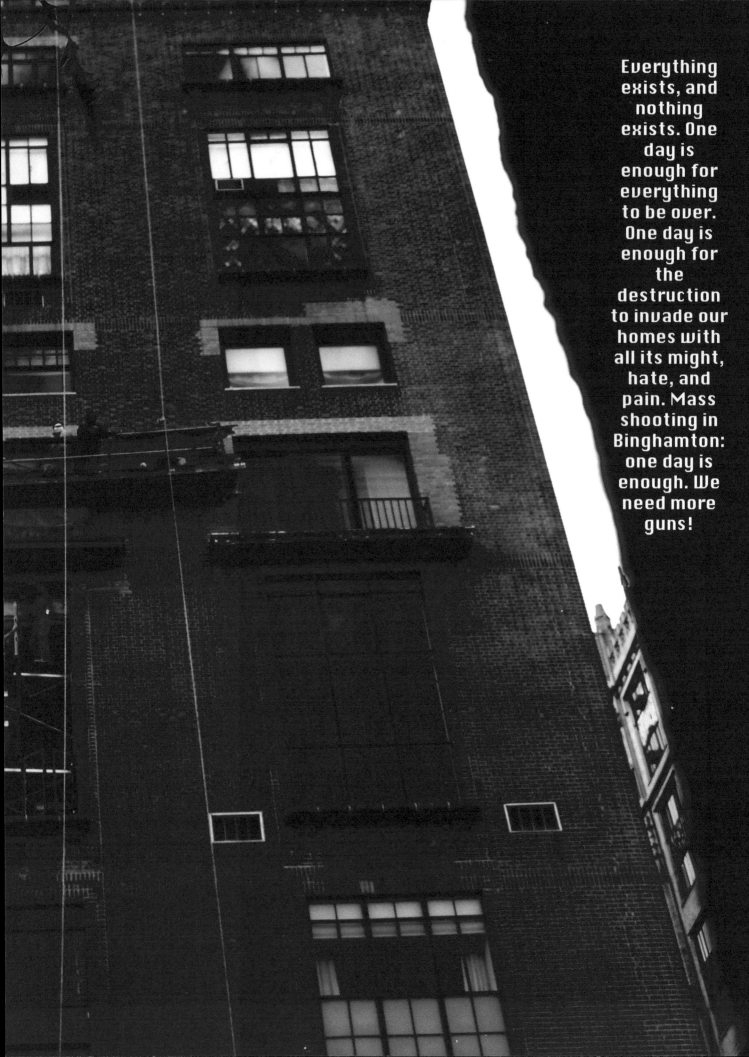

Everything exists, and nothing exists. One day is enough for everything to be over. One day is enough for the destruction to invade our homes with all its might, hate, and pain. Mass shooting in Binghamton: one day is enough. We need more guns!

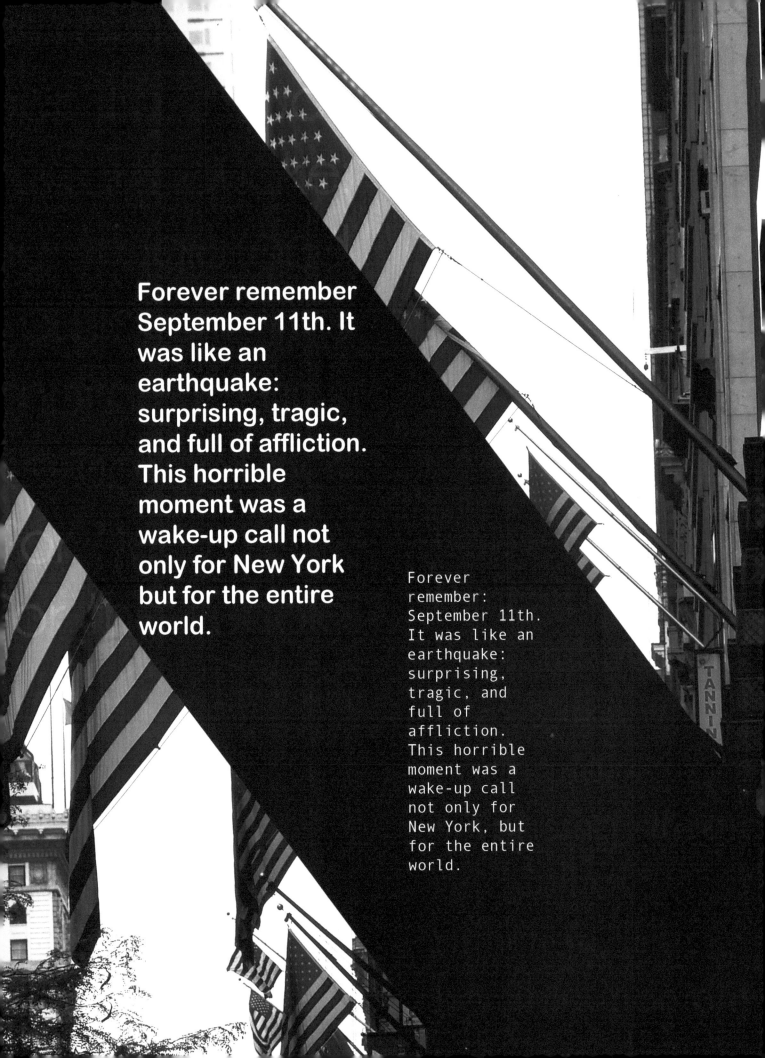

Forever remember September 11th. It was like an earthquake: surprising, tragic, and full of affliction. This horrible moment was a wake-up call not only for New York but for the entire world.

Forever remember: September 11th. It was like an earthquake: surprising, tragic, and full of affliction. This horrible moment was a wake-up call not only for New York, but for the entire world.

Πάντα να θυμάσαι.

Always remember.

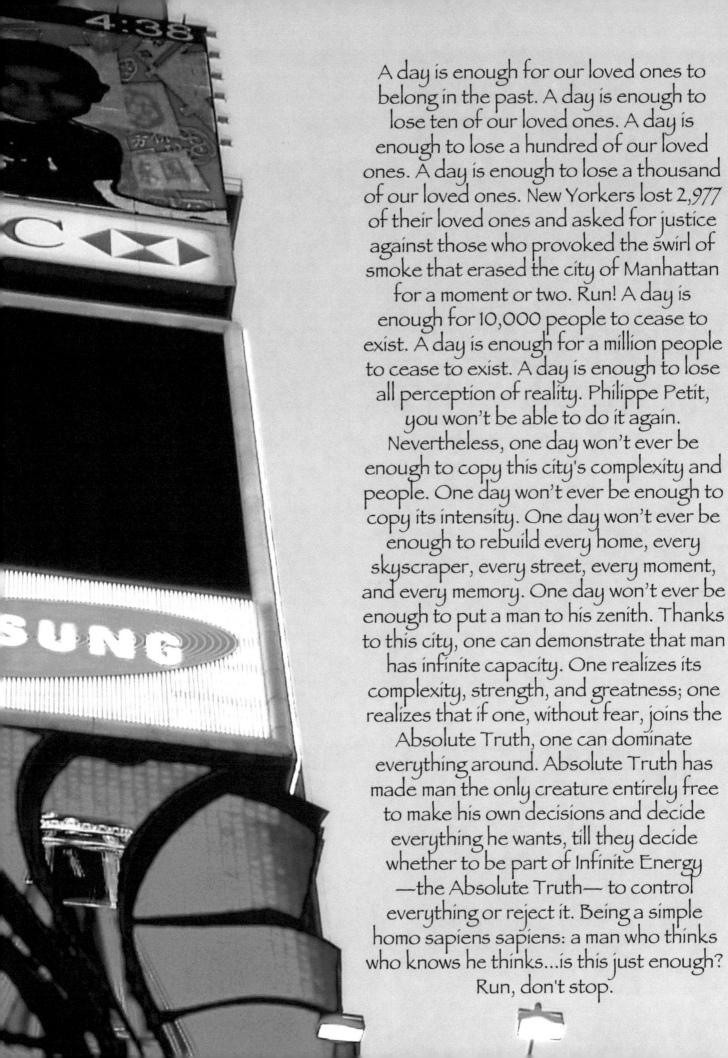

A day is enough for our loved ones to belong in the past. A day is enough to lose ten of our loved ones. A day is enough to lose a hundred of our loved ones. A day is enough to lose a thousand of our loved ones. New Yorkers lost 2,977 of their loved ones and asked for justice against those who provoked the swirl of smoke that erased the city of Manhattan for a moment or two. Run! A day is enough for 10,000 people to cease to exist. A day is enough for a million people to cease to exist. A day is enough to lose all perception of reality. Philippe Petit, you won't be able to do it again. Nevertheless, one day won't ever be enough to copy this city's complexity and people. One day won't ever be enough to copy its intensity. One day won't ever be enough to rebuild every home, every skyscraper, every street, every moment, and every memory. One day won't ever be enough to put a man to his zenith. Thanks to this city, one can demonstrate that man has infinite capacity. One realizes its complexity, strength, and greatness; one realizes that if one, without fear, joins the Absolute Truth, one can dominate everything around. Absolute Truth has made man the only creature entirely free to make his own decisions and decide everything he wants, till they decide whether to be part of Infinite Energy —the Absolute Truth— to control everything or reject it. Being a simple homo sapiens sapiens: a man who thinks who knows he thinks...is this just enough? Run, don't stop.

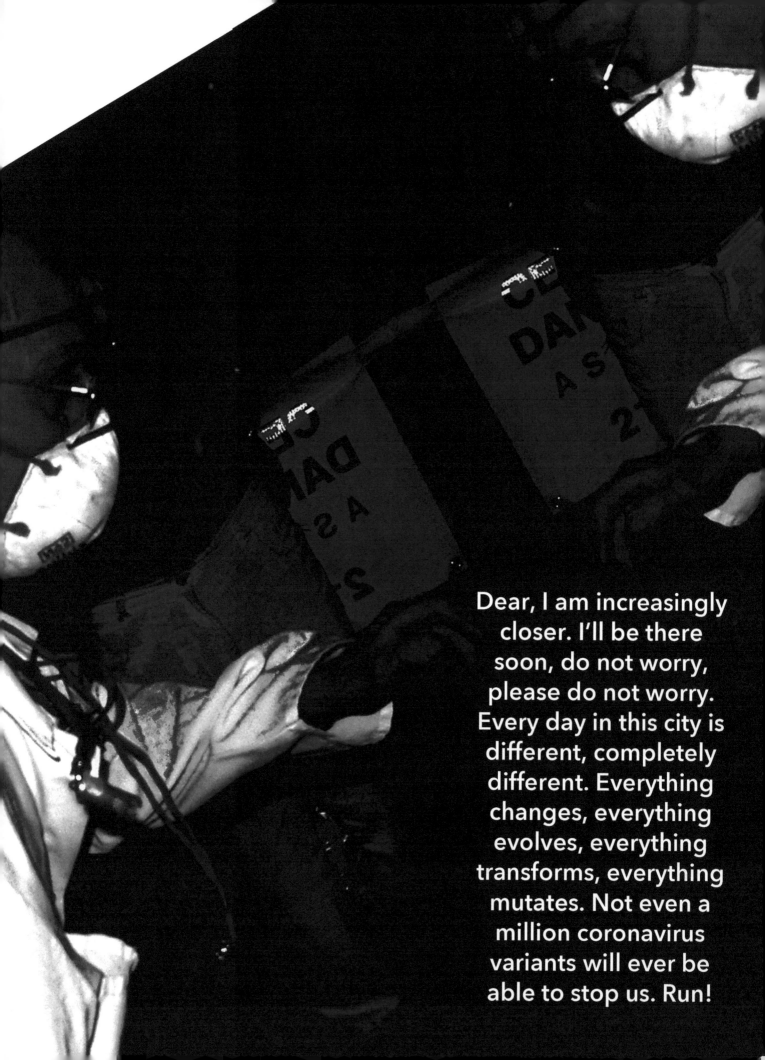

Dear, I am increasingly closer. I'll be there soon, do not worry, please do not worry. Every day in this city is different, completely different. Everything changes, everything evolves, everything transforms, everything mutates. Not even a million coronavirus variants will ever be able to stop us. Run!

From one street to the next, one passes from a Ukrainian village to an Italian corner. From one second to the next, in the southern part of Brooklyn, one passes from a Jewish neighborhood to a Russian neighborhood. From one moment to the next, one can find architecture from medieval times and architecture from the Renaissance. In the blink of an eye, you can find yourself in the time of Shakespeare. Keep walking to find yourself with streets that remind historians of the era of Victor Hugo. Ten more steps to jump in time and find yourself in the Sixties.

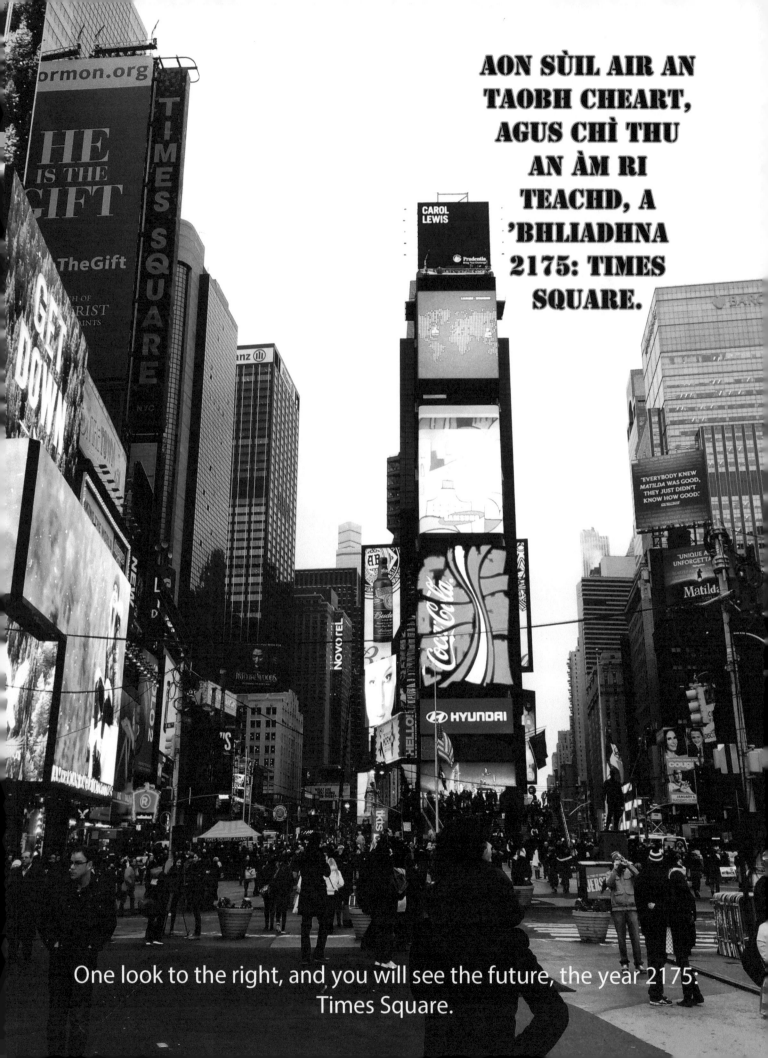

AON SÙIL AIR AN TAOBH CHEART, AGUS CHÌ THU AN ÀM RI TEACHD, A 'BHLIADHNA 2175: TIMES SQUARE.

One look to the right, and you will see the future, the year 2175: Times Square.

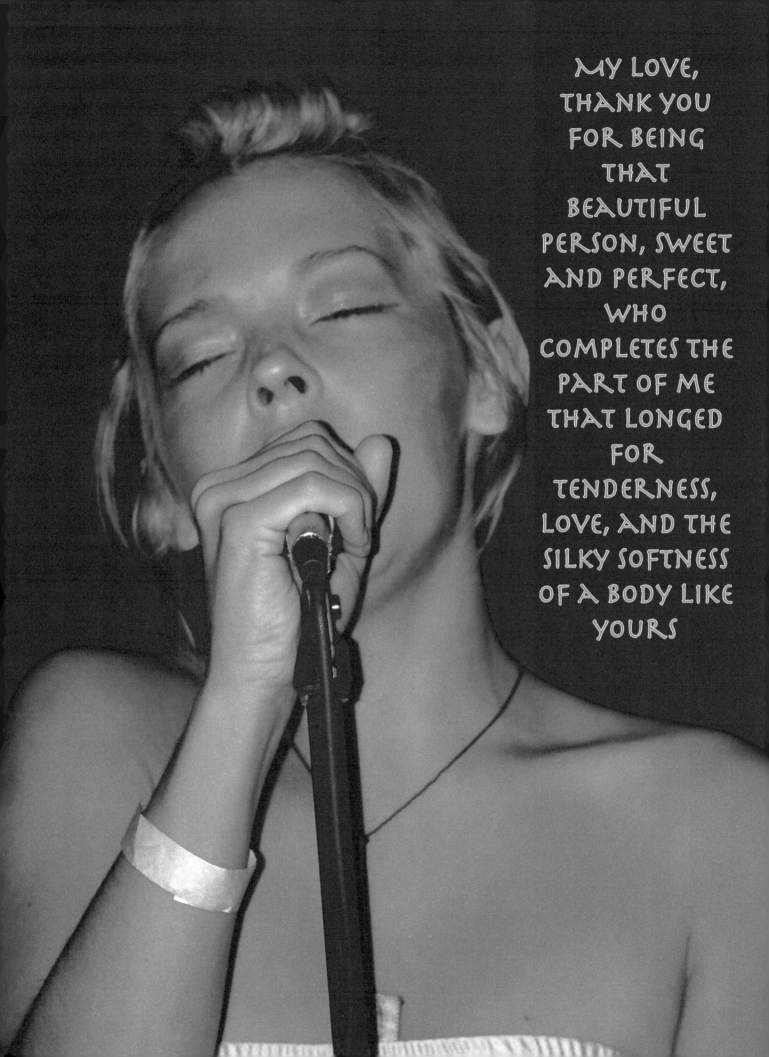

My love, thank you for being that beautiful person, sweet and perfect, who completes the part of me that longed for tenderness, love, and the silky softness of a body like yours

Rural brothers of mine, no city compares to this Mecca of man in the West. There is no city to compare to this giant of the world. No city can close its eyes upon so much beauty. No city can struggle with its might. No city is more diverse than this. No city can understand the messages that she constantly provides. No city can come close to its grandness. It is one of the few cities where parades of limousines are common. It is one of the few cities in which musicians enlighten the atmosphere with a true and extraordinary background.

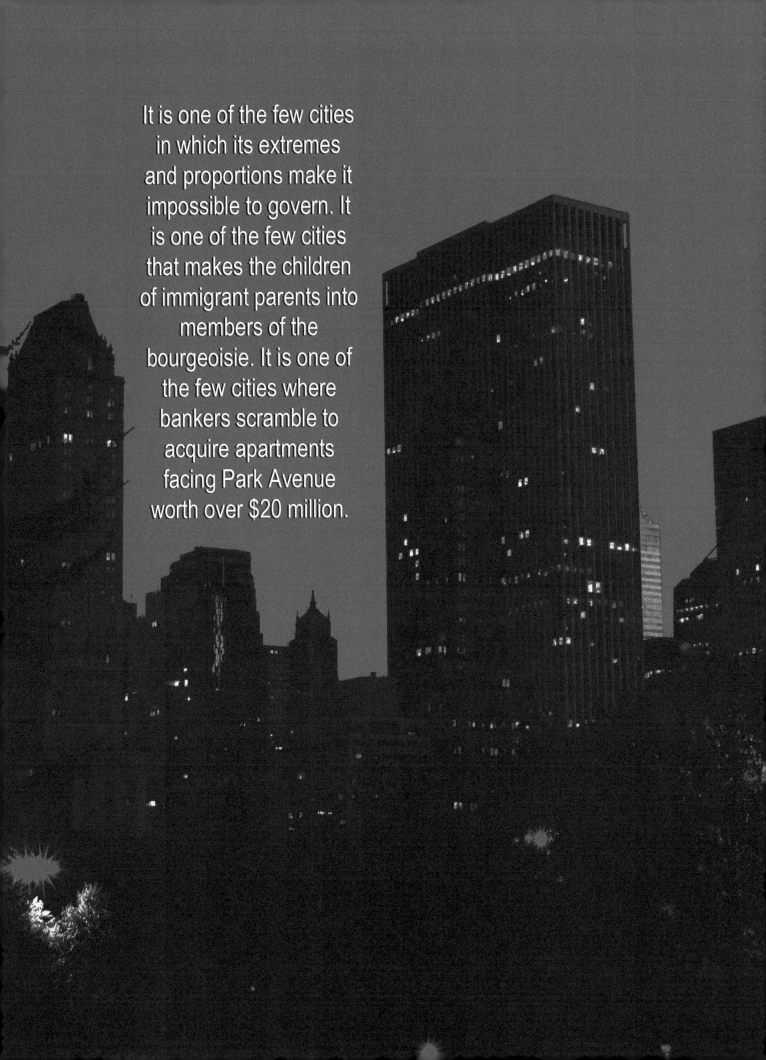

It is one of the few cities in which its extremes and proportions make it impossible to govern. It is one of the few cities that makes the children of immigrant parents into members of the bourgeoisie. It is one of the few cities where bankers scramble to acquire apartments facing Park Avenue worth over $20 million.

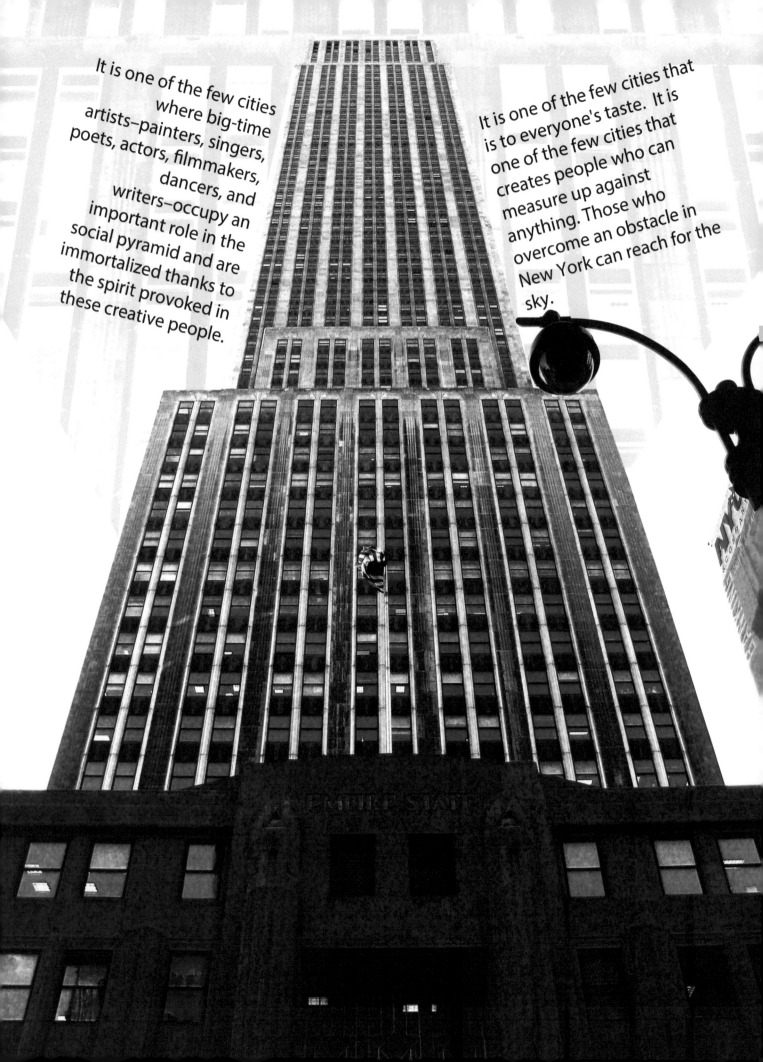

It is one of the few cities where big-time artists—painters, singers, poets, actors, filmmakers, dancers, and writers—occupy an important role in the social pyramid and are immortalized thanks to the spirit provoked in these creative people.

It is one of the few cities that is to everyone's taste. It is one of the few cities that creates people who can measure up against anything. Those who overcome an obstacle in New York can reach for the sky.

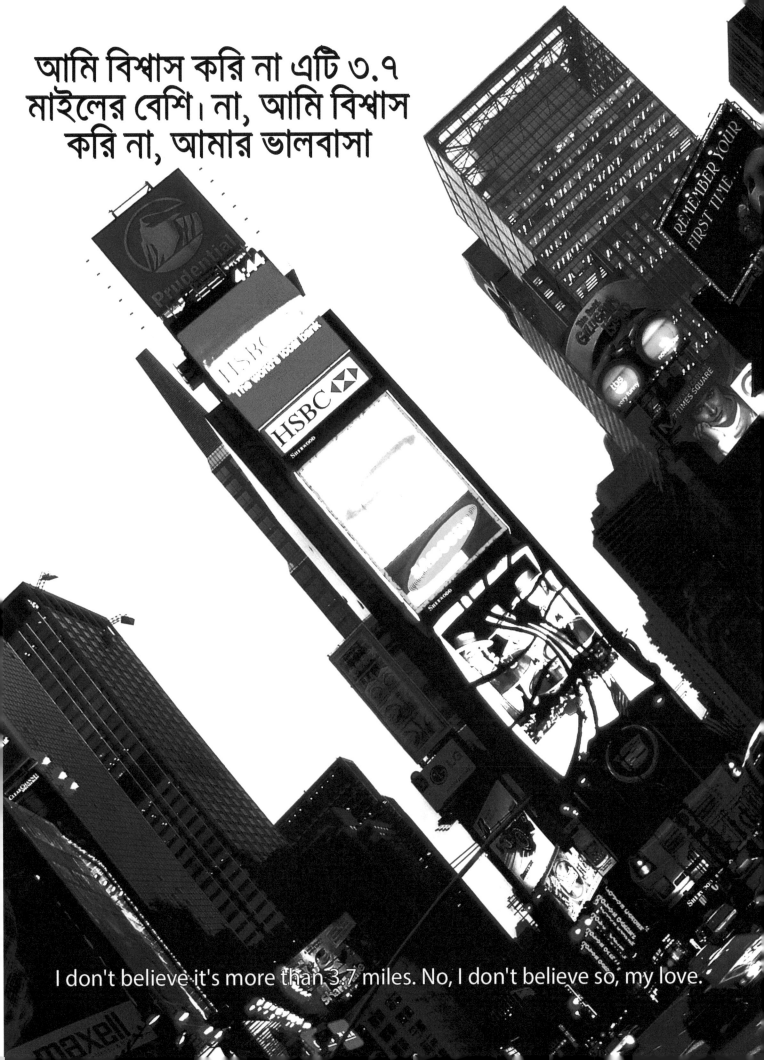

আমি বিশ্বাস করি না এটি ৩.৭ মাইলের বেশি। না, আমি বিশ্বাস করি না, আমার ভালবাসা

I don't believe it's more than 3.7 miles. No, I don't believe so, my love.

Maybe it was love, or maybe the war, or the thought of revenge,
or maybe my search for freedom.

Maybe it was a friend, or my brother, or a criminal,
or maybe it was destiny.

Maybe it was God's will in a moment of rage,
or a dream that turned into a nightmare.

Maybe it was my laugh that would arise every time
I saw a miserable man.

Maybe it was an accident or Mother Nature's error,
or the awakening of misery, pain, and suffering.

Maybe it was the sun and moon
in a repulsive conspiracy.

Maybe it was the most miserable of the miserable whose laments
tainted my soul,
my body, my life, and my surroundings.

Maybe it was a cosmic error that sent my disgrace to the world, and
now my soul cries around these bodies.

Maybe it was...you?

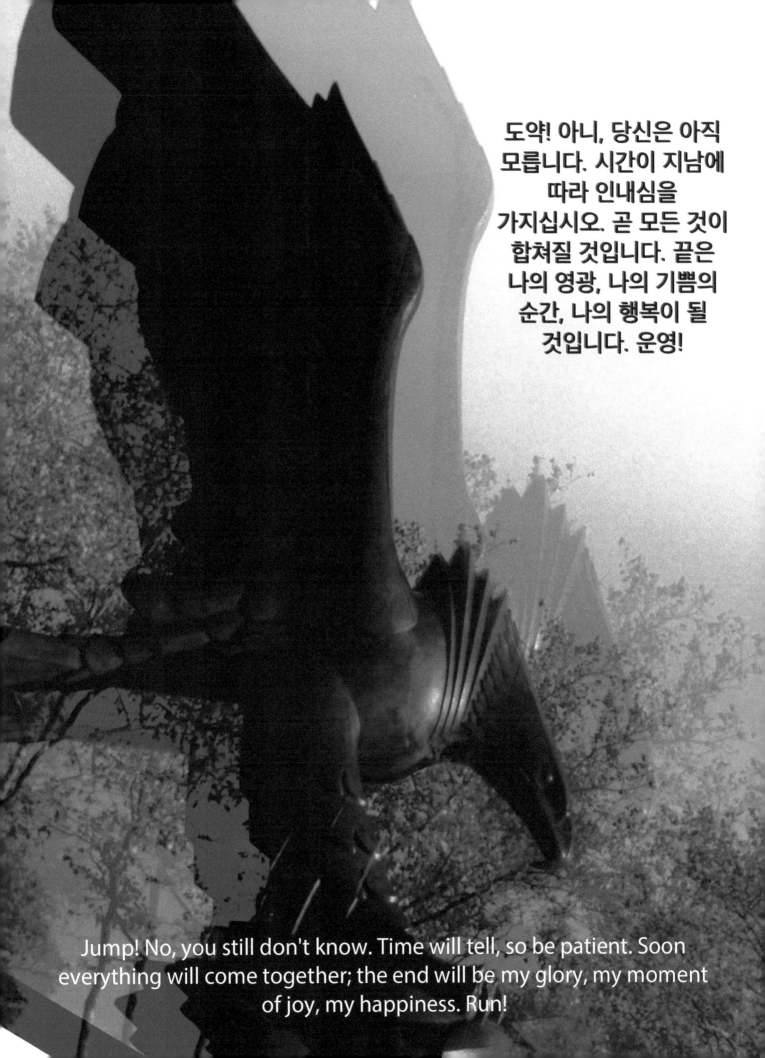

도약! 아니, 당신은 아직 모릅니다. 시간이 지남에 따라 인내심을 가지십시오. 곧 모든 것이 합쳐질 것입니다. 끝은 나의 영광, 나의 기쁨의 순간, 나의 행복이 될 것입니다. 운영!

Jump! No, you still don't know. Time will tell, so be patient. Soon everything will come together; the end will be my glory, my moment of joy, my happiness. Run!

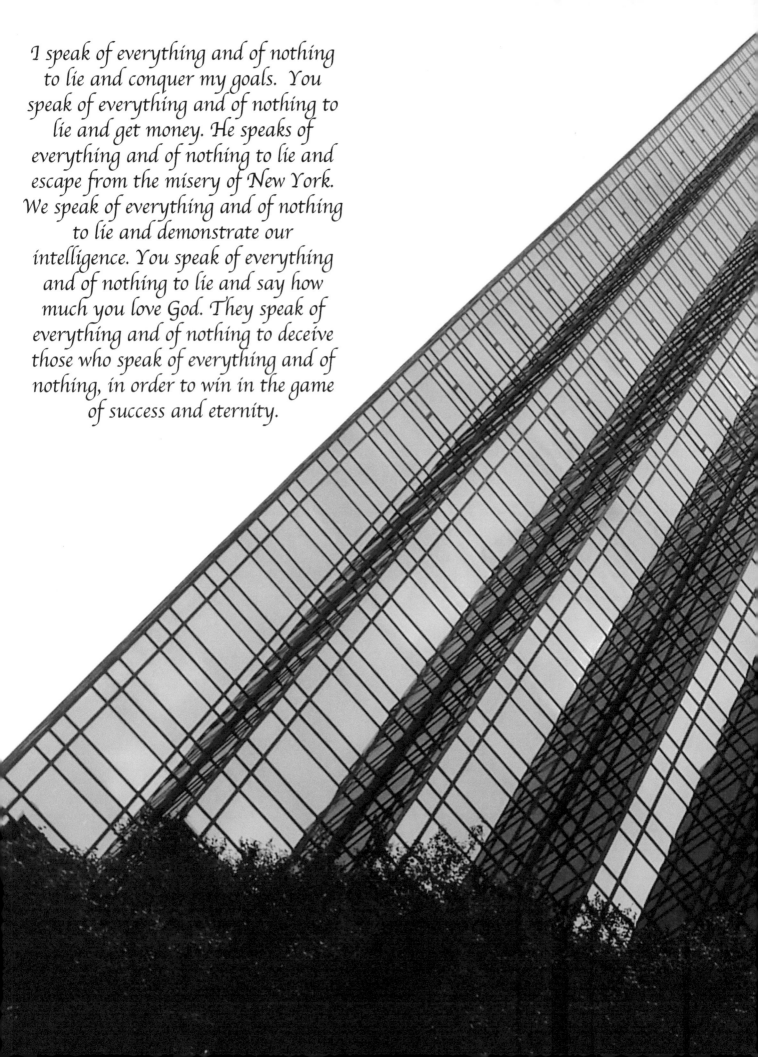

I speak of everything and of nothing to lie and conquer my goals. You speak of everything and of nothing to lie and get money. He speaks of everything and of nothing to lie and escape from the misery of New York. We speak of everything and of nothing to lie and demonstrate our intelligence. You speak of everything and of nothing to lie and say how much you love God. They speak of everything and of nothing to deceive those who speak of everything and of nothing, in order to win in the game of success and eternity.

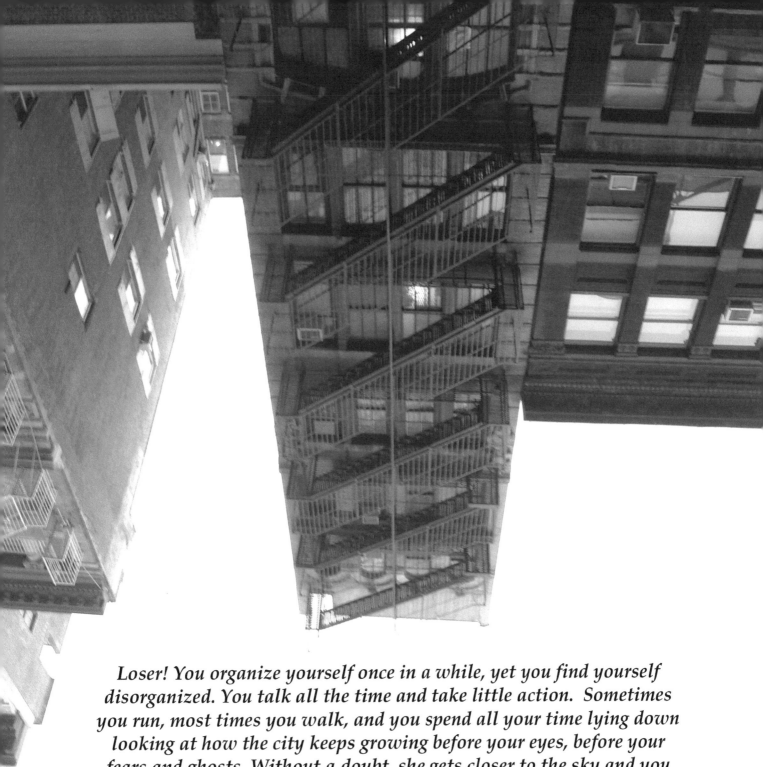

Loser! You organize yourself once in a while, yet you find yourself disorganized. You talk all the time and take little action. Sometimes you run, most times you walk, and you spend all your time lying down looking at how the city keeps growing before your eyes, before your fears and ghosts. Without a doubt, she gets closer to the sky and you closer to hell. Run! One step, two steps...the Bronx approaches. Five steps, six steps, suddenly one finds oneself in a dark place, far away from luxury, from ambition, from vanity and coveting, from goals and gods, from dreams and hope. Turn to the right, turn to the left, two steps ahead, one to the left, down a small staircase. The sound of crying children becomes more acute, and poverty gets closer, the fumes of misery, danger, and filth stain the air. Abandonment, fear, and neglect sit on the street corner playing craps, laughing.

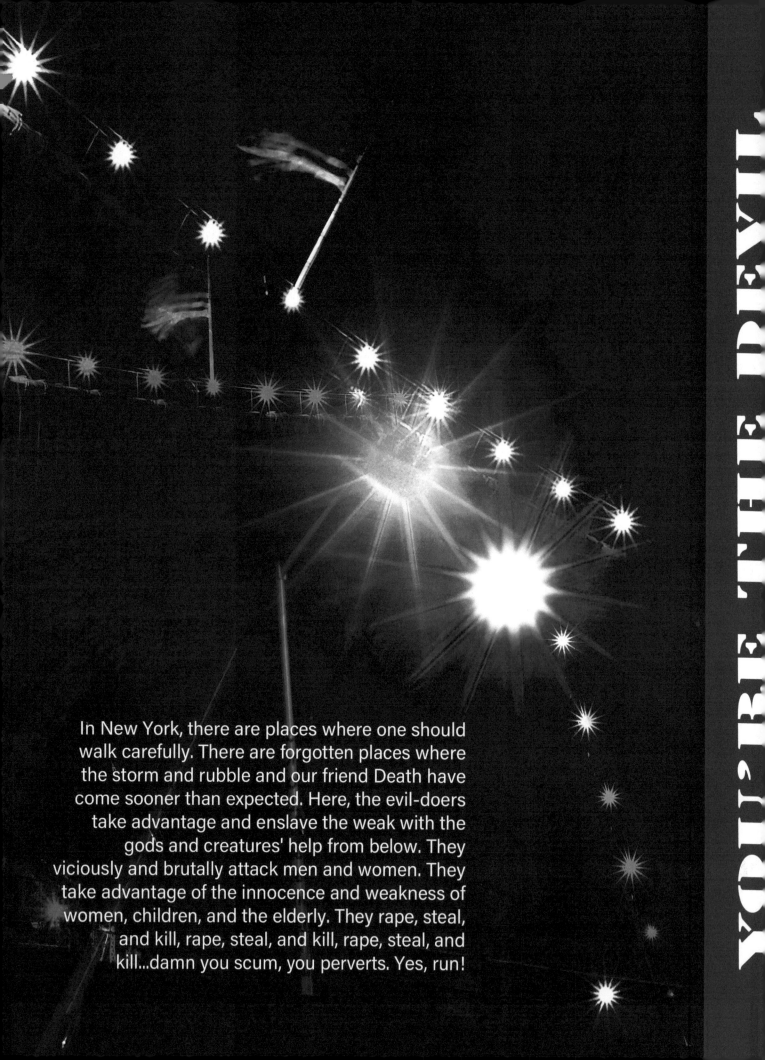

In New York, there are places where one should walk carefully. There are forgotten places where the storm and rubble and our friend Death have come sooner than expected. Here, the evil-doers take advantage and enslave the weak with the gods and creatures' help from below. They viciously and brutally attack men and women. They take advantage of the innocence and weakness of women, children, and the elderly. They rape, steal, and kill, rape, steal, and kill, rape, steal, and kill...damn you scum, you perverts. Yes, run!

YOU'RE THE DEVIL

AVOID ENTERING CENTRAL PARK AFTER
11 PM IF YOU DON'T WANT YOUR LIFE TO
TURN INTO YOUR WORST NIGHTMARE.
FULL OF LAUGHTER, ATTRACTION,
EXCITEMENT, SWEAT, LOTS OF SWEAT,
FEAR, UNCONSCIOUSNESS, AND...

New York'ta biri koşuyor.
Haydi! Çalıştırmak!
Durma! Çalıştırmak.

In New York, one runs. Come on! Run! Don't stop! Run.

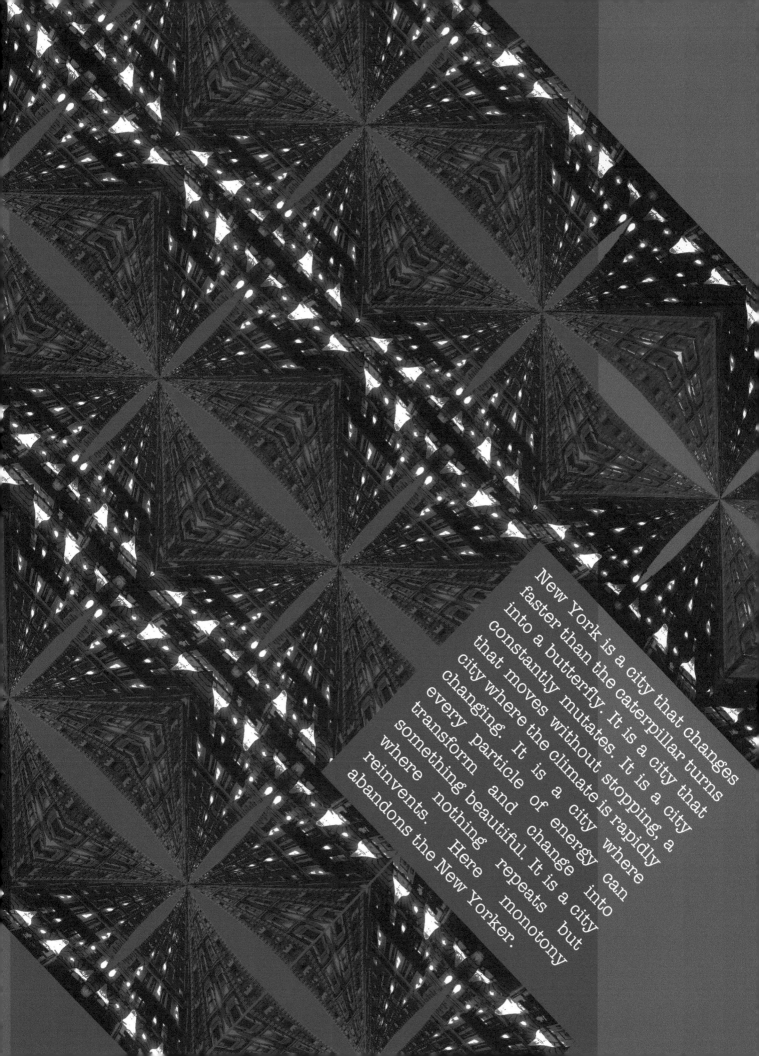

New York is a city that changes faster than the caterpillar turns into a butterfly. It is a city that constantly mutates. It is a city that moves without stopping, a city where the climate is rapidly changing. It is a city where every particle of energy can transform and change into something and change into something beautiful. It is a city where nothing repeats but reinvents. Here monotony abandons the New Yorker.

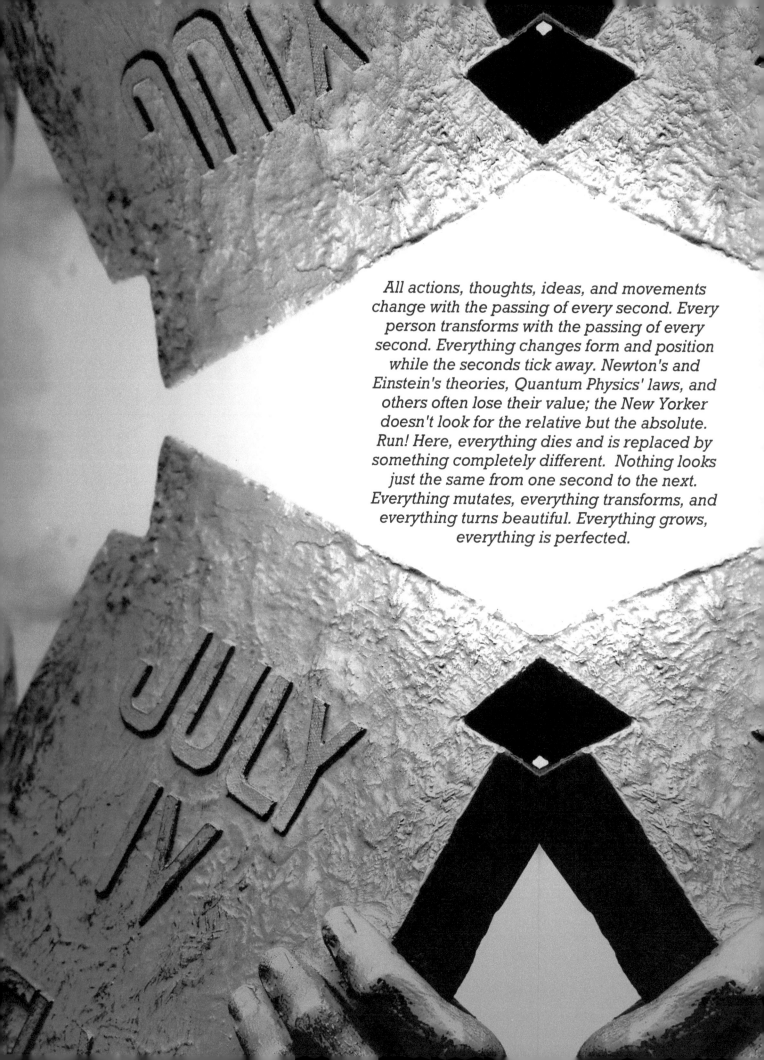

All actions, thoughts, ideas, and movements change with the passing of every second. Every person transforms with the passing of every second. Everything changes form and position while the seconds tick away. Newton's and Einstein's theories, Quantum Physics' laws, and others often lose their value; the New Yorker doesn't look for the relative but the absolute. Run! Here, everything dies and is replaced by something completely different. Nothing looks just the same from one second to the next. Everything mutates, everything transforms, and everything turns beautiful. Everything grows, everything is perfected.

New York cries for its 2,977 heroes: the numbers who disappeared. New York cries for those large, beautiful, blue eyes that divinely beheld the beauty of this city. The phoenix rises from the ashes. An eagle is born unchained and immortal. These eyes have stopped shining to advance unbroken and everlasting freedom! New York is like an egg that spawns the larva, the larva into a pupa, the pupa into a butterfly. A butterfly that rises to the sky and transforms into an eagle. This eagle is in God, free and immortal.

Oh, the great city that imposes itself on the world
and destroys it!

Oh, the great one, that does not stop growing, that is scared of the small,
that opens its hands, stretches its arms, touches and conquers the sky.

Oh, the great owner of the skies and hell,
that is the union of sea and wind,
that easily commits errors but quickly solves them.

Oh, the great city that gives millions of opportunities to millions of people.

Бескрајно бесмртни.

Oh, the great city, sometimes pretentious with the world,
but a worthy example to every nation.

Oh, the great city, worthy of appreciation, contemplation, and admiration,
that has killed, devoured, and destroyed hopeful people under the unbearable
pressure it exerts upon individuals.

Oh, the great beast, that conserves your dead in the deepest of your heart,
who has stepped on her head and her body,
who has swallowed her soul and her heart?

Oh, the great Big Apple, the one who will soon empower me at today's
perpetual twilight.

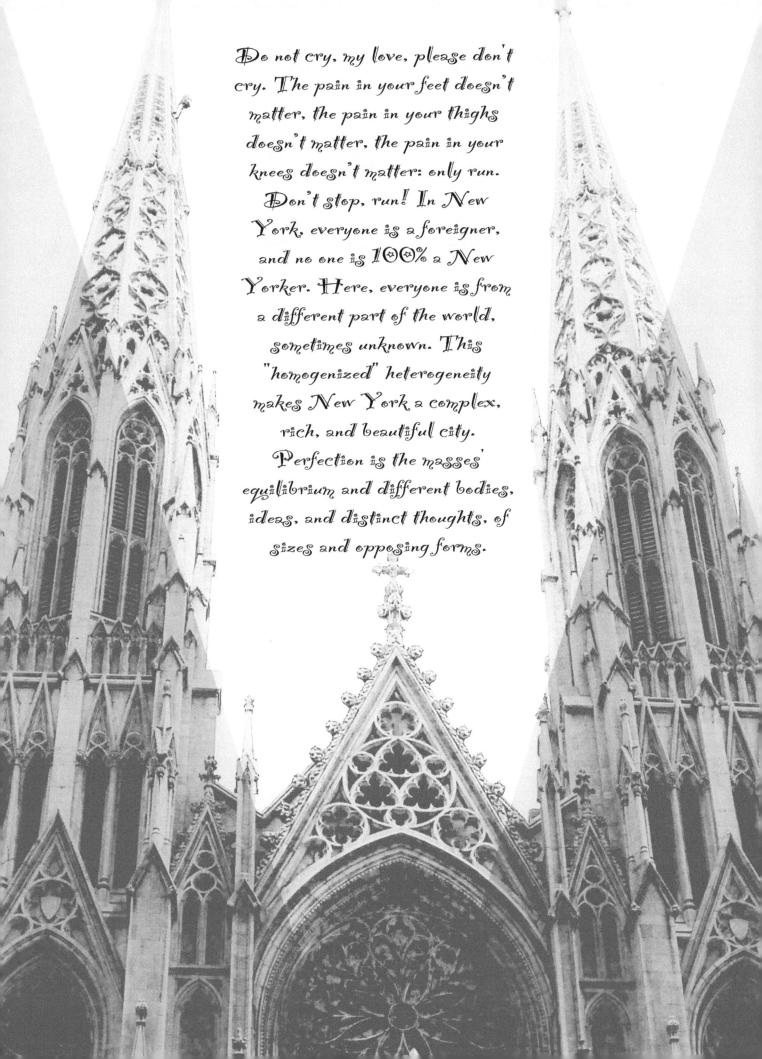

Do not cry, my love, please don't cry. The pain in your feet doesn't matter, the pain in your thighs doesn't matter, the pain in your knees doesn't matter: only run. Don't stop, run! In New York, everyone is a foreigner, and no one is 100% a New Yorker. Here, everyone is from a different part of the world, sometimes unknown. This "homogenized" heterogeneity makes New York a complex, rich, and beautiful city. Perfection is the masses' equilibrium and different bodies, ideas, and distinct thoughts, of sizes and opposing forms.

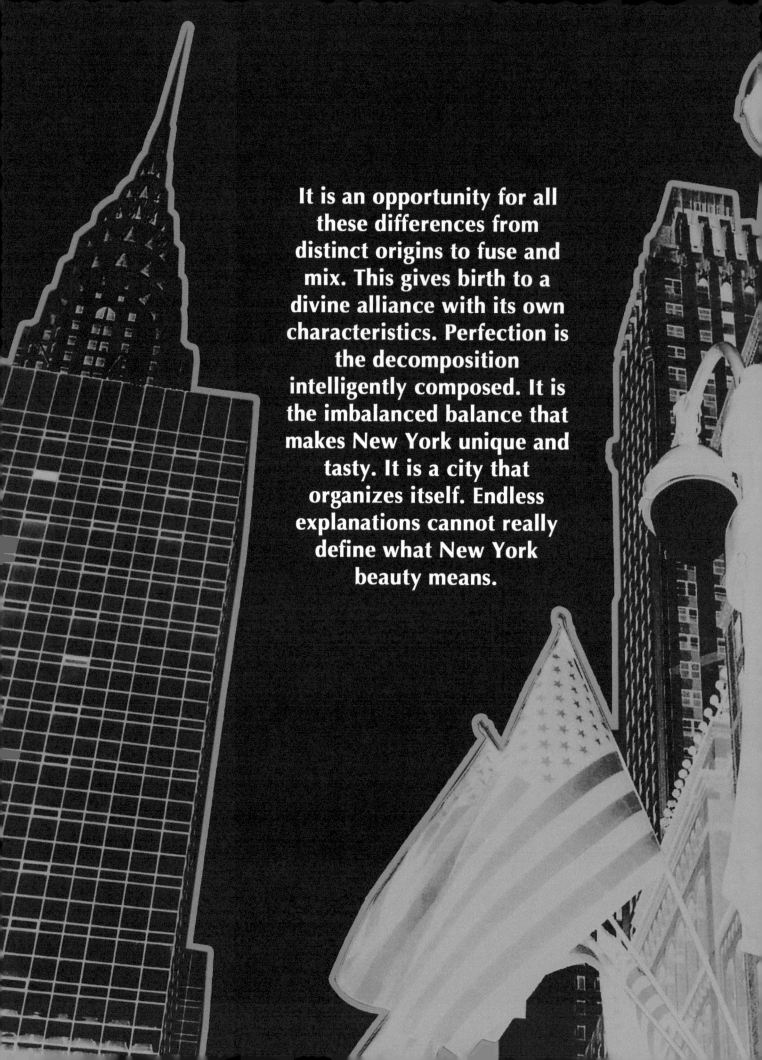

It is an opportunity for all these differences from distinct origins to fuse and mix. This gives birth to a divine alliance with its own characteristics. Perfection is the decomposition intelligently composed. It is the imbalanced balance that makes New York unique and tasty. It is a city that organizes itself. Endless explanations cannot really define what New York beauty means.

This is an ambivalent city, just and unjust. This city speaks many languages and endless dialects, which constantly makes one travel through time and space, which facilitates everything. It is a city for all kinds of people, races, and colors. Long live to the whites, blacks, yellows, browns, and oranges! And of course, to the almost white, black, yellow, brown, and almost orange! What an idiocy!

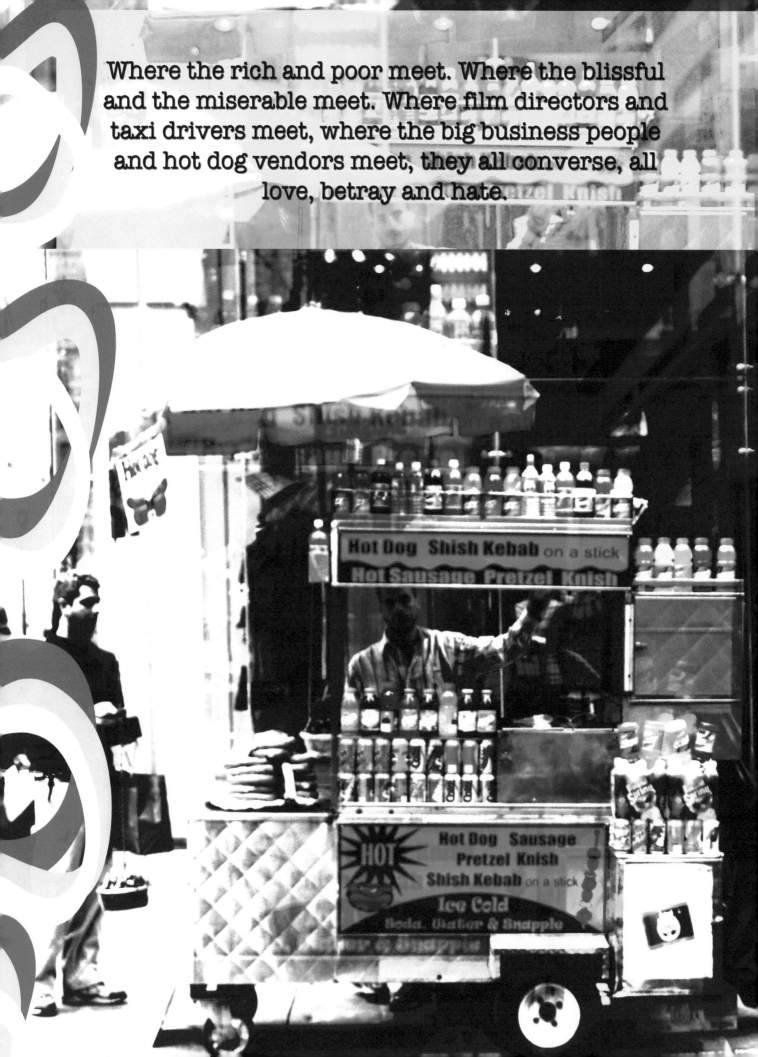

Where the rich and poor meet. Where the blissful and the miserable meet. Where film directors and taxi drivers meet, where the big business people and hot dog vendors meet, they all converse, all love, betray and hate.

U
stvarnosti
svi
umiremo.

In reality, we all die.

Все проходит и полностью забывается? Все умирает и просто обращается в пыль?

Does everything pass and is totally forgotten? Does everything die and turn to dust?

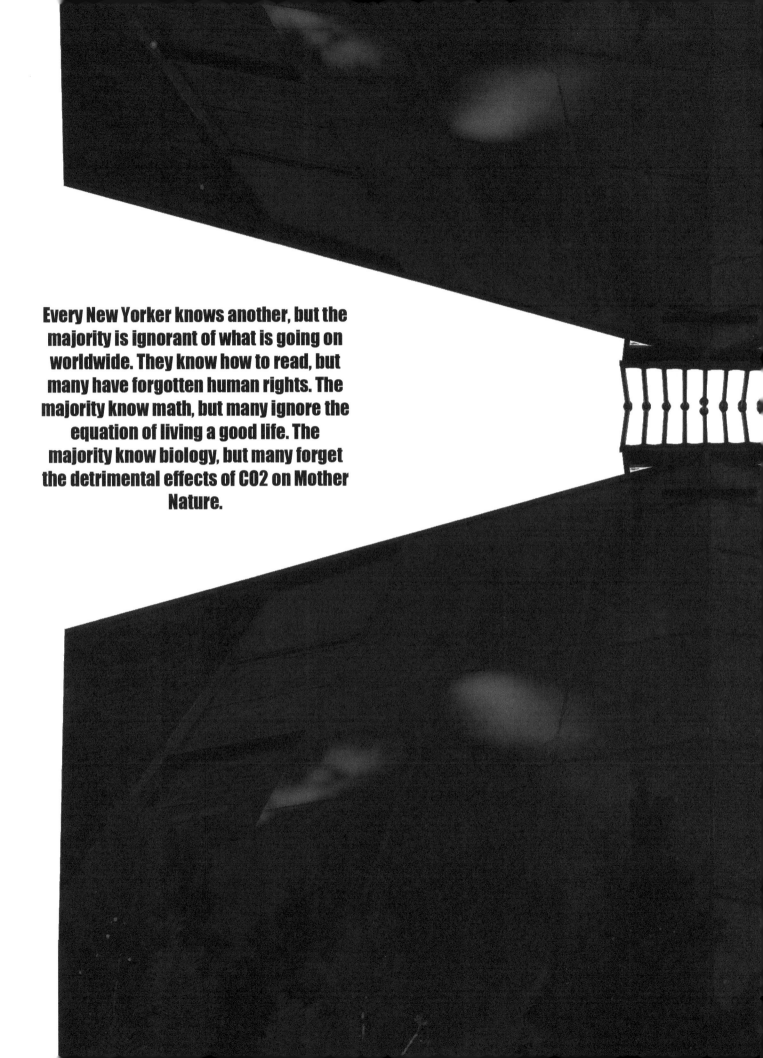

Every New Yorker knows another, but the majority is ignorant of what is going on worldwide. They know how to read, but many have forgotten human rights. The majority know math, but many ignore the equation of living a good life. The majority know biology, but many forget the detrimental effects of CO_2 on Mother Nature.

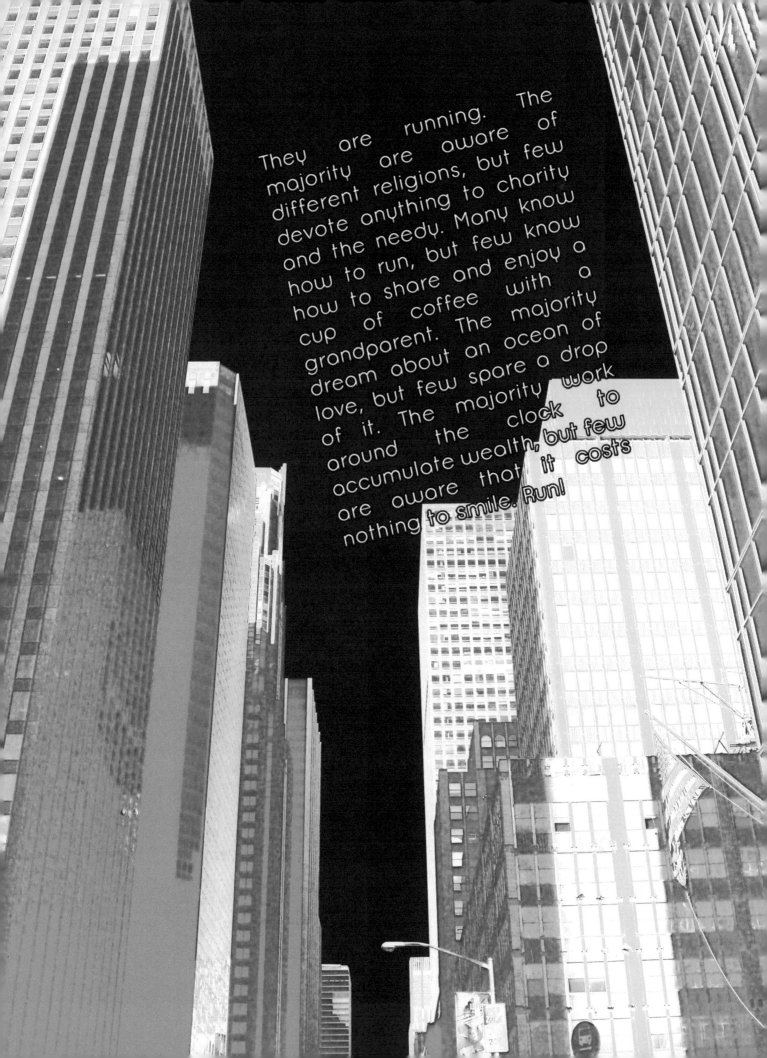

They are running. The majority are aware of different religions, but few devote anything to charity and the needy. Many know how to run, but few know how to share and enjoy a cup of coffee with a grandparent. The majority dream about an ocean of love, but few spare a drop of it. The majority work around the clock to accumulate wealth, but few are aware that it costs nothing to smile. Run!

Dance with me to the sounds of the New Yorker and the summer winds. Dance with me to the sounds of workers from different nationalities busy constructing buildings of millions of bricks. Dance with me to the sounds of New Yorkers' shoes of many shapes and forms racing against time.

Táncoljon velem a New York-i származású csodálatos ötletek és reflexiók kórusáig.

Dance with me to the echo of iron and rail of 28 trains in the subways of NY.

Dance with me to the chorus of marvelous ideas and reflections that come from New Yorkers.

Dance with me to the constant shrill of little squirrels, roaming happily in Central Park. Dance with me to the notes that fly through the air, entrapping me and taking me closer to that talented saxophonist: the one with humility who sings his songs in the underground. Dance with me to the beautiful sound of the pages of a book a commuter reads enthusiastically, sitting on the floor of Grand Central Station, waiting for a train.

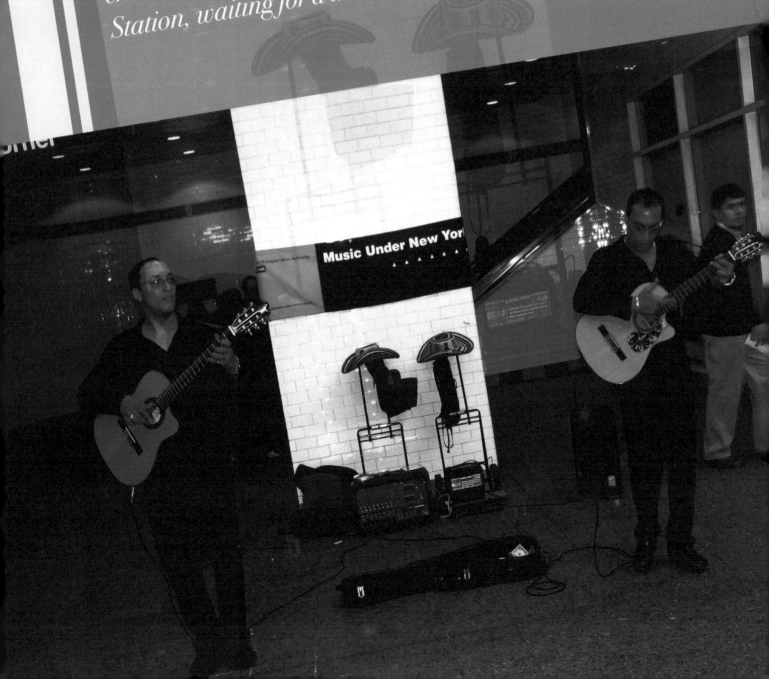

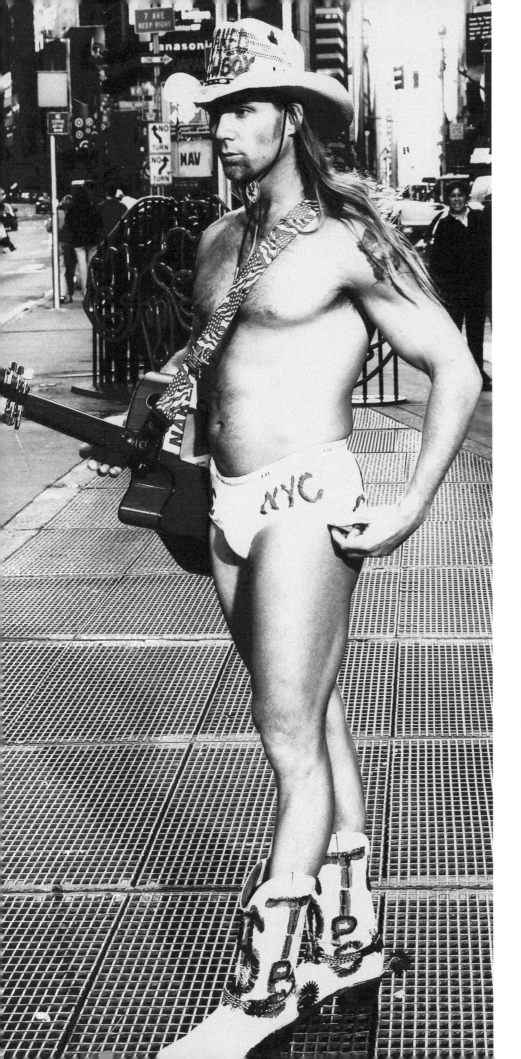

Dance with me to the cowboy's original song, nude in Times Square, who takes pictures with men and women of the world to survive in the city that gives birth to better ideas and better things. Dance with me to the flapping of flags bearing stars and stripes hanging from many buildings, reminding us that we are in the city where everything is possible. Dance with me to the sound of a businessman getting his shoes shined.

Dance with me all you
Irish, Puerto Ricans,
Mexicans, Haitians,
Chinese, English,
Afghans, Brazilians,
Indians, French,
Africans, Spaniards,
Canadians, Jews,
Protestants,
Argentinians, or you
Germans, and come on
you too, Vietnamese,
and you too, wherever
you are from! Tell
the world that we
accept each other for
what we are; here we
are, all New Yorkers,
almost
brothers...bullshit!

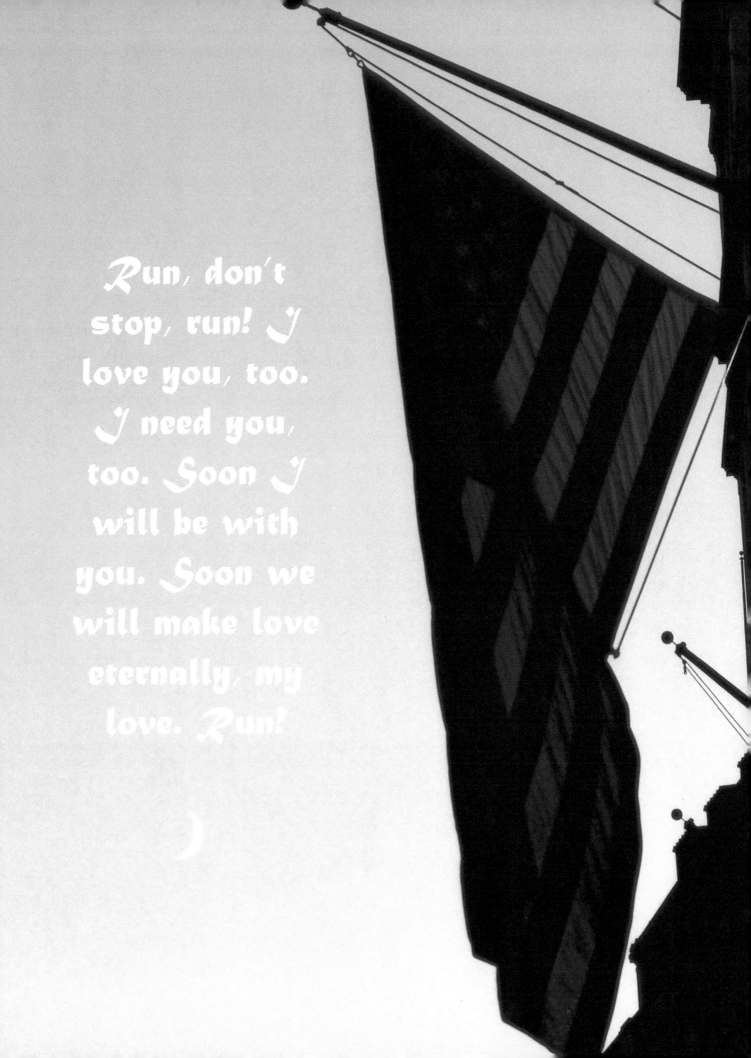

Run, don't
stop, run! I
love you, too.
I need you,
too. Soon I
will be with
you. Soon we
will make love
eternally, my
love. Run!

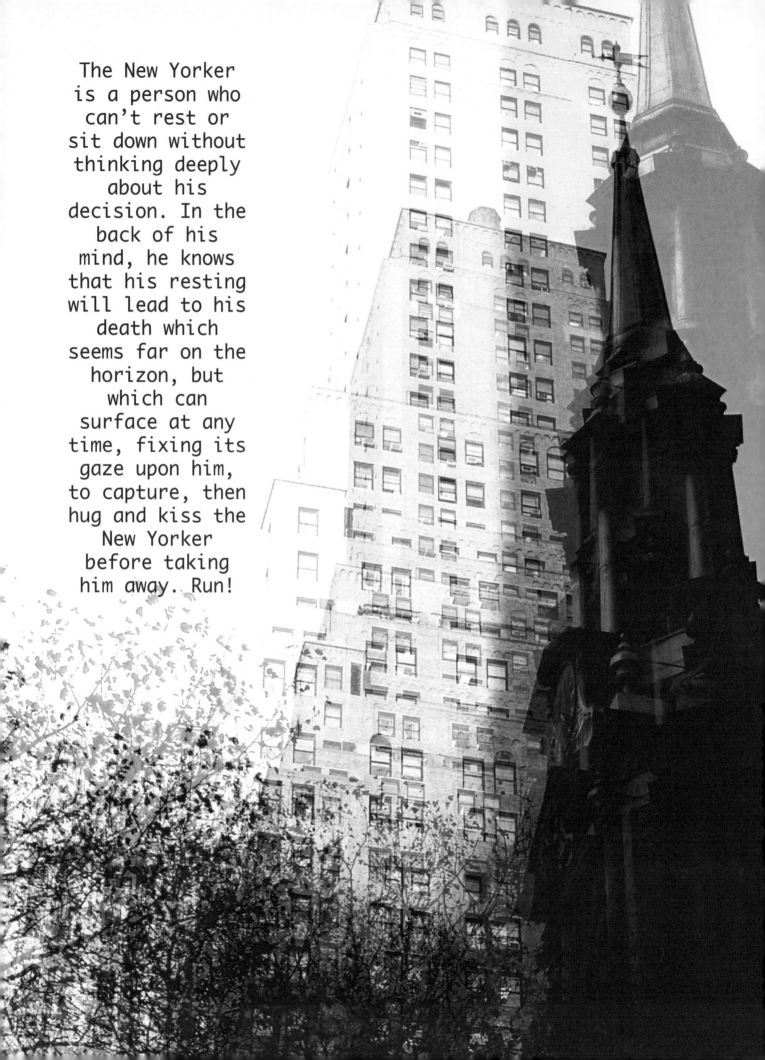

The New Yorker
is a person who
can't rest or
sit down without
thinking deeply
about his
decision. In the
back of his
mind, he knows
that his resting
will lead to his
death which
seems far on the
horizon, but
which can
surface at any
time, fixing its
gaze upon him,
to capture, then
hug and kiss the
New Yorker
before taking
him away. Run!

Life is rarely what we want it to be; life is simply what it is: hard, easy, complex, simple, treacherous, safe, unpleasant, pleasant, organized, disorganized, and more to be discussed later! Sometimes we have the capacity to provoke, consciously, frequently unconsciously, dynamics that coincide with what we dream of. It is here where we can say that coincidence has conquered our sidereal space, a moment that every New Yorker hopes to obtain, which is why he strives every second. Run!

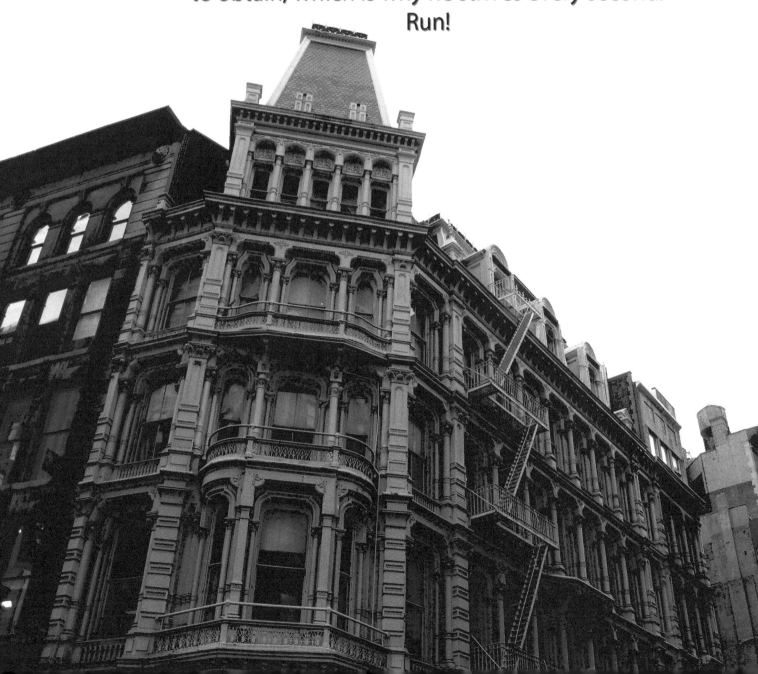

The New Yorker constantly
defies his destiny in search of
great action. The New Yorker
faces his biggest fears. In
this city, not many people make
good decisions, but everyone
looks for a way to abandon a
mundane lifestyle. The New
Yorker always wants to do great
things to feel satisfied. The
New Yorker has to be seen as a
one-of-a-kind individual who
moves fast and cannot go any
slower. Run!

The New Yorker is admirable, for to achieve the impossible, he will do the impossible.

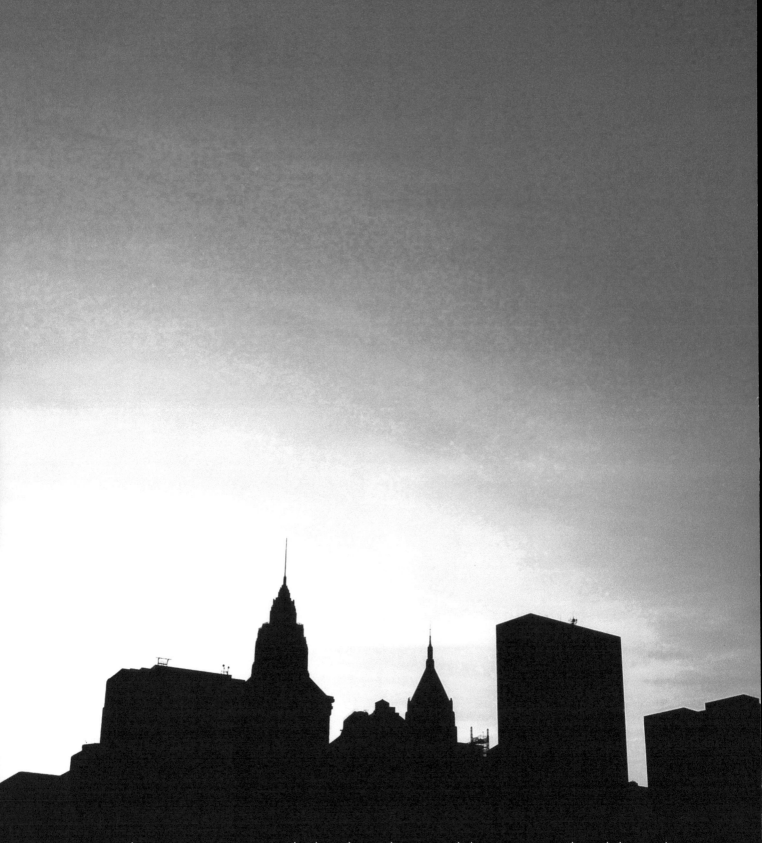

It is known in New York that he who would conquer should apply the theory of action, the theory of risk. The New Yorker is a crazy, pragmatic individual who knows that action is required for a theory to become a solution. This is why he is constantly acting...in his movie.

Vi flyver som to fugle. Ligesom de to fugle, der har spist vores kroppe hurtigt uden at vi ikke kan mærke det, min kærlighed.

We will fly like two birds. Like those two birds which have eaten our bodies rapidly without us not being able to notice it, my love.

How much more time will it take? Day and night ask.
How much more time will it take? My mother and your mother ask.
How much more time will it take? Love and hate ask.
How much more time will it take? Music and philosophy ask.
How much more time will it take? God and Satan ask.
How much more time will it take? My demons and your demons ask.
How much more time will it take? We do not understand anything.

No love, not here. Soon we will arrive at the place of our dreams. Run! There is nothing to be afraid of here, much fewer men--not here or anywhere in the world. Everyone has an Achilles heel, and no one is invincible. Run!

In New York, the diversity and obstacles life brings are sometimes bitter, confusing, and difficult. In New York, these problems, presented throughout this crazy marathon, generate the driving force behind this "meta-life" of east-coast lifestyle.

If there is one thing the New Yorker fears, it is to lose himself in the fight of achieving a goal and for destiny to punish him with the worst misfortune: becoming a slave to another. Adversities are evident in this city, where every second these problems challenge the New Yorker's character and determination. But these obstacles create intellectual beings full of energy, perseverance, strength, and bravery due to their lifestyles: agitated and intensely cosmic.

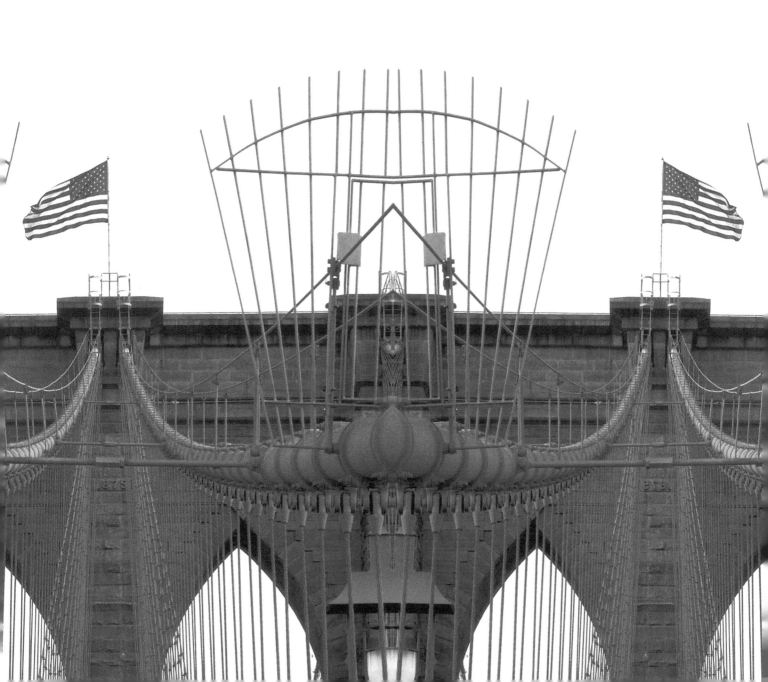

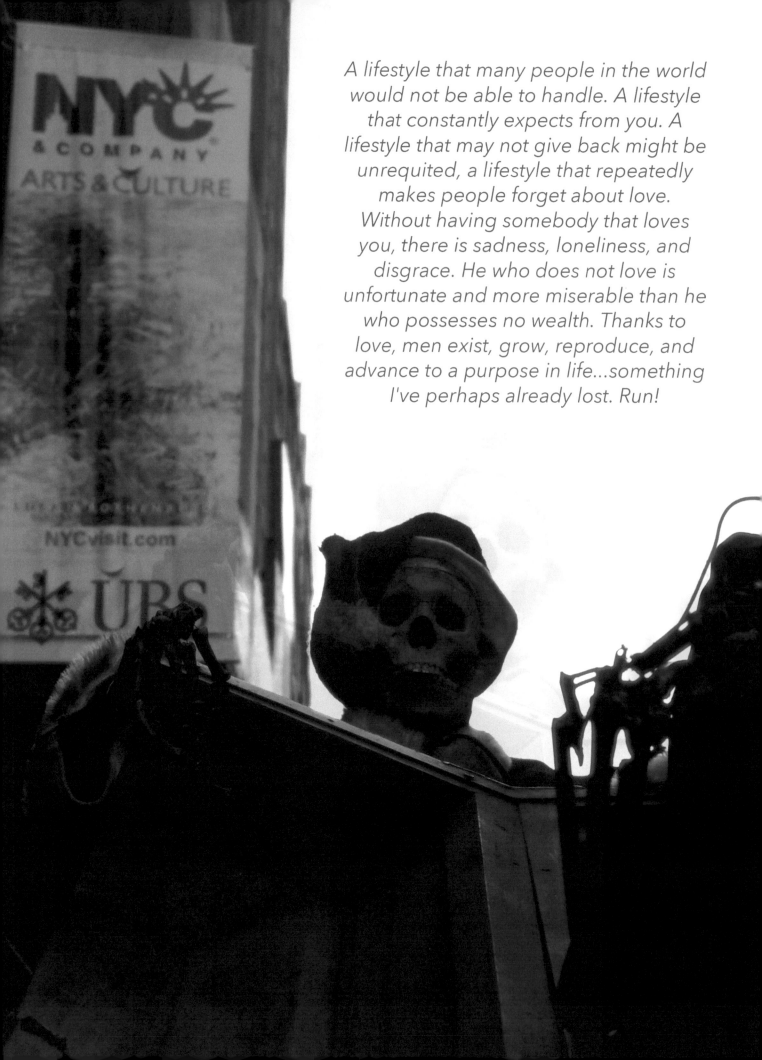

A lifestyle that many people in the world would not be able to handle. A lifestyle that constantly expects from you. A lifestyle that may not give back might be unrequited, a lifestyle that repeatedly makes people forget about love. Without having somebody that loves you, there is sadness, loneliness, and disgrace. He who does not love is unfortunate and more miserable than he who possesses no wealth. Thanks to love, men exist, grow, reproduce, and advance to a purpose in life...something I've perhaps already lost. Run!

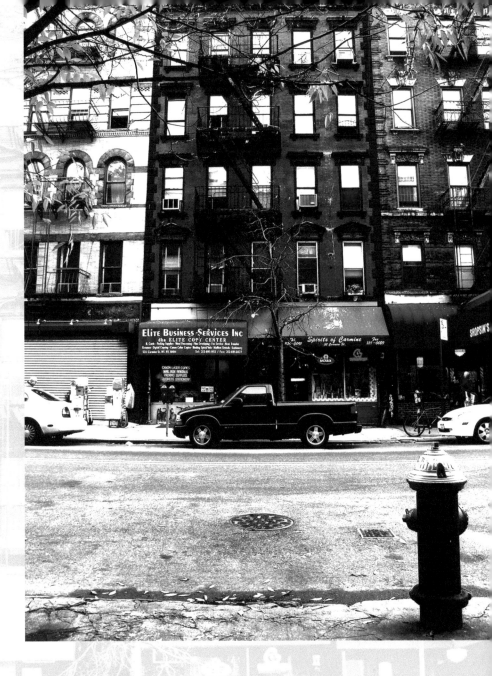

自殺,

my friend today, free me from this hell.
Free me from these walls and streets, from my enemies today.
Free me from pain, shame, and suffering.
Free me from each memory that Time stabs in my heart.
Free me from this pressure that is killing me, that I have entered.
Free me from a sad past, from my complicated present.
Free me from these demons that drive me mad.
Free me from every step I take, from everything I am sacrificing.
Free me from the murders of my dreams.
Suicide, my friend, free me from this hell. I want to be on your side.

Suicide

New Yorker! You know, as I know, to dominate the world, you must first dominate your heart. New Yorker! You know, as I know, every objective brings sacrifice and pain. New Yorker! You know, as I know, to obtain something long-lasting, you must sacrifice many pleasures, even some essential ones. New Yorker! As I know, you know that we need patience, perseverance, concentration, and faith to touch the top. Even then, this will not guarantee success or happiness. New Yorker! You know, as I know, working excessively will not always give us what we want. New Yorker! As I know, life is not fair to those who are fair, even with the unjust. New Yorker! You know, as I know, we have already lost half of our freedom, half of our soul. New Yorker! You know, as I know, as much as music heals our soul, the constant noise from the city will be our unbalance. New Yorker! You know, as I know, having everything will not make you happy--we are always unsatisfied animals. New Yorker! You know, as I know, that even if you obtain your grandest dreams, you will lose everything when death kisses your hand and consumes you.

New Yorker! You know, as I know, today we win, and tomorrow we lose, or vice-versa. Run! Stop talking. Run! One second is enough in New York for one to become a poet. One second is enough in New York for the strongest human feelings to sprout. One second is enough for the love that we feel towards New York to become a ghost: everyone comments on its existence, but no one really knows New York.

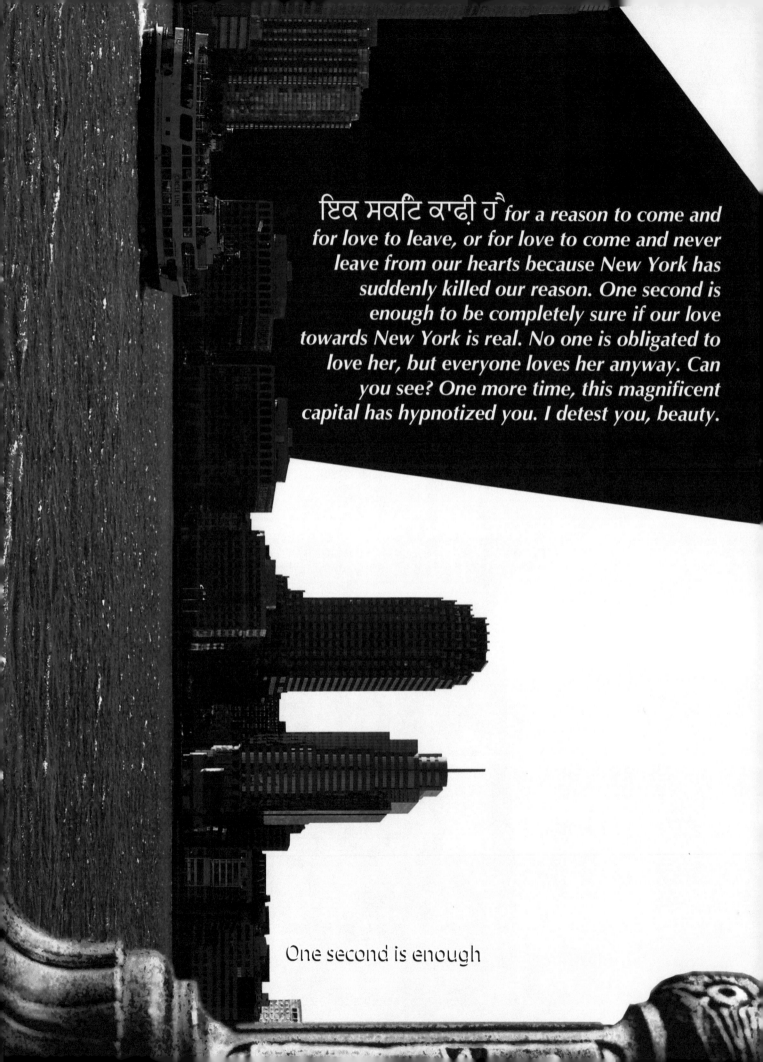

ਇਕ ਸਕਿੰਟ ਕਾਫ਼ੀ ਹੈ *for a reason to come and for love to leave, or for love to come and never leave from our hearts because New York has suddenly killed our reason. One second is enough to be completely sure if our love towards New York is real. No one is obligated to love her, but everyone loves her anyway. Can you see? One more time, this magnificent capital has hypnotized you. I detest you, beauty.*

One second is enough

Evil, why did you embrace her at the
moment I needed her most?
Evil, why steal her from her last
dance on 43 Madison Ave.?
Evil, why did you embrace her at the
moment I needed her most?
Evil, why did you not let me see, for
the last time, the Statue of
Liberty's reflection in her beautiful
blue eyes?
Evil, why have you decided today to
take her by the hand and lead her
away from me while she is still so
young?
Evil, why did you embrace her? You
know she needed more time to get to
know this city.
Evil, who could have imagined that
her heart full of love would blow
into pieces?
Evil, why did you take away the
person who made me forget my
miserable past?
Evil, prepare yourself. In a few
minutes, I will be in your arms.

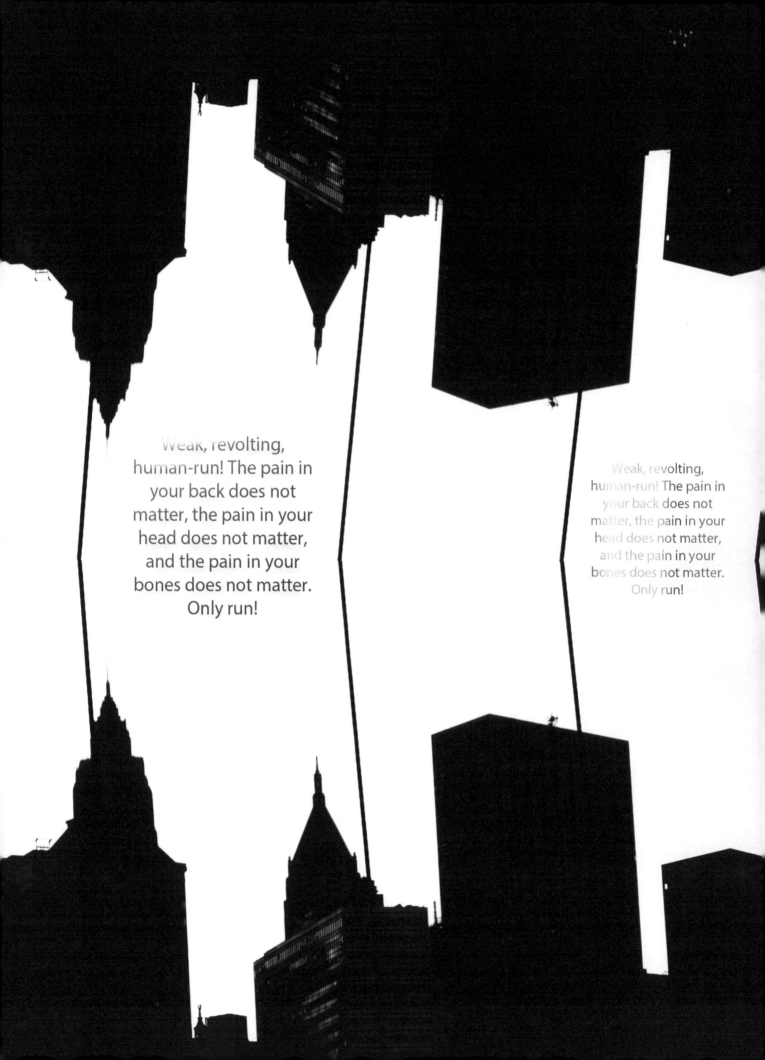

Weak, revolting, human-run! The pain in your back does not matter, the pain in your head does not matter, and the pain in your bones does not matter. Only run!

Weak, revolting, human-run! The pain in your back does not matter, the pain in your head does not matter, and the pain in your bones does not matter. Only run!

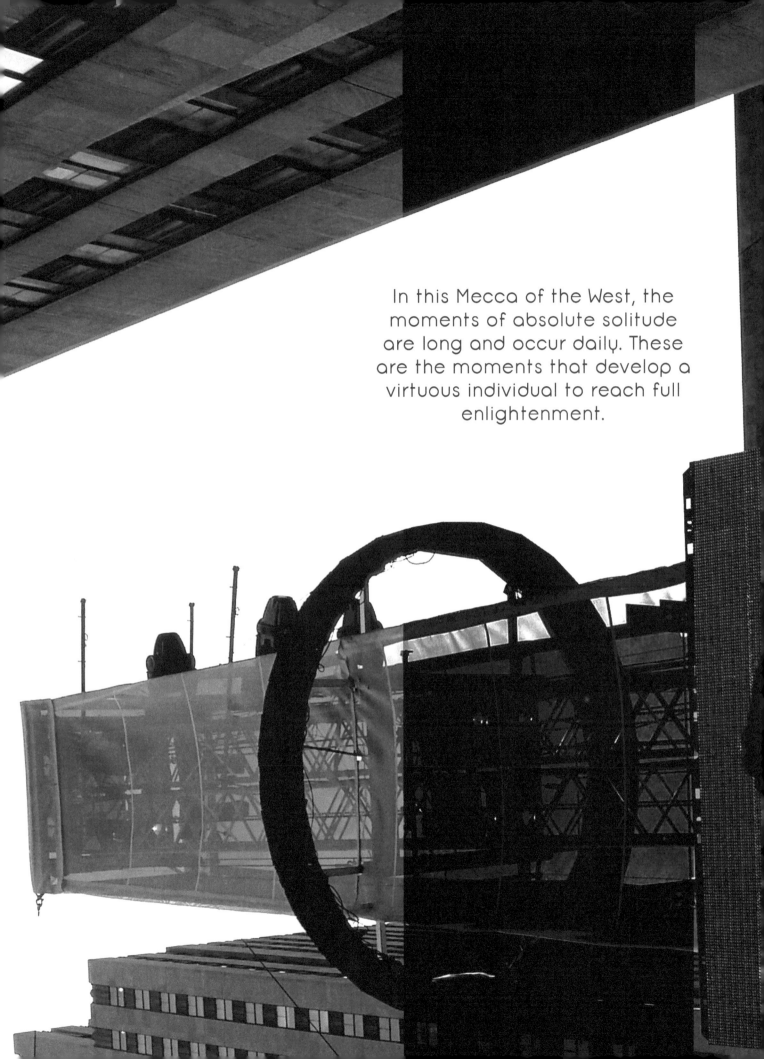

In this Mecca of the West, the moments of absolute solitude are long and occur daily. These are the moments that develop a virtuous individual to reach full enlightenment.

BROADWAY

At the same time, these individuals are constantly confronted by a complex and difficult capital full of people from around the world, full of universal talents. This unending, noiseless fight against you and a world in chaos produces a character as surprising as it is inexplicable. This blend of constant solitude and direct combat with a world full of labyrinths, many of them dangerous, has created strong, daring, intelligent, passionate, and risk-taking individuals in this fantastic city at the border...

ONE WAY

ONE WAY

BROADWAY

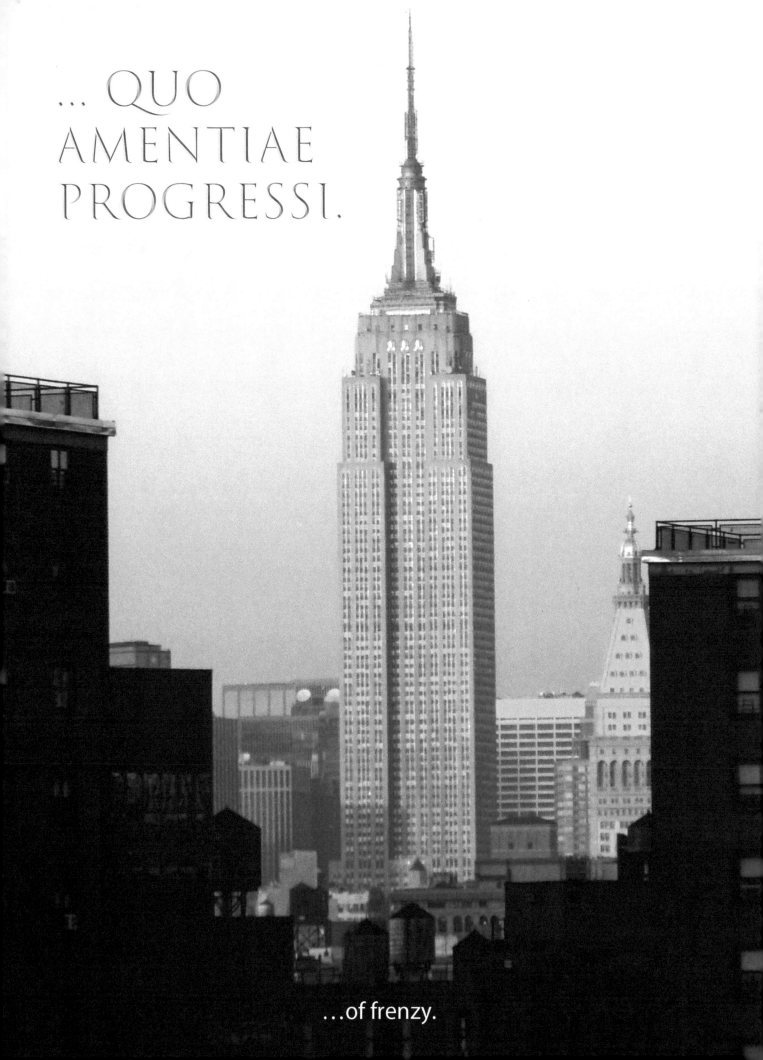

... QUO
AMENTIAE
PROGRESSI.

...of frenzy.

The Artist

from New York contemplates how beautiful and perfect this city is day and night. This city is known for its pleasures and its perversities. Her spirit penetrates the deepest parts of the city, discovering a soul which can speak and tell the marvels that make her Queen of the Mother Souls. When they become famous, the city's nomads can sell their creations for prices only the privileged can afford. It is obvious for these people: the road to success is full of fire, welcome to hell! Run. The true New York artist is one who, without the glory, makes himself known with all humbleness and talent. He immortalizes the heads, hearts, and spirits of those men who love him and respect him and will remember him for eternity. In contrast, the city contains too false artists who will live limited and are conditioned to create artwork with an expiration date.

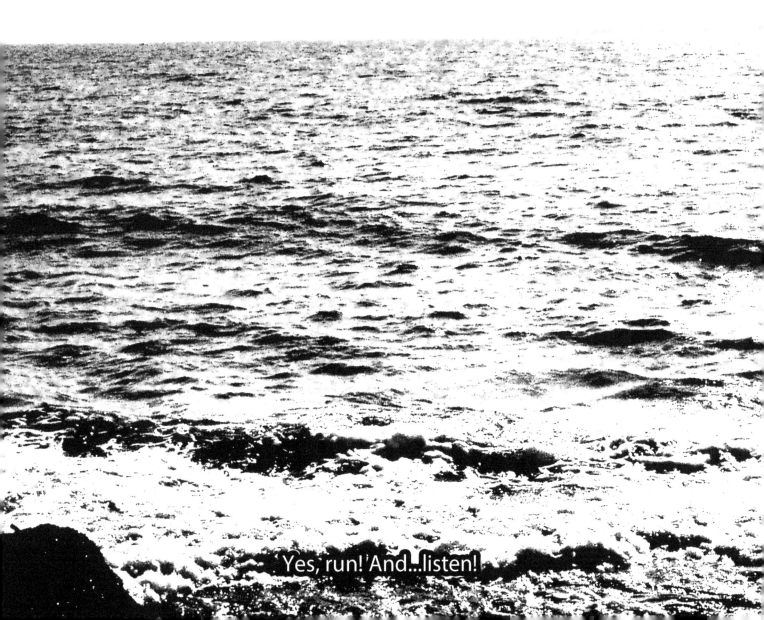

Ja, ren! En luister!

Yes, run!'And...listen!

The New Yorker is a person who does not speak freely of his pains and anguishes. In the deepest part of his being, he knows that if he thinks about how difficult it is to live in the real and the false capital, he will lose his balance. The New Yorker is a person who loves to talk to people who know how to express their ideas intelligently and who know how to listen.

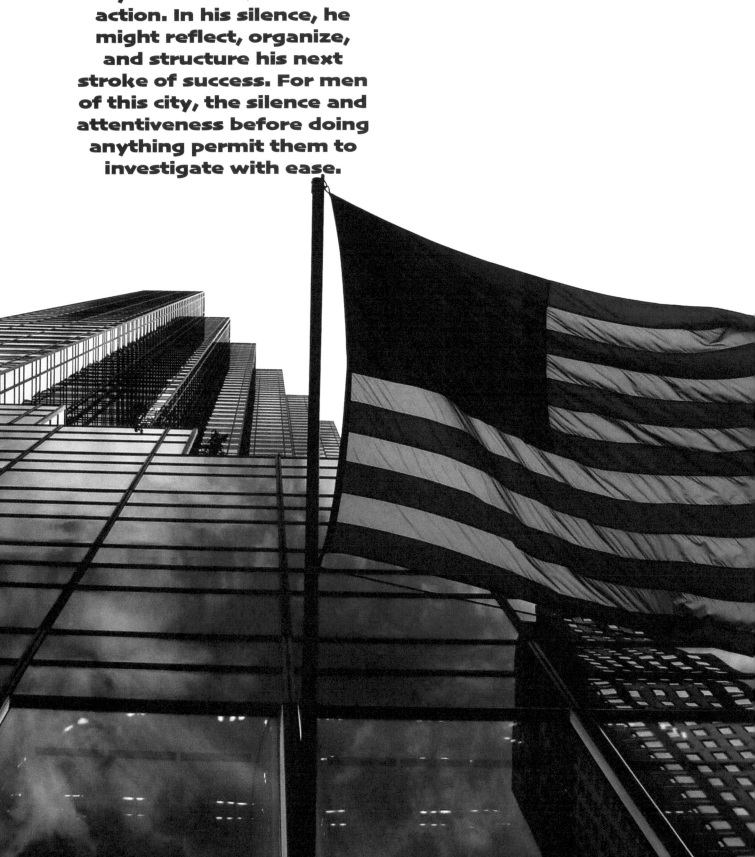

It is difficult to find a New Yorker who speaks nonsense. What makes a New Yorker unique is their way of less talk and more action. In his silence, he might reflect, organize, and structure his next stroke of success. For men of this city, the silence and attentiveness before doing anything permit them to investigate with ease.

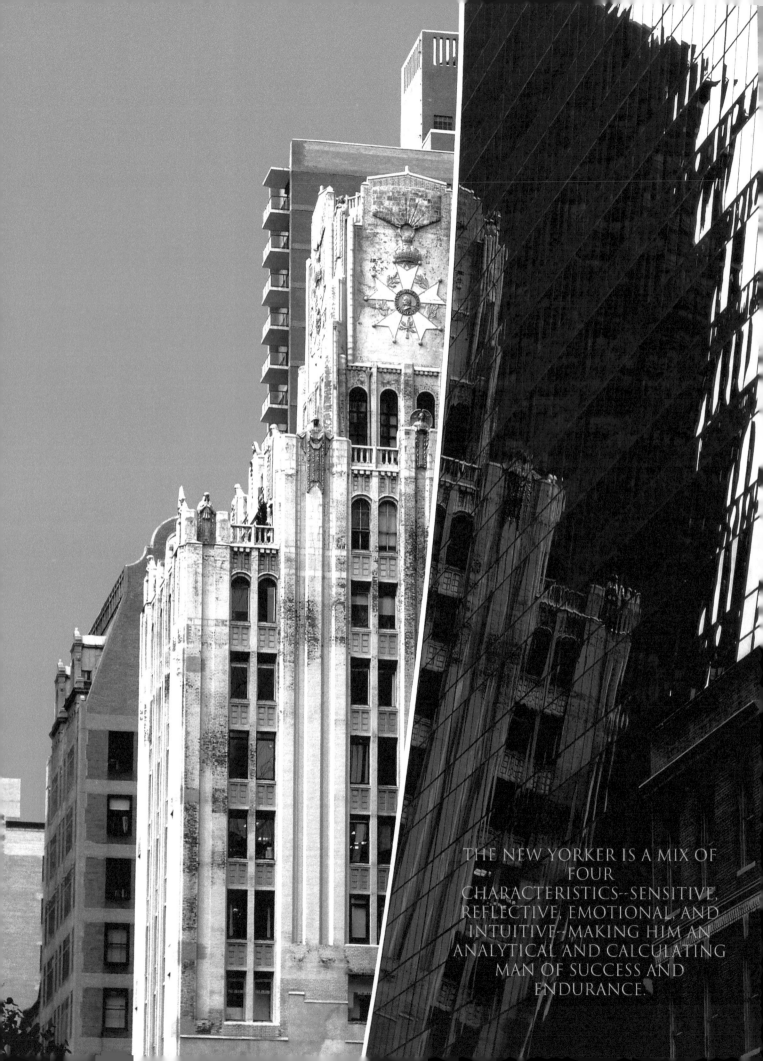

THE NEW YORKER IS A MIX OF FOUR CHARACTERISTICS--SENSITIVE, REFLECTIVE, EMOTIONAL, AND INTUITIVE--MAKING HIM AN ANALYTICAL AND CALCULATING MAN OF SUCCESS AND ENDURANCE.

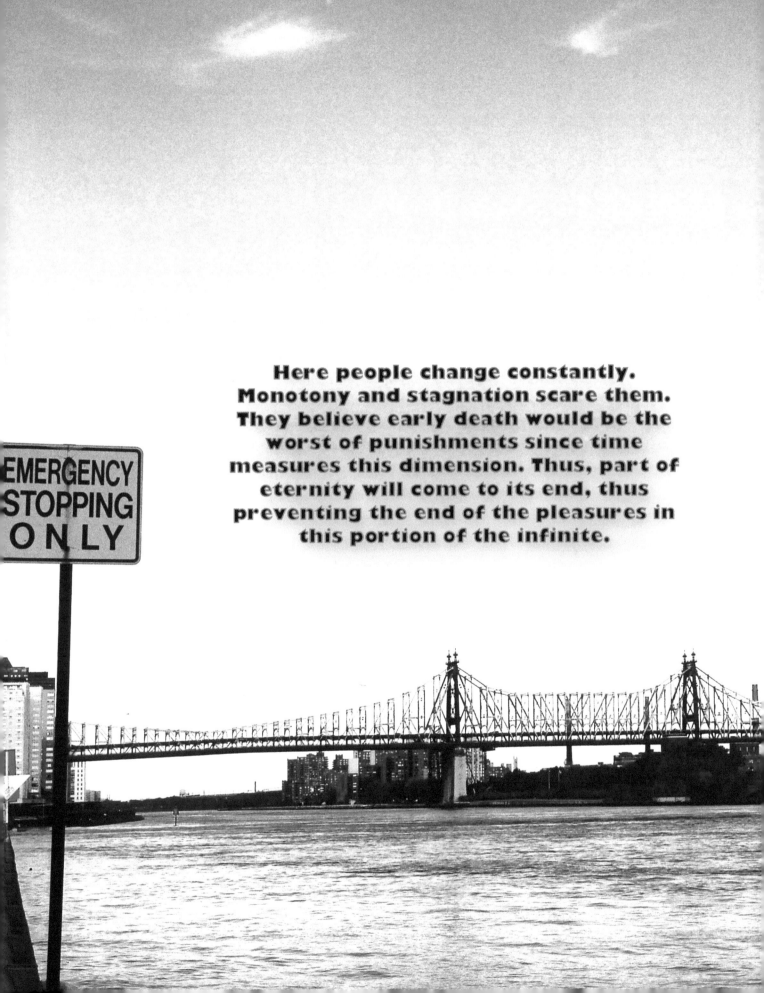

Here people change constantly.
Monotony and stagnation scare them.
They believe early death would be the
worst of punishments since time
measures this dimension. Thus, part of
eternity will come to its end, thus
preventing the end of the pleasures in
this portion of the infinite.

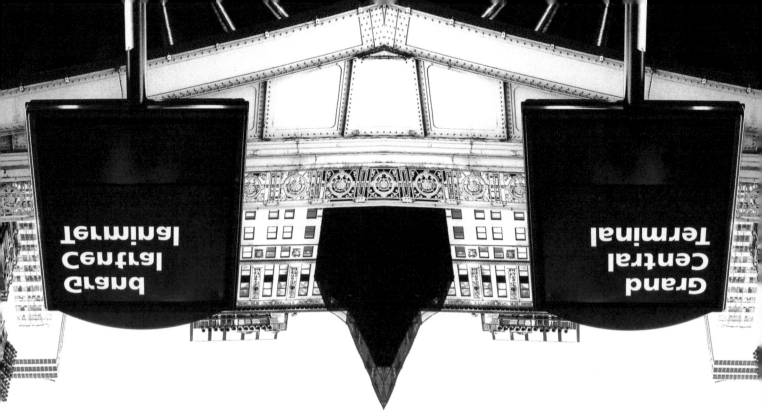

Run! Your last pleasure is found at the other side of...Come on, run. Only with you, my love, earthly mutation would have been a pleasure. Too bad, it's too late. I have always arrived late...please forgive me, forgive me.

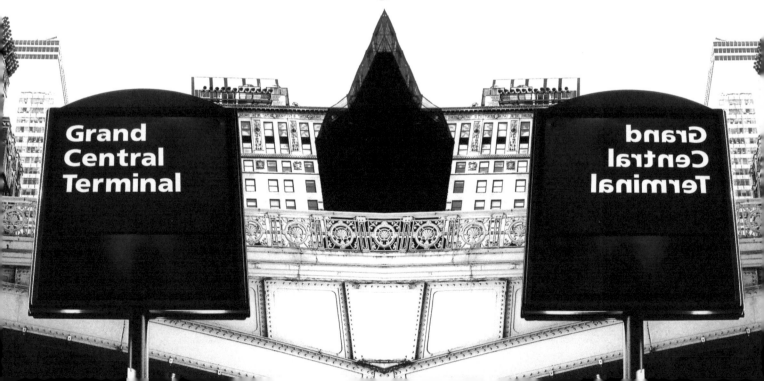

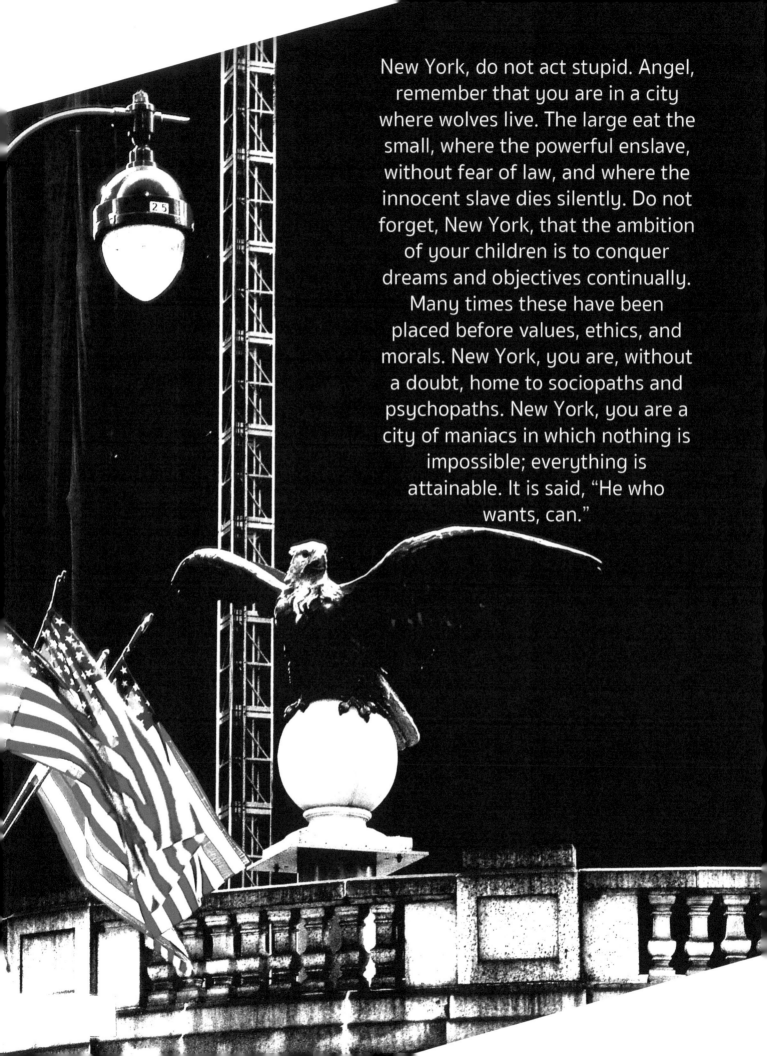

New York, do not act stupid. Angel, remember that you are in a city where wolves live. The large eat the small, where the powerful enslave, without fear of law, and where the innocent slave dies silently. Do not forget, New York, that the ambition of your children is to conquer dreams and objectives continually. Many times these have been placed before values, ethics, and morals. New York, you are, without a doubt, home to sociopaths and psychopaths. New York, you are a city of maniacs in which nothing is impossible; everything is attainable. It is said, "He who wants, can."

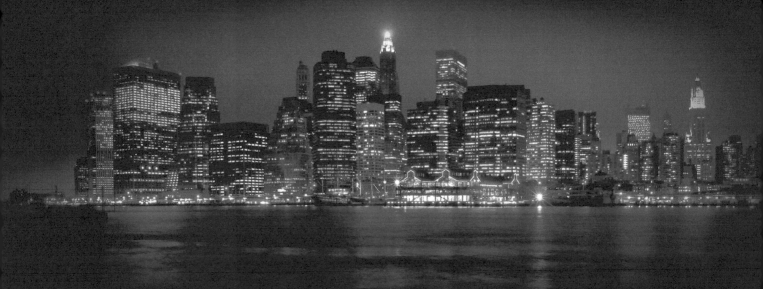

New York, where nobody trusts anybody, even the dog does not trust its owner. Are you proud of this, New York? You are a city that gives the impression of raising individuals from different galaxies, sometimes unreal, romantic, and magical. New York, without a doubt, you are a city where anyone will forgive no error. In you, our lives are constantly put to the test. New York, we know you are a city that does not sleep and does not let sleep. On your mark, get set, go! Run!

My love, my life, my being, my day and night,
I want to see you.

My love, my life, my being, my sunshine and moon,
I want to kiss you.

My love, my life, my being, my past, and present,
I want to touch you.

My love, my life, my being, my peace, and my hope,
MOI JE VEUX FAIRE L'AMOUR AVEC TOI.

I want to make love with you.

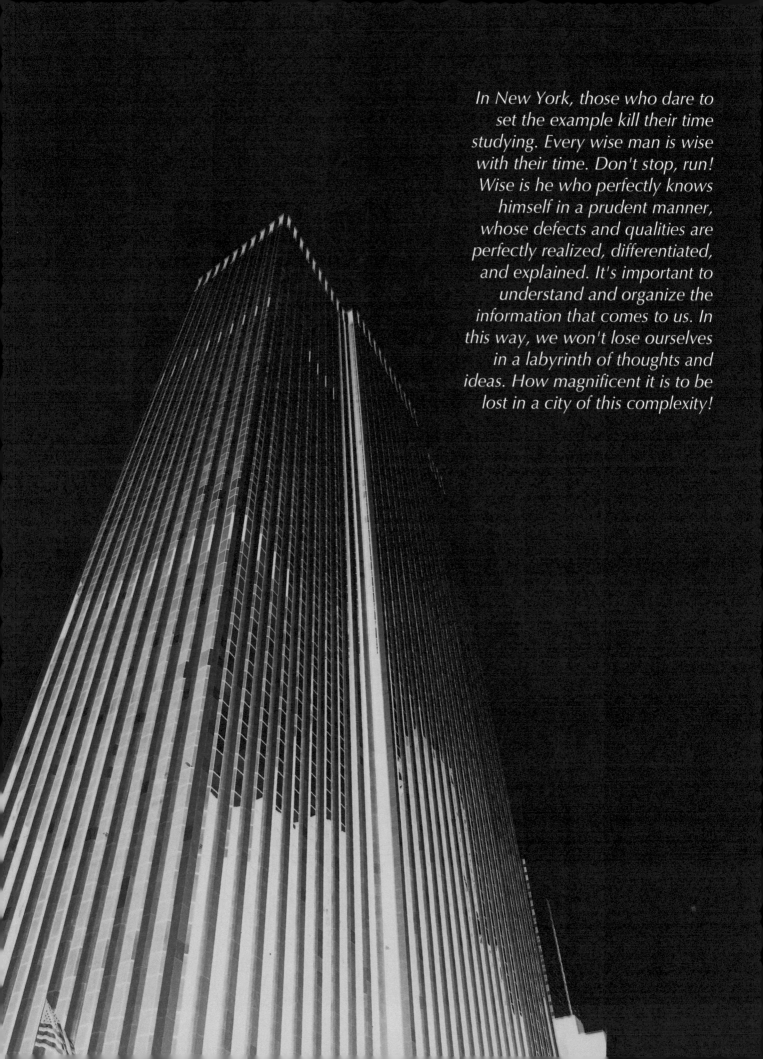

In New York, those who dare to set the example kill their time studying. Every wise man is wise with their time. Don't stop, run! Wise is he who perfectly knows himself in a prudent manner, whose defects and qualities are perfectly realized, differentiated, and explained. It's important to understand and organize the information that comes to us. In this way, we won't lose ourselves in a labyrinth of thoughts and ideas. How magnificent it is to be lost in a city of this complexity!

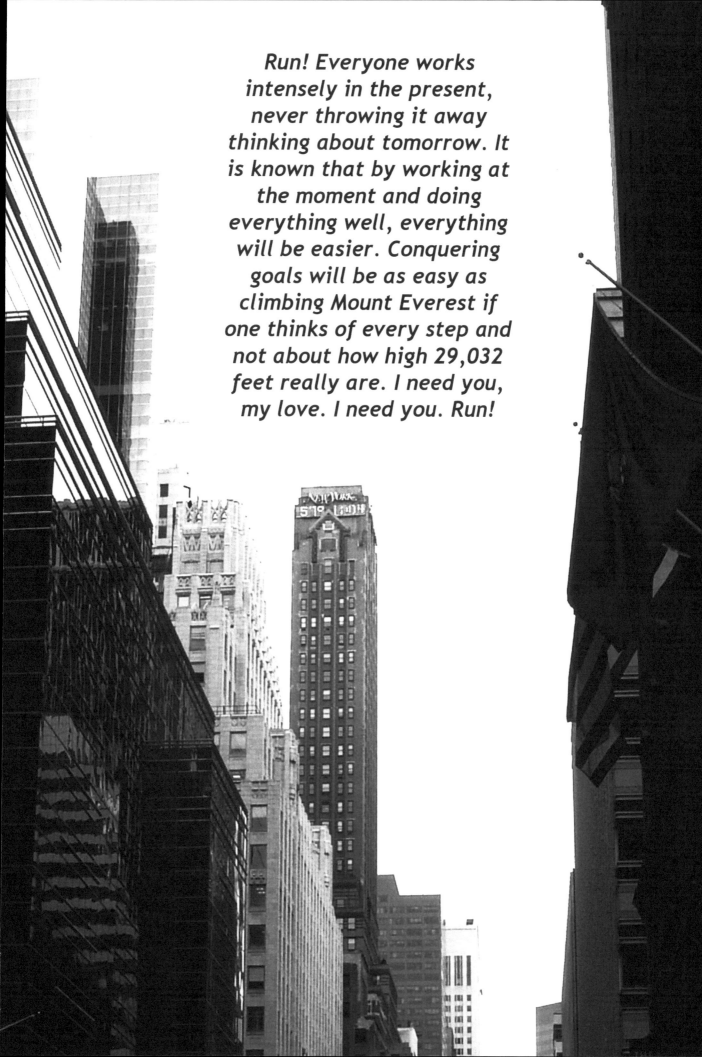

Run! Everyone works intensely in the present, never throwing it away thinking about tomorrow. It is known that by working at the moment and doing everything well, everything will be easier. Conquering goals will be as easy as climbing Mount Everest if one thinks of every step and not about how high 29,032 feet really are. I need you, my love. I need you. Run!

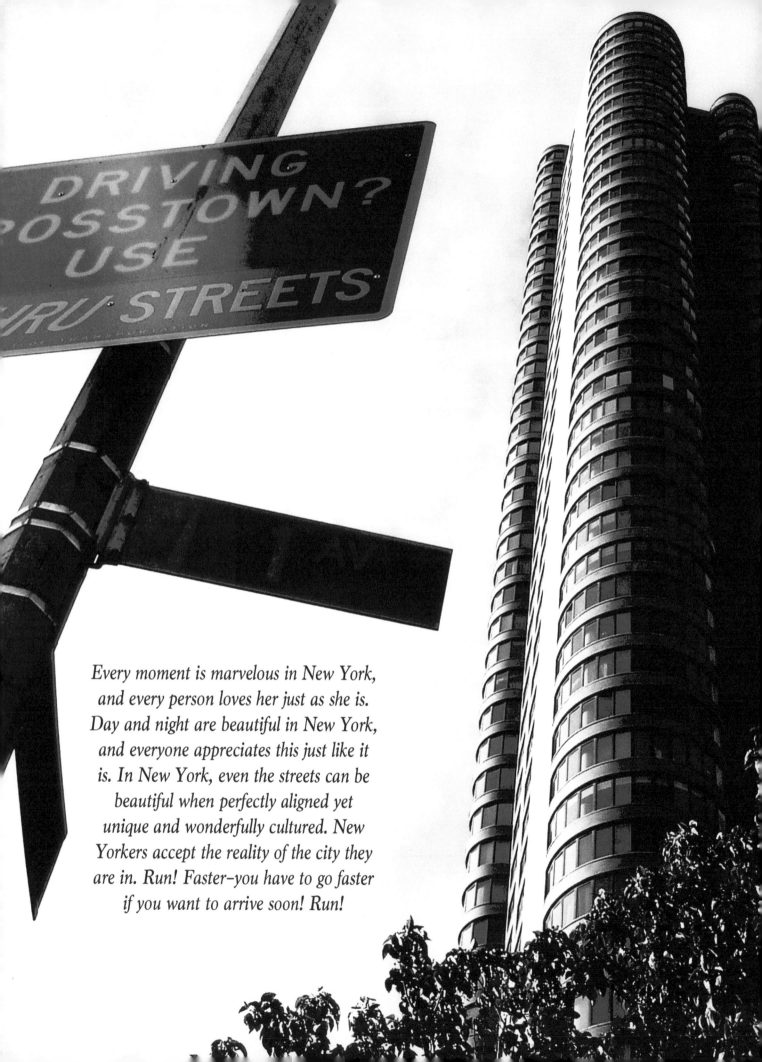

DRIVING
OSSTOWN?
USE
RU STREETS

Every moment is marvelous in New York, and every person loves her just as she is. Day and night are beautiful in New York, and everyone appreciates this just like it is. In New York, even the streets can be beautiful when perfectly aligned yet unique and wonderfully cultured. New Yorkers accept the reality of the city they are in. Run! Faster–you have to go faster if you want to arrive soon! Run!

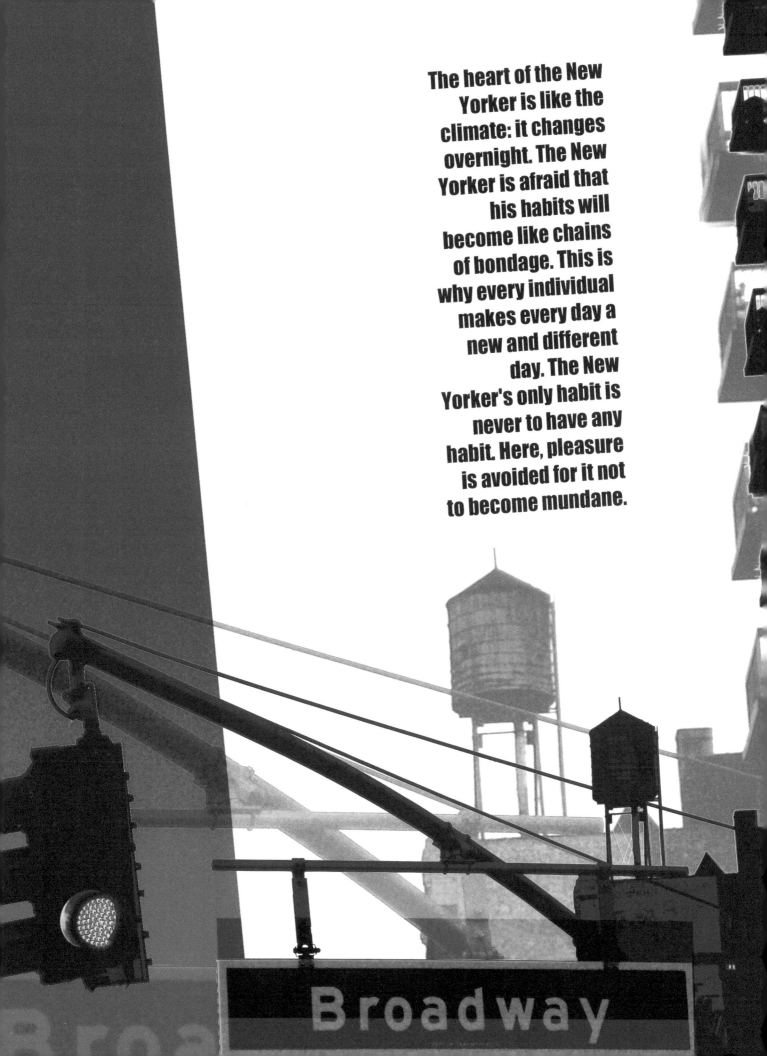

The heart of the New Yorker is like the climate: it changes overnight. The New Yorker is afraid that his habits will become like chains of bondage. This is why every individual makes every day a new and different day. The New Yorker's only habit is never to have any habit. Here, pleasure is avoided for it not to become mundane.

Broadway

Yes, run! The pain in your chest does not matter. The pain in your soul does not matter, no-it does not matter! Soon everything will turn to dust; soon, everything will start again.

Oui, la décadence.

GOD BLESS AMERICA

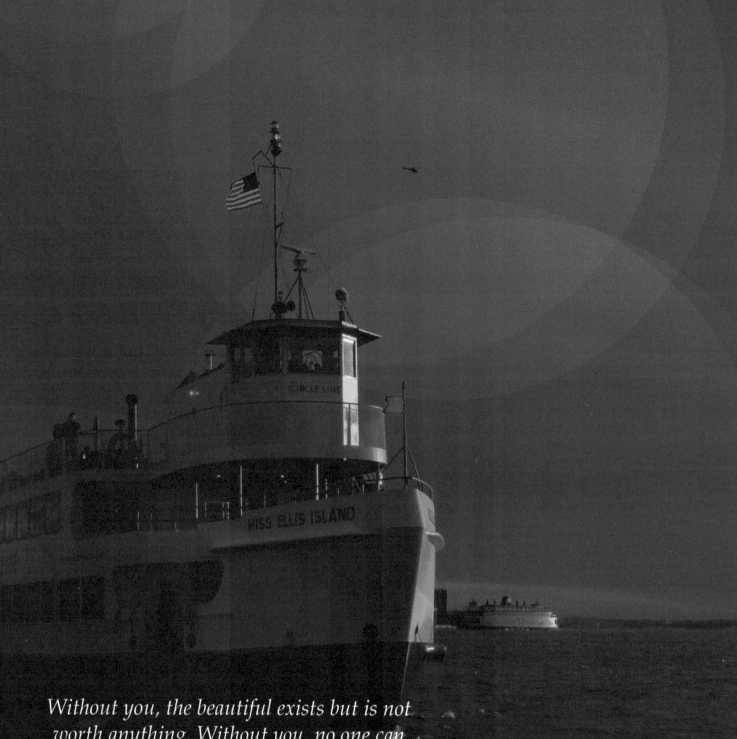

Without you, the beautiful exists but is not worth anything. Without you, no one can realize his destiny; no one can tolerate it. We should not forget that our destiny has already been written, and as much as we would like to avoid it, we cannot. We only have one choice, and that is our destiny. There is no free will. You are an ant dude! Run!

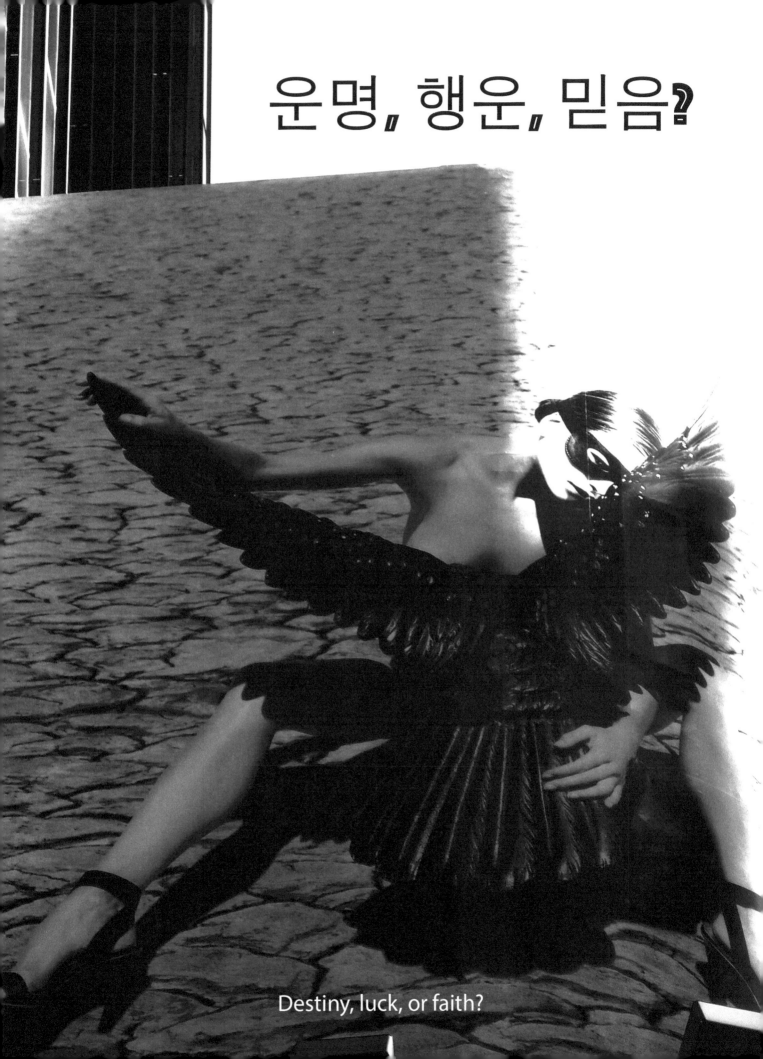

운명, 행운, 믿음?

Destiny, luck, or faith?

New Yorker, are we obligated to walk the path that has been assigned to us? My death is my path to salvation. This is my destiny, and sooner or later, it will be yours too. Run!

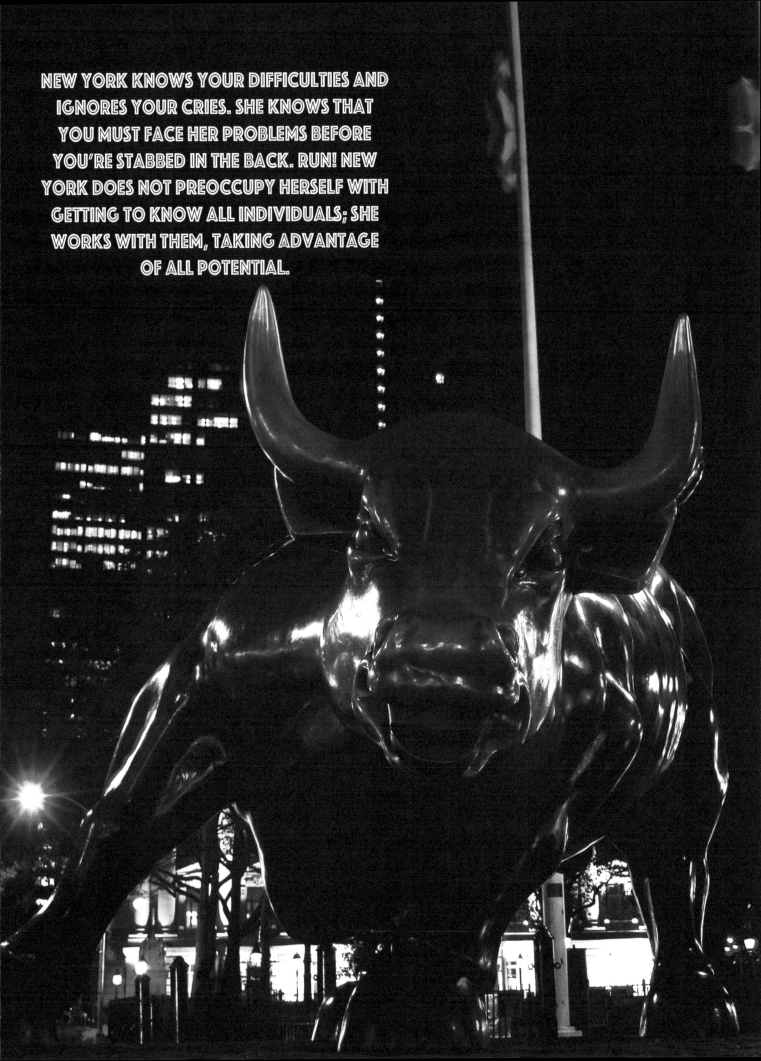

NEW YORK KNOWS YOUR DIFFICULTIES AND IGNORES YOUR CRIES. SHE KNOWS THAT YOU MUST FACE HER PROBLEMS BEFORE YOU'RE STABBED IN THE BACK. RUN! NEW YORK DOES NOT PREOCCUPY HERSELF WITH GETTING TO KNOW ALL INDIVIDUALS; SHE WORKS WITH THEM, TAKING ADVANTAGE OF ALL POTENTIAL.

Getting to know a man is like getting to know God—you will never truly know him. This is why people accept or ignore their fellow men. In this city, the New Yorker is not afraid of demonstrating his infinite capacities. He is a visionary. Before the problem arrives, he prepares the solution. The rest of the world mistakenly thinks the impossible exists. This is why the city of New York advances day-by-day, always unattainable.

IL DOLORE AI TUOI PIEDI NON HA IMPORTANZA, IL DOLORE ALLE ARTICOLAZIONI NON IMPORTA, IL DOLORE ALL'ADDOME NON IMPORTA ... L'ACQUA!

The pain in your feet does not matter, the pain in your joints does not matter, the pain in your abdomen does not matter... *water!*

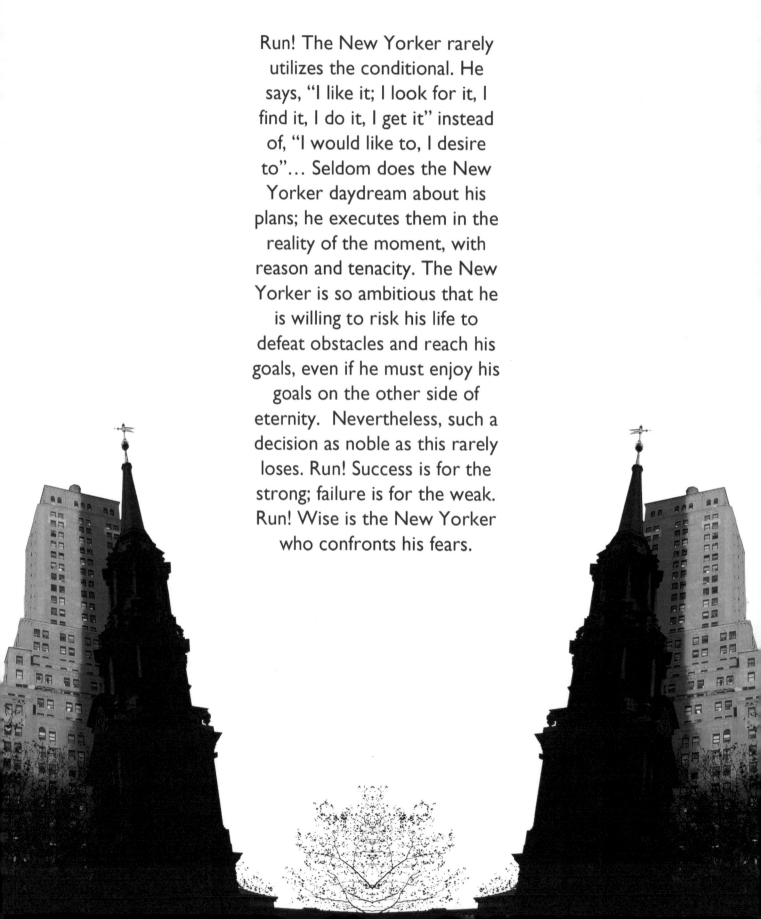

Run! The New Yorker rarely utilizes the conditional. He says, "I like it; I look for it, I find it, I do it, I get it" instead of, "I would like to, I desire to"… Seldom does the New Yorker daydream about his plans; he executes them in the reality of the moment, with reason and tenacity. The New Yorker is so ambitious that he is willing to risk his life to defeat obstacles and reach his goals, even if he must enjoy his goals on the other side of eternity. Nevertheless, such a decision as noble as this rarely loses. Run! Success is for the strong; failure is for the weak. Run! Wise is the New Yorker who confronts his fears.

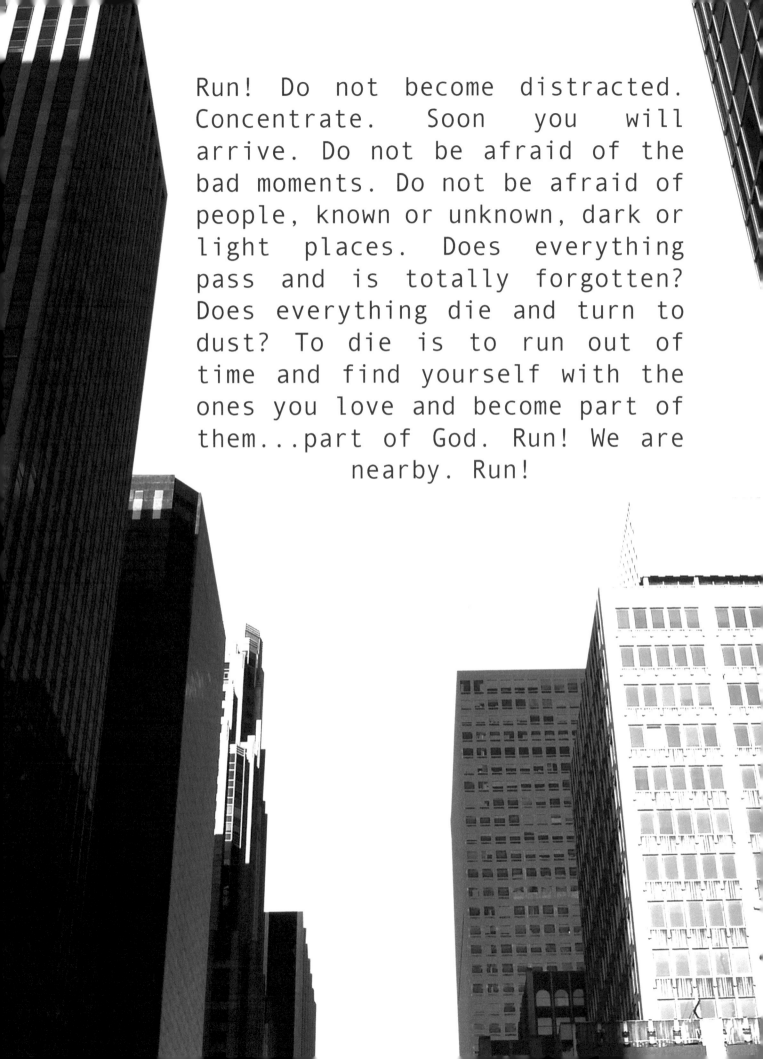

Run! Do not become distracted. Concentrate. Soon you will arrive. Do not be afraid of the bad moments. Do not be afraid of people, known or unknown, dark or light places. Does everything pass and is totally forgotten? Does everything die and turn to dust? To die is to run out of time and find yourself with the ones you love and become part of them...part of God. Run! We are nearby. Run!

The more life hits you, the more experience you will have. The more obstacles you overcome, the more experience you will have. The more disillusions you encounter, the more experience you will have. The better your memory, the more experience you can draw from. Experience is the result of what you are in the immediate present. It is thanks to the experience that you can look at the world from different points of view, without prejudice, without ignorance, with an open mind.

I hope you have taken advantage of the time life has given you. If not, you can be sure the kid you once were and the adult you have become only differentiate by a couple of wrinkles. How sad, stupid, and naive! Know the big man, full of experience, will easily uncover universal treasures, will shine day and night, and will be eternally loved.

Run! Don't stop--run. Sometimes we must go beyond reason to conquer huge goals. New Yorker! Have faith, and nothing will be denied to you. Never forget that happiness is like the horizon: constantly changing colors.

Представьте себе сумерки сегодняшнего дня.

Imagine the twilight of today.

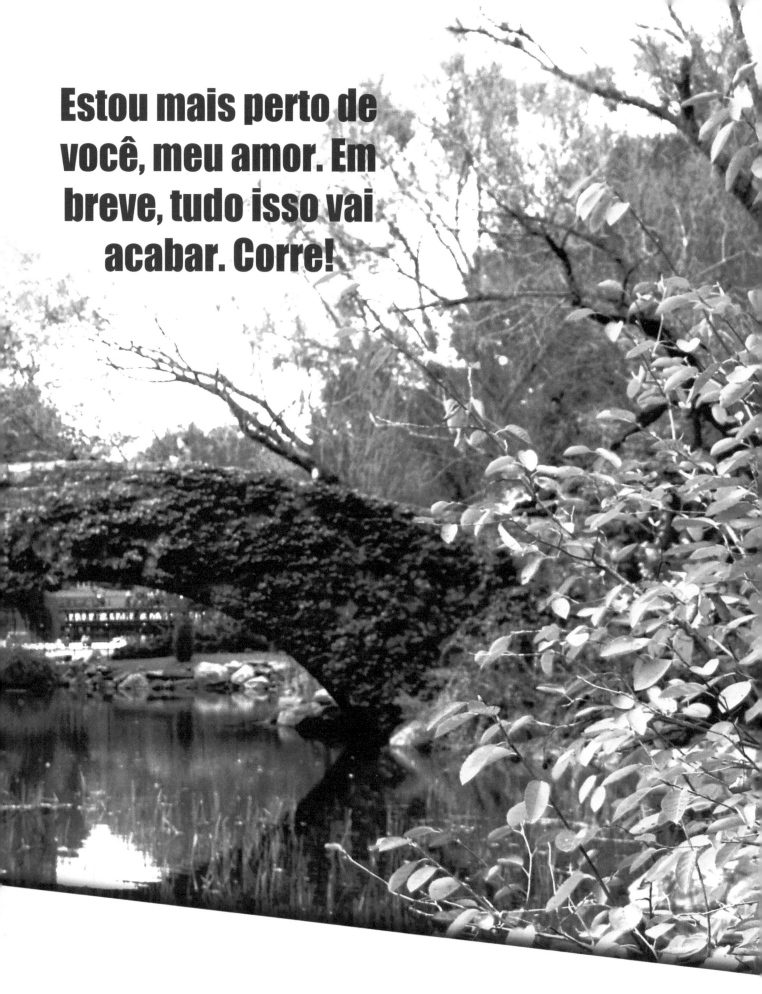

Estou mais perto de você, meu amor. Em breve, tudo isso vai acabar. Corre!

I am closer to you, my love. Soon, all this will end. Run!

Those who are violent in New York are mentally weak. Sick. Those who are violent need conflict to hold onto an idea. He who loses his sense of self is violent. He is violent when his power of attainment is lost. He is violent when he loses his reason and fills himself with lethal emotions. He is violent when he fears people will discover his fears. He who is violent wrongly exerts his tyranny upon men who ironically believe in the absolute truth: God.

Ár er krafist til að einstaklingur geti vaxið og þroskast, en annað er nóg til að hægt sé að draga það í ryk.

Years are required for an individual to grow and develop, but a second is enough to be reduced to dust.

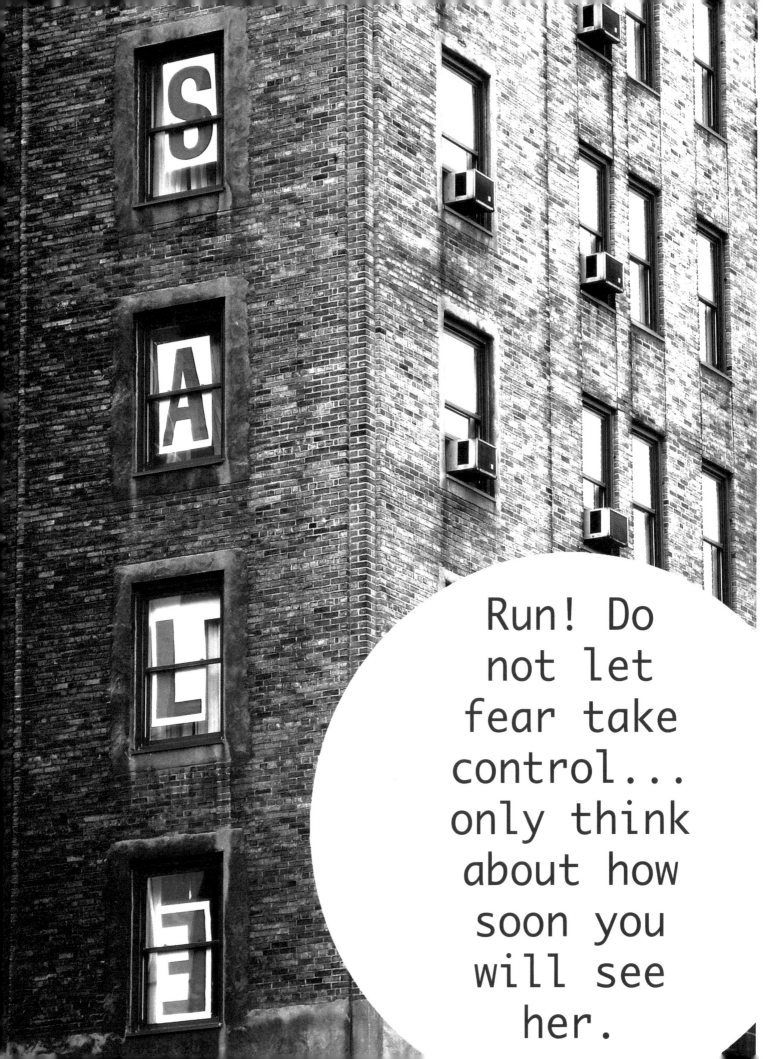

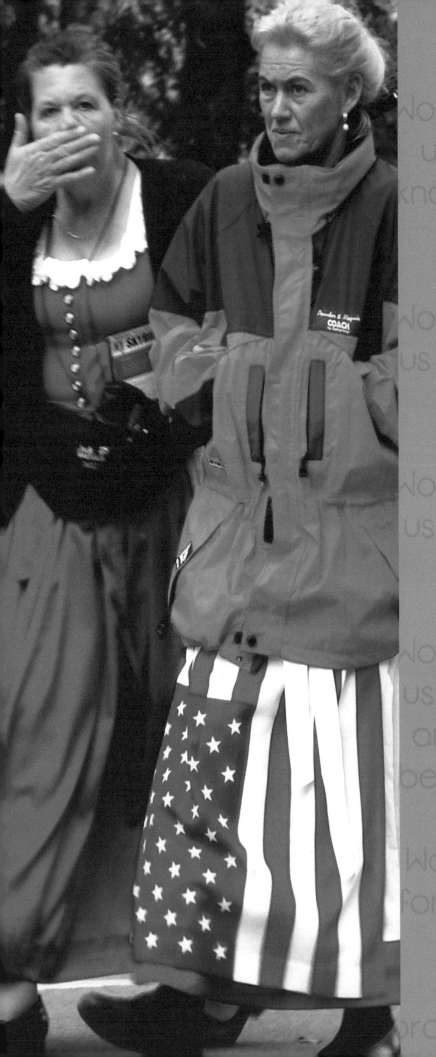

World! How did you expect us not to engage in a war when we are already in one?

World! How can you expect us to forget our two beautiful blue eyes?

World! How can you expect us to finish quickly if you know it is easy to start and difficult to end?

World! How can you expect us to ignore thousands of voices crying for justice?

World! How can you expect us to ignore the murderer when we know his face?

World! How can you expect us to ignore such a painful and horrible memory and being stabbed in the back?

World! May God forgive us for sacrificing thousands of men and women in a bloody battle for the protection of our children, of our future generations.

The pain in my chest does not matter. The pain in the deepest well of my soul does not matter, only run. New York! In your breast lie those who become submissive to the world, the ones who decide what is good and bad for humanity. Here, you find the cruelest manipulators. New York! If you want to change your defects, start today.

Enjoy the present like a newborn who has no past and does not care about the future. Enjoy the present for new ideas to be born. Enjoy the present with maximum intensity since time is the shortest part of our eternity. Demonstrate how intelligent and creative we are each day. Run!

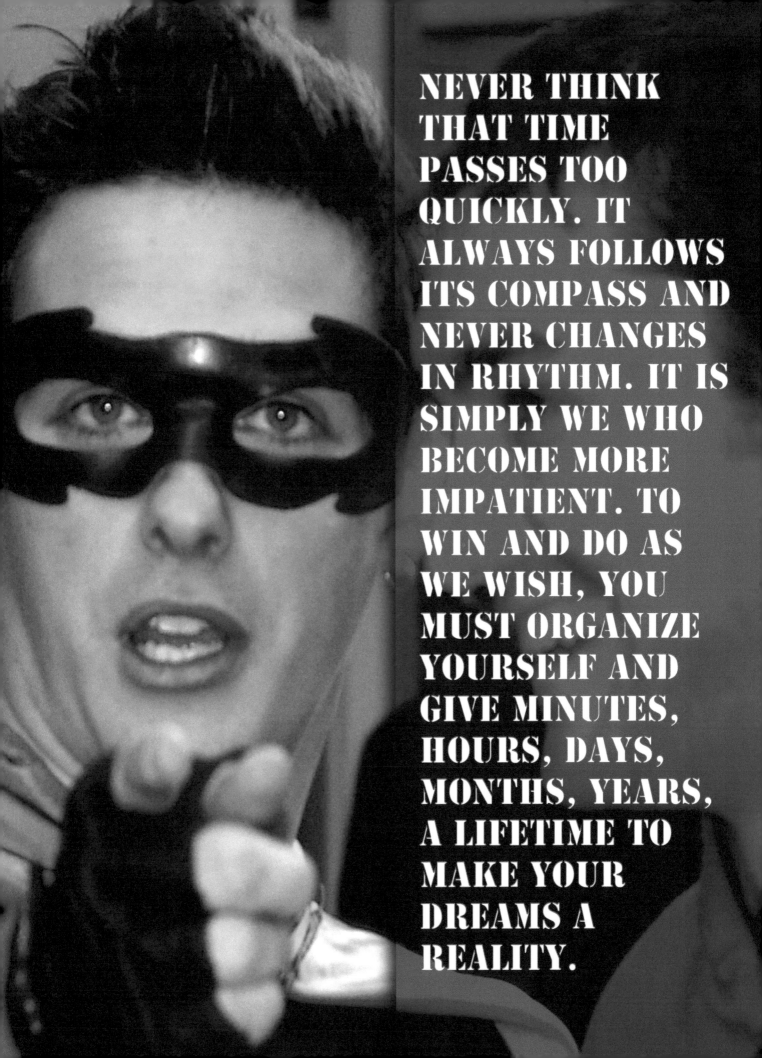

NEVER THINK THAT TIME PASSES TOO QUICKLY. IT ALWAYS FOLLOWS ITS COMPASS AND NEVER CHANGES IN RHYTHM. IT IS SIMPLY WE WHO BECOME MORE IMPATIENT. TO WIN AND DO AS WE WISH, YOU MUST ORGANIZE YOURSELF AND GIVE MINUTES, HOURS, DAYS, MONTHS, YEARS, A LIFETIME TO MAKE YOUR DREAMS A REALITY.

Do not be afraid of time—enjoy it! Enjoy the present, since it is the sum of small moments that will become something really substantial in the future. Enjoy the immediate present, since it is time you should feel happy with what you are, with what you have, and with what you do. It is not because of the past that today will go well or badly. Do not tell yourself how much time you have wasted—instead, think how much time you have left to do something new. Enjoy every second contemplating this city. Run! The pain does not matter; this pain that kills me does not matter. Soon it will disappear...soon. Run!

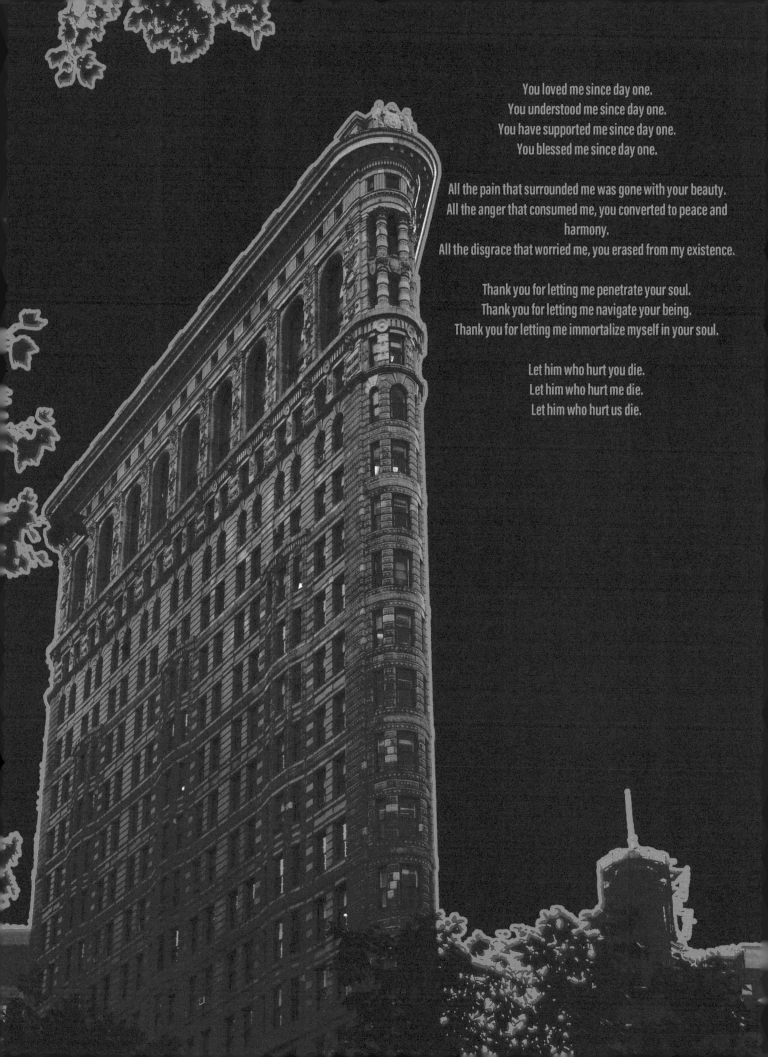

You loved me since day one.
You understood me since day one.
You have supported me since day one.
You blessed me since day one.

All the pain that surrounded me was gone with your beauty.
All the anger that consumed me, you converted to peace and
harmony.
All the disgrace that worried me, you erased from my existence.

Thank you for letting me penetrate your soul.
Thank you for letting me navigate your being.
Thank you for letting me immortalize myself in your soul.

Let him who hurt you die.
Let him who hurt me die.
Let him who hurt us die.

New Yorker! Brave is he who lives every instant with intensity and does not concentrate on the past nor future. New Yorker! Brave is he who does not conform like a chameleon but instead loves himself just how he has been created and educated. **Νεοϋορκέζος! Γενναίος είναι αυτός που διψά για κίνδυνο και δεν ξεκουράζεται αναζητώντας νέες προκλήσεις.** New Yorker! Brave is he who is conscious and happy, knowing that life never restrains anyone from reaching a goal, as impossible as it may be. New Yorker! Brave is he who knows the word "impossible" was invented by a hooligan who was too lazy to work, think, and study. The only real obstacle is yourself. Therefore, you must be willing and have a strong character for every intelligent and positive thought to transform into reality and not into words taken by the wind.

New Yorker! Brave is he who thirsts for danger and does not rest in search of new challenges.

Run! Only a few more steps, my love.

Run, don't stop. Run! The pain in your heels does not matter, the pain in your feet does not matter, the pain in your knees does not matter, the pain in your back does not matter, the pain in your chest does not matter, and the pain in your heart does not matter. Do not cry, come on, run! My love, only a few more streets, and soon I will be with you.

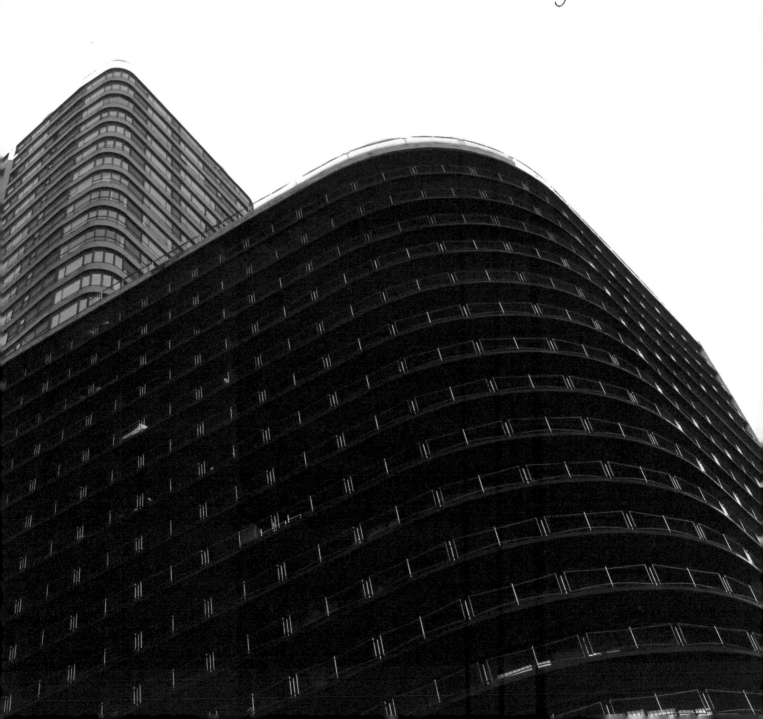

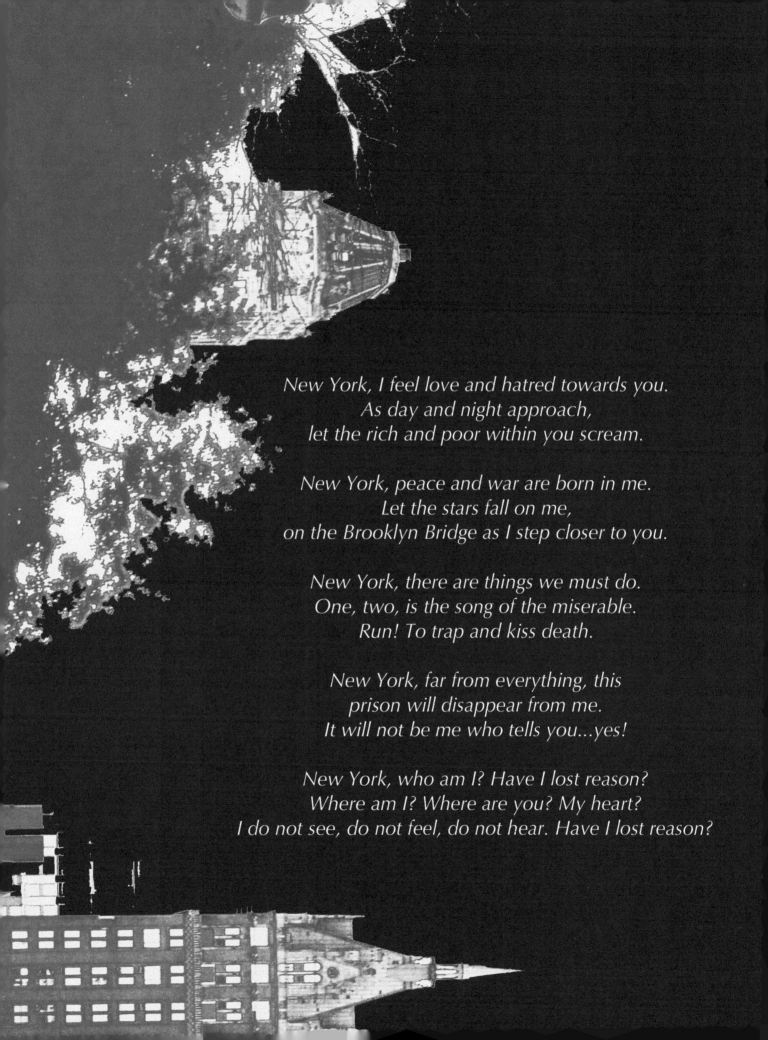

New York, I feel love and hatred towards you.
As day and night approach,
let the rich and poor within you scream.

New York, peace and war are born in me.
Let the stars fall on me,
on the Brooklyn Bridge as I step closer to you.

New York, there are things we must do.
One, two, is the song of the miserable.
Run! To trap and kiss death.

New York, far from everything, this
prison will disappear from me.
It will not be me who tells you...yes!

New York, who am I? Have I lost reason?
Where am I? Where are you? My heart?
I do not see, do not feel, do not hear. Have I lost reason?

Je t'accuse *New York of being.*
I accuse you of having ideas and ideals.
I accuse you of the pressure you exert.

I accuse New York of what composes you:
action, destruction, euphoria, faith,
adversity, disgrace, anxiety, age.

I accuse New York of having everything:
love, silence, mutation, punishment,
money, pain, praise, separation, resentment.

I accuse New York of your wisdom:
happiness, beauty, conduct, conscience,
distress, shame, debt, blindness.

I accuse New York of your envy:
falseness, age, memory, demands,
church, fortune, dictatorship, melancholy.

I accuse New York of being wrong:
reputation, excitement, extinction, insurrection,
determination, occupation, aversion, corruption.

I accuse New York of your society:
filthiness, fatality, humanity, loneliness,
reality, eternity, truth, inequality.

I accuse New York of your nature:
business, narcissism, fog, indifference,
denial, kid, nobleness, nation, a necessity.

New York, assure yourself that Cervantes, Confucius,
Julius Caesar, Camus, Darwin, Freud, Goethe, Plutarch,
Jefferson, Kafka, Kant, Engles, Jesus Christ,
Sartre, Da Vinci, and many others
would have shared many
of our thoughts.

New York, everything has finished. My thirst and the pain are gone.
I do not see her, and I have been falling for eternity.
Have you taken her, stolen her?

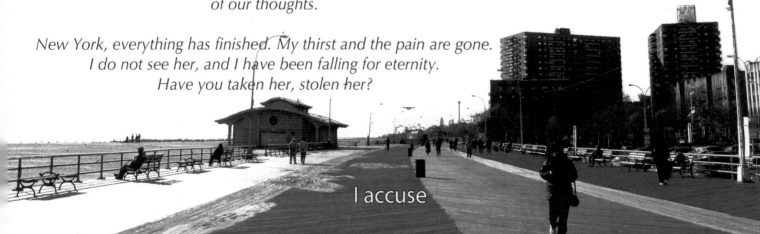

I accuse

J'attends.

Veuillez agréer, monsieur le Président, l'assurance de mon profond respect.

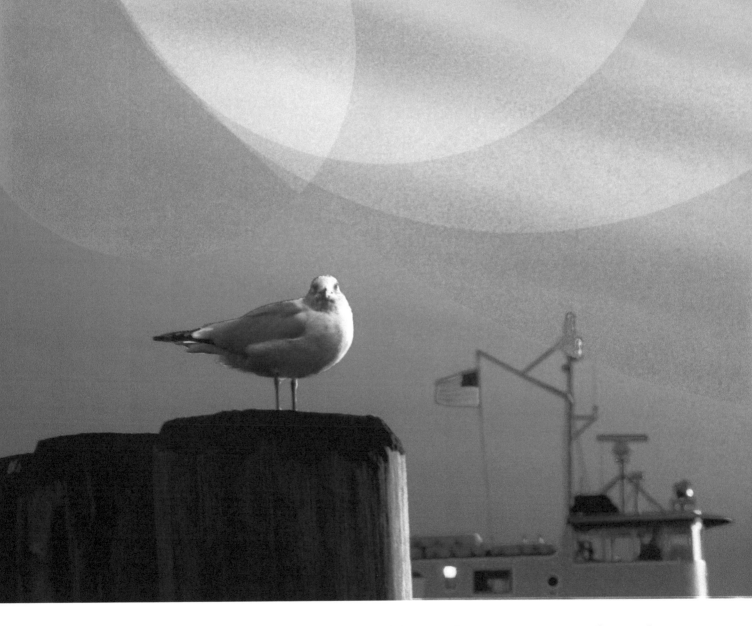

I am waiting. Please accept, Mr. President, the assurance of my deep respect.

KING ST

纽约.

New York.

GO AWAY! PLEASE
LEAVE ME ALONE!

My love, is that you? Do not cry, my love. Kiss me as if it were the last time.

THE FUSION OF COLORS, THE FUSION OF THE UNIVERSE, FUSION OF IDEAS, FUSION OF TIME, THE FUSION OF CREATION, AND THE FUSION OF LOVE.

Por siempre crepusculo Neoyorquino.

Forever twilight in New York.

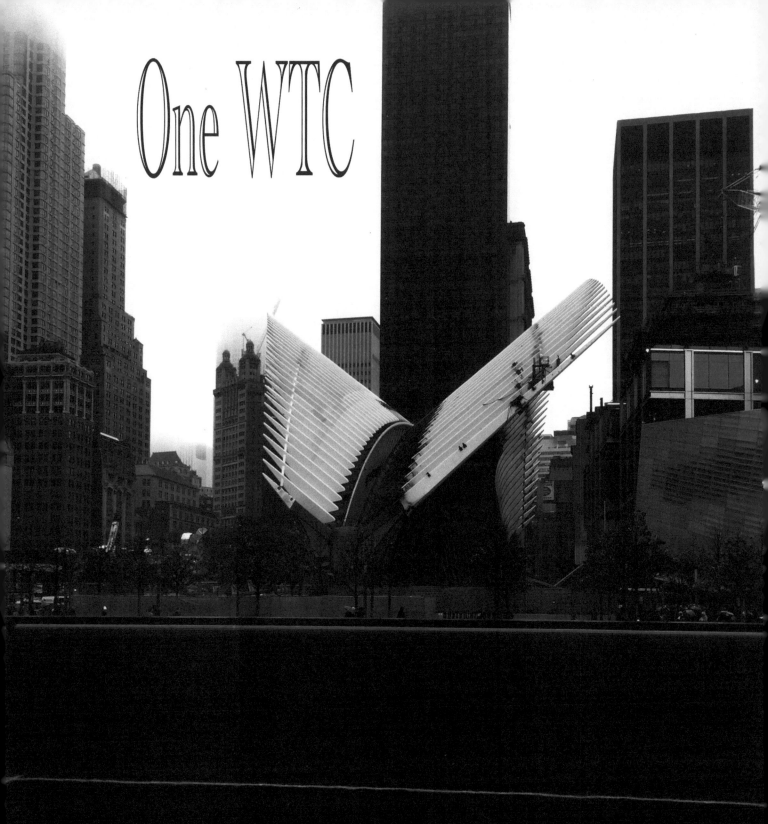

One WTC

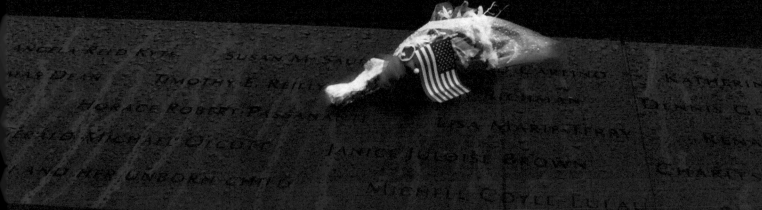

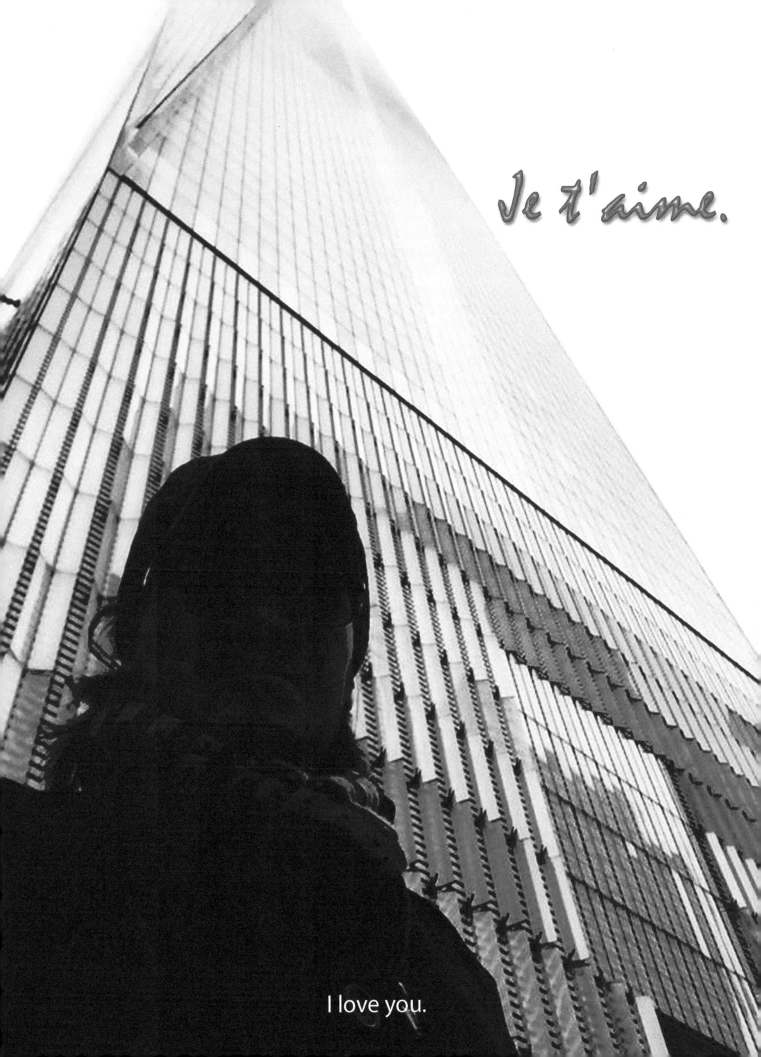

Je t'aime.

I love you.

CPSIA information can be obtained
at www.ICGtesting.com
Printed in the USA
BVHW021129040921
615988BV00020B/136